GERMAN CATHEDRALS

GERMAN CATHEDRALS

WITH AN
INTRODUCTION BY
JULIUS BAUM

PHOTOGRAPHS BY
HELGA SCHMIDT-GLASSNER

THE VANGUARD PRESS · NEW YORK

INTRODUCTION

THE temple of antiquity was built to house a divine image. The interior received light solely from the open portal, and was accessible only to the priest. The god was worshipped in the open air, at the altar in front of the temple; and the outer walls are the more richly adorned, to heighten the solemnity of the act of worship. The purpose of the Christian church, on the other hand, is to enclose and harbour the ceremonies of a cult. The altar, the clergy, the community—all have their appointed and fixed places. It is consideration of the inner space, not of the exterior, that determines the design: centuries had to pass before the exterior was deemed worthy of architectural expression.

Although the circular plan in no way precludes liturgical functions, the basilican was the form adopted for the performance of religious services in the Early Middle Ages. It has in common with the forensic basilica of antiquity not only a name but also its length, considerable size and inner colonnades. Exedra and presbytery are added in the east, to enclose the altar towards which all the colonnades are orientated. Although churches may have three or five aisles of unequal width, the central aisle or nave is in general wider and always taller than the others, and accommodates the clerestory windows in the upper, free section of its walls. These windows are the sole but fully adequate source of light. In large churches, as in St Peter's and S. Paolo fuori le mura in Rome, exedra and nave are separated by means of a transept that is unrelated, both in width and height, to the rest of the church, and gives to the ground-plan of the whole the shape of a cross—though this is not yet the so-called Latin cross. A confessional connects the altar with an underground room, in which the saintly relics are kept. A passage may lead from this to a "ring-shaped" crypt under the semicircle formed by the exedra. "Hall crypts" are of later date.

It is surprising how quickly the art of vaulting died out among the peoples of the western Mediterranean region, to be preserved only by those of Provence and Aquitaine. Basilican ceilings are simply the framework of the roof, although in isolated instances ceilings with bays were probably constructed. Vaulting remained a constant feature of centrally planned Byzantine architecture. In the Occident it became restricted, in a technically primitive form, to those comparatively rare centrally planned churches built to serve specific functions, for example, Holy Sepulchre churches—circular with ambulatory, on the model of the Church of the Holy

Sepulchre at Jerusalem—for the celebration of the Passion and Resurrection. Mausoleums, too, were circular. They were generally placed behind the main church and dedicated whenever possible to the Archangel Michael, the comforter of the soul, although his special function is that of guardian at the entrances of churches and castles. Baptisteries, which were dedicated to St John, were also on the whole centrally planned. They were placed to the west of the church. The significance of patron saints is all too easily overlooked nowadays; yet many art-historical problems could be more readily solved were they to be taken more into account. The Cathedral of Mainz is an example.

In spite of national differences that soon developed, these characteristics hold good for the architecture of Western Christendom throughout the old Roman Empire and the areas converted by missionaries. They apply also to the age of Charlemagne, who, recognizing the superiority of the architecture of the South, as for example in the construction of walls, was largely responsible for the increased use of stone as a building material among his peoples. Not until the tenth century did a clear-cut and final distinction appear between the national styles.

It is the distinctly national character of the architecture of the Middle Ages that is reflected in the accompanying plates. Not only antique Roman and later Italian, but also Byzantine, Gallic and Anglo-Saxon influences gave German medieval architecture its form. Yet in the process of absorption they were refashioned into something peculiarly German. Both the architecture and the sculpture of the so-called transition period prove that Germans interpreted foreign influences in the light of their own experience. The cathedrals of Magdeburg and Limburg-an-der-Lahn reveal many technical details of Early French Gothic, yet the exterior of the cathedral at Limburg is a masterpiece of German Romanesque, and the choir of the metropolitan church at Magdeburg obstinately German in its spirit. Both buildings express the German need for circumscribing, enclosing stone walls. On the other hand, French mysticism at the time of St Louis gave us stained-glass windows that disembody the stone walls. And in the face of the Bamberg statue of a knight on horseback is caught the roving, irrational German temperament that is not to be found in the features of its prototypes, the kings of Rheims Cathedral.

And so each plate in this book is evidence of a specifically German spirit: tells of the pride of the great princes of the Church during the days of glory of the German emperors; of the strength of the burghers during the latter half of the Middle Ages; of the poetry and the longing for adventure during the age of Minnesong; of the irrational and visionary spiritual fervour during the time of mystical piety which came to Germany belatedly but all the more violently.

The churches described in this book varied in their functions. The metropolitan cathedrals of Mainz, Cologne and Magdeburg were the seats of archbishops, and those of Mainz and Cologne had a large share in the government of the Empire. The bishoprics of Speyer, Worms and Bamberg came under the jurisdiction of the archbishopric of Mainz, the bishoprics of Naumburg and Regensburg under the archbishoprics of Magdeburg and Salzburg respectively.

After the Congress of Vienna the collegiate church of St George at Limburg-an-der-Lahn was made the cathedral of a bishopric; the Minster at Freiburg, which until then had been an ordinary parish church, was raised to the status of metropolitan church in place of the Cathedral of Constance; and the Frauenkirche at Munich, raised to the dignity of collegiate church in 1484, became the cathedral of the archbishopric of Munich-Freising. Only the Minster at Ulm remained what its high-minded founders had intended it to be, the greatest parish church in Germany.

I. MEROVINGIAN AND CAROLINGIAN BEGINNINGS

Just as worshippers of Mithra had their mithraeums, worshippers of Isis their sanctuaries, so Christians in the Roman Empire had their stone-built places of worship. Evidence of these exists at Trier in the foundations of the two basilicas built between 324 and 348 on the site later occupied by the cathedral, and in those of the baptistery situated, as at Grado, between them;[1] at Cologne, in the foundations of the Church of St Gereon built on the site of an Isis sanctuary, and in those of the present cathedral[2] and of other churches. A large number of these Early Christian churches were later desecrated and destroyed by Alemannic hordes. As Wetti records in his *Casus Sancti Galli*, St Columbanus came upon three gilt bronze statues that were being worshipped in the ancient church at Bregenz dedicated to St Aurelia, a companion of St Ursula. When Gallus broke these statues into fragments, St Columbanus founded an Irish missionary monastery there in 610.[3] The beauty of the wooden buildings of this time is the theme of the much-quoted verses of the Lombard Venantius Fortunatus, who spent most of his life in Aquitaine:

> altior, inmitior, quadrataque portibus ambit
> et sculpturata lusit in arte faber.[4]

Viking ships, like the three in the museum at Bygdö from Gokstad, Tun and the Oseberg, are evidence of a richness of carpenter's and wood-carver's work from which that produced inland probably differed little. The latter, however, can only be assessed from smaller finds, such as the Oberflacht coffins.[5] Evidence of other aspects of Germanic art, particularly goldsmith's work, is more abundant.[6]

Survivals of stone churches from Merovingian Austrasia are so rare that it is now doubted whether the Church of St Mary in the Burghof at Würzburg, built in imitation of an Italian or Dalmatian circular building with niches, was, in fact, dedicated as early as 706—as has hitherto been assumed. It was not until the age of Charlemagne that stone began to be widely used as a building material. It is for this reason that all German terms of reference to stone building are borrowings from the Latin.

It was under Charlemagne, too, that imitation of the Mediterranean style in all branches of art was encouraged. The monastery of Lorsch in the Bergstrasse was dedicated in 774 in the presence of Charlemagne. Its entrance hall to the atrium, which has a chapel dedicated

to St Michael in the upper floor—lately somewhat fancifully called a king's hall[7]—presupposes a knowledge of the entrance hall in front of the atrium of St Peter's in Rome. Similarly, individual features such as the reticulated work, the columns and capitals indicate acquaintance with the architectural forms of the South, whilst the gables are reminiscent of Northern carpenter's work such as appears on the tower of Earl's Barton. Circular buildings occur not infrequently. The Church of St Mary at Würzburg is followed by St Michael's at Fulda around 822, cylindrical with ambulatory, on the model of the Holy Sepulchre Church at Jerusalem or one of its numerous imitations; and then by the imposing Chapel Palatine at Aachen, whose architect obviously simplified the ground-plan of Justinian's S. Vitale at Ravenna.

Of greater significance in the history of church architecture, however, is the development of the Early Christian basilica.[8] The first abbey-church at Fulda (750), an aisled basilica without transept but with east apse, still follows the pattern of Ravenna. At St Emmeram in Regensburg (740–791), on the other hand, the columns are replaced by square piers and there are three east apses and a crypt under the central apse.

An unprecedented feature of the architecture of the North is the "Westwork", as at St Nazarius, Lorsch (764–774), in the first Cathedral of Hildesheim (871–875), and in the abbey-church at Corvey after the later additions (873–885). The "Westwork" is the expression of the desire for an impressively high exterior—a desire which began to influence German architecture at an early stage. The interior of "Westworks" often contains an entrance hall, a gallery; occasionally a choir.[9] Examples of "Westworks" separated from a main church by a courtyard are found at St Othmar (864–867); beside the monastery church at St Gall; and in St Salvator at Werden (875–943).

The second abbey-church at Fulda (791–819) has east and west apses and a "Roman" west transept between nave and presbytery. The foundations of the Carolingian Cathedral of Cologne, begun by Archbishop Hildebold (794–819), reveal a similar ground-plan with, however, a square choir added to the east apse.[10] The west choir was originally designed along the lines of the St Gall plan. It is a matter of speculation whether Benedict of Aniane also dealt with matters of building either during the meeting of Benedictine abbots at Aachen in the August of 816 or during the Aachen convention, called in connexion with the dedication of the monastery at Inden in July 817 for discussion of monastic reform and in particular of a stricter adherence to the Regula Sancti Benedicti.[11] (The resolutions of this convention are laid down in the charter of the 10th of July 817 by Louis the Pious.) In the dedication of the St Gall plan on vellum by the Reichenau Abbot Heito to the younger Abbot Gozbert of St Gall, probably in the year 820, mention is made of the fact that the plan was a copy of another, in the possession of Heito. This other plan may have been handed to the Reichenau Abbot in 816, whilst he was attending the Aachen convention. It is possible that the plan of the early Carolingian Cathedral of Cologne, first traceable (787) at St Maurice d'Agaune,[12]

so impressed Benedict of Aniane as to cause him to recommend it as model for the construction of large Benedictine churches to the high ecclesiastical dignitaries who followed him in his reform. The plan, however, was used at St Gall only for the monks' dwellings. During the following decades a transept was added to the west choir of Cologne Cathedral, the west apse reduced in size, and the cathedral monastery built in front of it around a rectangular atrium. Recent excavations have revealed the positions of the columns surrounding the atrium and the cantharus in the centre. Around the middle of the century, under Archbishop Gunther (850–863) the St Peter's choir was decorated with frescoes.[13] For long the cathedral was considered one of the most beautiful churches in Christendom, second only to St Peter's in Rome. The first ground-plan of Cologne Cathedral was novel not only because it had two choirs but because the addition of the east choir resulted in the "Latin cross" shape with square cross-head in place of the old plan terminating in transept and central apse. Thus centralizing tendencies became evident in the plan and structure of the basilica which were to lead—although in Carolingian times their possibilities were not recognized—to magnificent developments later. Double choirs, adopted in Gaul during the early period but soon abandoned, are a peculiarly German feature.

II. EARLY ROMANESQUE ARCHITECTURE

A period of architectural decline separates Carolingian from Early Romanesque buildings. The word "Romanesque" denotes the link with Mediterranean antiquity. It has become customary in Germany to refer to the early phase of this style as "Ottonian"—after the rule of the Saxon emperors whose contributions to the architecture of their country are still today evidence of their great understanding for art. Much that had been merely begun in Carolingian times was fully developed during the early Romanesque period. The polygon of the minster at Aachen was imitated in the Chapel Palatine at Nymwegen; at St Peter's, Wimpfen; at St John's, Lüttich; at Ottmarsheim in Alsace. The feature of double choirs, in particular, was now fully exploited, although in most cases the intersection of the nave was already clearly emphasized, the tendency being to make it the central unit in a "metrical" system. The aim was to introduce an element of rhythmic grouping. Towards this aim the Abbess Mathilda (974–1011) made her own contribution during the erection of the collegiate church of Essen by designing the west choir in the shape of a semi-hexagon as at Aachen, and the ground-plan in the shape of a Latin cross with east apse. The convent church of St Cyriacus at Gernrode, begun in 961, is, apart from its galleries modelled on the Byzantine, a somewhat diluted imitation of the magnificent metropolitan church of St Maurice at Magdeburg, which Otto the Great had founded in 955—a basilica on a large scale with east and west choirs and two transepts. The most consummate example of this type of church is St Michael's, Hildesheim built by Bishop Bernward between approximately 1001 and 1033. It had east and west choirs,

two transepts, with crossings clearly emphasized, and towers over the crossings. The centralizing tendency of the emphasized crossings is counteracted in the interior of the church by the rhythmic alternation of supports in the arcades of the nave.

III. THE CATHEDRAL OF SPEYER

German Romanesque architecture reached its height in the twelfth century under the rule of the Franconian or "Salian" emperors—an appellation derived from that of the Salian Franks along the North Sea coast. This was also the century that saw the struggle for supremacy between Empire and Papacy, between the bearer of the Imperial Crown and the Head of Christendom in Rome. No aspect of life could remain untouched by the seriousness of this clash—the artistic as little as any other. Artistic expression becomes stricter, more austere and more solemn. This is most directly evident in the monumental sculpture of the time; but also

Pl.
116, 117

in church architecture the stricter organization, the prouder bearing, are unmistakable; in so far as new plans are not consciously adapted to older foundations, as in the cathedrals of Mainz, Worms and Bamberg. In the two impressive buildings of Conrad II that date from the very beginning of the new phase the feature of east and west choirs is abandoned and the new approach strikingly formulated. These are the Benedictine monastery of Limburg-an-der-Hardt which he founded in 1024 on the site of his ancestral castle; and the Cathedral of Speyer, of which he laid the foundation-stone between 1024 and 1030[14] after the Merovingian cathedral built 400 years earlier by Dagobert I had been completely dismantled. Both are cruciform flat-ceilinged basilicas with transepts half as long as the nave, extensive crypts and "Westworks". Limburg still has columns, but they are decorated with expressive block capitals; Speyer has piers with shafts on the nave-side from which spring blind arches that frame the windows. The shafts served at first to strengthen the walls; their function became more significant later, when the vaults were added. The choir was presumably tunnel-vaulted.

6

On the other hand, the crypt, which extends under the choir and transept, has well-constructed, strong groin-vaults, which were either already a feature of Conrad II's building, or were added at the latest during Henry IV's reinforcing necessitated by the effect on the building of the strong Rhine current. Byzantine masons had been employed to provide the vaultings for the hall church of St Bartholomew at Paderborn, completed at a slightly earlier date under Bishop Meinwerk. At Speyer, however, the vaulting was a purely German achievement. The time was ripe for the reintroduction of groin-vaulting. Around 1083 and 1090 it was used in the choir of St Nicholas and at Holy Trinity in Caen. And when the Cathedral of Speyer, symbol of Franconian imperialism, was re-dedicated in 1106, the year before the death of its

4

patron, the aisles as well as the nave were groin-vaulted, the weight of the vaults being borne by the walls without the use of buttresses. For the supervision of the reinforcement, begun

around 1083, Henry IV had chosen Bishop Benno of Osnabrück, an ecclesiastic well-versed in the art of church-building. By virtue of the unity of the ground-plan designed under Conrad II the exterior of this cathedral—measuring 441 feet, and so the longest Romanesque church in Germany—must have presented an equally impressive sight. The approach from the west was, contrary to the general medieval custom, by a wide street resembling a market-street. Mention of this, the *Altpörtel*, is found as early as 1176. It opened directly on to the west porch, the central tower and two side-towers. The west front of the Benedictine church at Maursmünster may well be a modest imitation of the façade carried out a century later. The terrible destruction of the town in 1689 at the command of Louis XIV offered Franz Ignaz Neumann, who was also responsible for the heightening of the west tower of the Cathedral of Mainz, the opportunity to plan a new façade. The new plan was in a mixture of Romanesque and Baroque, and the façade was erected between 1772 and 1778. Replacement of this by a trite reconstruction in the nineteenth century was a fresh disaster for the cathedral. The choir has been better preserved. Its tower over the crossing and the two side-towers that were added 1, 2 during the building period confront one majestically from the Rhine which once flowed almost immediately behind the choir. An outer gallery decorates the clerestory walls. A 3 cathedral cloister, rich in works of art, once adjoined the south side which today gives a slightly bare impression. The fire in 1689 left little of the original interior ornamentation intact. The crypt contains the tombs of the Salian Conrad II and his wife Gisela, Henry III, Henry IV and his first wife Bertha, and Henry V; and, of the Hohenstaufen dynasty, those of Beatrix, the second wife of Frederick Barbarossa, and her daughter Agnes, as well as those of King Philip of Swabia and, from later times, Rudolf of Habsburg, Adolf of Nassau and 7 Albrecht of Austria, who was assassinated. The memorial figure of Rudolf of Habsburg, of whom it is said that he rode from Basel to Speyer when he knew death was near, was found in 1811 in the Johanniterhof. It was made immediately after his death. On the occasion of the burial of Henry IV, which did not take place until 1111, when his excommunication had been revoked, the crypt received its final form through the addition of the Kings' Choir, in which all the sovereigns buried at Speyer found their last resting-place. A memorial of red marble, which was to be in the form of a large crown supported by pillars decorated with statues,[15] was begun by Hans Valkenauer on the commission of Maximilian I, but the work remained unfinished at Salzburg.

IV. THE CATHEDRAL OF MAINZ
PRIOR TO THE SALIAN PERIOD

The three mid-Rhenish cathedrals are generally treated as a group. A striking link between them is their gleaming red sandstone from the quarries on either side of the broad Upper Rhine valley; a more fundamental one is the high-minded Salian spirit that has left its mark

on each of them. A detailed comparison, however, reveals considerable differences both in their history and in their structure. The will of the imperial founders of the Cathedral of Speyer seems to find expression in the very length of the church, in the large crypt designed as an imperial sepulchre, in the single choir, and in the emphasis on the west front which anticipates the idea of the Gothic twin-tower façade. The metropolitan cathedral of the powerful Archbishop of Mainz makes its claim to be worthy of note in a different way. It is not without reason, though occasionally without historical justification, that archbishops of

24 Mainz of the thirteenth and fourteenth centuries are always represented on their tombs as laying their hands on the crowned heads of German kings.

The history of Mainz Cathedral reaches back to Roman times.[16] In the sixth century, Bishop Sidonius built a baptistery. It is uncertain whether the Church of St John, a building approximately in the form of a square, erected by Archbishop Hatto (891–913) west of the cathedral, took the place of the older baptistery. It is equally doubtful whether this Church of St John is the one that was used as a makeshift cathedral for the dedication in 1009— "Consumitur igne, sola veteri ecclesia remanente"—of the "basilica nova" built by Archbishop Willigis (975–1011), and that was subsequently raised to the dignity of collegiate church on the occasion of the re-dedication of the cathedral in 1036. (The east choir was not completed until 1049.)

The cathedral of Willigis was dedicated to the Virgin Mary and St Martin, whose altar was placed in the west choir. The east choir contained the altar to the Virgin and also one to St Stephen. An obvious relationship exists between the Willigis cathedral, a basilica with pillars and a generously proportioned west transept, and the abbey-church at Fulda. It is possible that the west choir was already three-apsed—St Mary-in-Capitol was begun at

9 Cologne about 1030—while the west crossing was surmounted by a tower. Behind the east choir, whose staircase-towers are among the oldest surviving parts of the building, a group of pillars led, as at Cologne Cathedral, to the "Liebfrauenkirche ad Gradus". The metro-politan church of Mainz suffered more serious outbreaks of fire than the Cathedral of Speyer. After a fire in 1081 the opportunity arose of making such far-reaching alterations as to render it once and for all fit to compare with the suffragan church of Speyer, imperial cathedral though it was. The size of the church was not increased to any considerable extent. But Archbishop Adalbert I (1109–1137), though retaining the old foundations, began, around 1118 to replace the pillars of the nave by piers, and to groin-vault nave and aisles. Since the new piers were spaced out according to the old ground-plan, the distance between two neighbouring supports of the nave-vaults was only 33·5 feet against a vault span of 44·3 feet.

14 The main piers have shafts. The blank arches on the elevation of the nave form an arcade
15 underneath—not, as at Speyer, embracing—the clerestory windows. A crypt was added under the east choir. The east crossing was surmounted by a graceful octagonal tower, to which was added a slender Gothic octagon in 1361. The roof of the tower was clumsily restored in 1870.
9 As at Speyer the exterior of the east apse is articulated by means of windows framed by

mouldings and by a gallery, which, however, is not continued along the nave wall. Adalbert I added a two-storeyed private chapel dedicated to St Gothard to the north side of the west transept to receive his own tomb. Its two square bays have groin-vaults.

8

V. MIDDLE AND LATE ROMANESQUE ARCHITECTURE

The abbey-church of SS. Peter and Paul at Hirsau in the diocese of Speyer, built under the strict Abbot William towards the end of the eleventh century in imitation of the second church at Cluny, has been said to be a building which, in its many similarities to Early Christian churches—its clearly defined cruciform shape, deep atrium, pillars, omission of a crypt—was intended to form a contrast to the splendour of the imperial cathedral of Speyer. During the investiture disputes Hirsau was a stronghold of Pope Gregory VII and sided against the imperial builders of Speyer. Yet the considerable extent to which Mainz Cathedral shows the influence of that of Speyer is evidence above all of the increased desire of the princes of the Church for outward show and glory, a desire very different from the ideal of strict self-discipline of the Cluniac and, soon after, of the Cistercian Orders, too. Long after the Concordat of Worms, into the age of Lothar von Supplinburg, the spirit of the time and therewith its artistic expression were conditioned by the uncompromising bitterness of the investiture disputes. Those for whom architecture has no message may find the bronze memorial figure of Frederick of Wettin, Archbishop of Magdeburg, who died in 1152, a more telling symbol of this age.

116, 117

The age of the Hohenstaufen dynasty, and of the Late Romanesque in architecture, is an age not lacking in severity; one need only look at the monument of Henry the Lion in the courtyard of his castle at Brunswick. But the severity is less unrelieved during this age of the epic of chivalry and Minnesong. Side by side with it grew the spirit of gentleness. "Masze" —just measure—is a favourite word of poets; it is sought, as it was not to be sought again until the Humanism of the fifteenth century, in patterns of antiquity; and a surprising receptivity for everything human, in the good as well as in the bad sense, is characteristic of outstanding personalities such as, for example, the Emperor Frederick II. Similarities occur between Early and Late Romanesque, due to the imitation of similar classical prototypes or of patterns in the classical tradition. As at no other time in the Middle Ages a breadth, clarity and solemnity are achieved that recall Roman antiquity. In Germany this new spirit was at first expressed in terms of traditional forms, with borrowing from Mediterranean antiquity, and degenerating here and there, particularly in the north and east, into a wild Romanesque "Baroque"—note, for example, the capitals in the choir at Magdeburg. France, on the other hand, developed the Gothic style directly out of the stiffening of High Romanesque—"Gothic" because Italian historians made the Goths responsible for the decay of antique art and for

113, 114

everything that was produced during the next millenium, including late medieval art. However, the style that we know today as Gothic was developed without doubt during the latter half of the twelfth century in the Ile-de-France, in Normandy and in Picardy, and reached its height during the reign of St Louis. Whereas England adopted the new style at once, it was at first rejected in Germany and Italy, and did not become generally accepted until the end of the Hohenstaufen dynasty. Nevertheless, already at the beginning of the thirteenth century there are in Germany isolated buildings that bear the essential characteristics of the new art, in particular the Cathedral of Magdeburg, St Elisabeth's at Marburg, the Liebfrauenkirche at Trier; and, similarly, works of sculpture at Magdeburg, Mainz and Bamberg. The most charming, perhaps, are buildings like St George's at Limburg-an-der-Lahn, where the new technical devices are used to create an exterior of pure Late Romanesque character.

39, 40

VI. THE CATHEDRAL OF MAINZ
DURING THE HOHENSTAUFEN PERIOD

One of the most magnificent achievements of Late Romanesque architecture which, apart from the use of rib-vaulting, borrowed no essential feature from the new French art, is the trefoil-shaped west choir at Mainz, together with the crossing and the outer shell. Already under Archbishop Conrad I of Wittelsbach, who died in 1200, the nave was rib-vaulted, the thickness of the existing walls making reinforcement unnecessary. The aisle-vaults were also strengthened. The floors of the west choir and crossing were made level with each other. Over a massive substructure the tower above the crossing rises in two octagonal storeys with windows, terminated in the interior by an eight-ribbed groin-vault. The crossing, as well as the east choir, are separated from the nave by rood-screens that are already carved in the spirit of French Gothic. On the west side, however, the crossing opens on to the trefoil with its three exedrae, which lend it an almost antique air. The effect aimed at with the trefoils of St Mary-in-Capitol and Holy Apostles at Cologne, with their semicircular apses, is here seen consummated. The cathedral was dedicated in 1239 by Archbishop Sifrid III of Eppstein in the presence of the young, art-loving King Conrad IV and the entire assembly of his suffragan bishops. The beauty of the exterior of the cathedral with its three polygonal exedrae, their walls decorated with couple-shafted galleries over the windows, with its angular staircase-towers and imposing tower over the long-armed crossing, is unrivalled by any other German Romanesque church. The tower did not suffer but rather gained an effective finishing touch through the stone superstructure compounded of Romanesque and Baroque styles added on to the Gothic upper floor of 1490 by Franz Ignaz Neumann some time after 1767.

Simultaneously with the re-vaulting of the west transept the chapter-house was built, a square room with a cross-ribbed vault and with blind arcading along the walls. Around 1420

16
19

10

it was transformed, probably by the Frankfurt master, Madern Gerthener, into a memorial chapel for the cathedral's founders, and a richly carved portal added. Already at an earlier 17, 18 date Gothic chapels had been added to the two aisles, their large windows detracting considerably from the original spatial effect. The south cloister had also been rebuilt in Gothic style. In spite of the loss of numerous valuable works of art, many of the best examples of German sculpture are preserved in the bishops' tombs.

VII. THE CATHEDRAL OF WORMS

Although less magnificent than Speyer and Mainz, the suffragan church of Worms nevertheless holds its more modest own. Its two main and four staircase towers give it distinction 27 —a quality also found in the interior, although this lacks the abundance of sculptures of the Mainz tombs.[17] 33

At the time of the *Völkerwanderung* a reflowering of culture, of which we possess an unusual amount of information from the *Nibelungenlied* and the *Edda*, occurred in the Celtic-Roman town of Borbetomagus during the short rule of the Burgundians in the first half of the fifth century. Unfortunately archaeological finds so far have not been of a significance equal to that of our literary heritage. No archaeological evidence has yet been found of the Christian cults which the Burgundians are known to have embraced in their Rhenish kingdom. In Merovingian times we find mention of the Cathedral of SS. Peter and Paul, which stood on the forum of Roman Worms and which, as excavations have proved, already had, in the year 600, the dimensions of the present nave and aisles. Boniface raised the Bishop of Mainz to the dignity of Metropolitan, and placed under his jurisdiction Worms, Speyer, Würzburg, Constance and Augsburg—a wide area reaching from the Alpine watershed to the boundaries of Thuringia. The loss in ecclesiastical dignity suffered by Worms was in some measure compensated by its position of royal town from the time of Charlemagne to the days of the famous Worms Imperial Diets under Maximilian I and Charles V. During the darkest phase of the investiture disputes Worms remained loyal to its emperors. The Concordat that ended the long struggle bears the name of Worms.

Already in the ninth century the Merovingian cathedral was enlarged by the addition of an east transept and east choir, perhaps already in the present proportions. When the millenium passed without the expected apocalyptic judgment, and a spate of church-building on a more magnificent scale set in, Bishop Burchard I built a new cathedral, of which the socles of the east choir and the east staircase towers are still visible. The ground-plan of a west apse was discovered between the west towers, whose foundation-walls still stand. The church was dedicated in 1018 in the presence of the Emperor Henry II. It was re-dedicated in 1110 after a fire, but the building of Burchard lost none of its Ottonian character. The vaulting of the

flat-roofed basilica on the pattern of Speyer and Mainz was not undertaken until much later, being begun in 1171 by Bishop Conrad II, who furthered the work so effectively that the east choir and east transept were dedicated in 1181. The conical stone superstructures of the east staircase-towers were not added until after an interval of some decades. Subsequently the nave and aisles were groin-vaulted. The shafts from which spring the vault-ribs and the arcadings framing the clerestory windows were modelled partly on Speyer and partly on Mainz. The string-course over the nave-arcading is a distinct feature. Eventually it was decided not to
28 construct a west façade with porch—which would have been in keeping with the frequent imitation, particularly in Alsace, of this feature of the Cathedral of Speyer—but, instead, to take down the little west apse and to add a polygonal west choir directly to the substructure of a crossing tower built between the west bell-towers. This work was not completed until the third decade of the thirteenth century.

 In its restraint and severity the east part of the Cathedral of Worms is clearly a derivation of the Salian style. It is distinguished from the east choirs of the cathedrals of Mainz and
27, 28 Speyer by its magnificent flat façade which, incidentally, was surrounded by houses from medieval times until the Second World War, so that its substructure was visible only from the immediate vicinity. This fact throws some light on the profusion of diabolical animals, to
30, 31 which we shall return later, with which the sills of the three enormous round-arched windows are decorated. The gallery over the windows is visible at long range and is of great beauty.
27 With its carefully proportioned round towers and the squat octagonal tower over the crossing the east aspect is an untarnished record of the proud spirit of the twelfth century. This is true
16 also of the interior. The economy and restraint of the east crossing is very different from the
34 exuberance of the Late Romanesque west crossing at Mainz. The west choir at Worms, however, dedicated to St Lawrence, is a slightly excrescent late blossom of the Romanesque
28, 35 style with its moulded blind arches on the ground floor, large round segmented window in the centre—which Lombard masons may well have copied from some cathedral in the Po valley—and the five circles arranged around it "like planets around the sun" ("*Wie der Sterne Chor um die Sonne sich stellt*"). The master-mason who designed the west choir evidently did not attempt to emulate the Mainz choir. At the same time it must be conceded that his solution of the problem does not lack originality of conception.

 The building changed little during the Gothic period. A number of chapels were added
32 to the aisles, and a rich Gothic portal built between the St Nicholas Chapel (*c.* 1300) in the west and the St Anne Chapel in the east. In 1689 the cathedral suffered heavily, like so many others, at the hands of the French armies. The vaulting of the nave collapsed, destroying the interior almost completely. The cloistered cathedral forecourt on the south side was also demolished. The new High Altar was designed by Balthasar Neumann, the carvings being the work of Johann Wolfgang von der Auwera.

VIII. THE CATHEDRAL OF LIMBURG-AN-DER-LAHN

The collegiate church of St George at Limburg-an-der-Lahn[18] in the former bishopric of Trier cannot emulate the three large mid-Rhenish cathedrals, the metropolitan cathedral of Mainz and the suffragan Speyer and Worms. The little Protestant Duchy of Nassau had no employment for an episcopal see until 1827, when law and order had been newly established in Germany after the Napoleonic wars and the dissolution of the Imperial Diet, and when reorganization of the diocesan divisions proved unavoidable. Its first bishop could not have wished for a more beautiful cathedral, although in size—in keeping with the smallness of its chapter—it does not approach the Rhenish cathedrals. Its short nave and aisles and over-emphasized transept tend to give it the appearance of a centrally planned building. The interior, however, has all the essential features of a three-aisled basilica, although its style is very different from the mid-Rhenish. This can be explained, on the one hand, by the later date at which building operations on the cathedral in its present form were begun, and on the other by the fact that it is one of a group of churches, such as the Liebfrauenkirche at Ander-nach, which are more closely related to the school of Cologne. The majestic trefoil-shaped cross-head and arms of St Mary-in-Capitol at Cologne were centrally planned on so massive a scale that they were generally assumed—until subsequent investigations of the foundation-walls proved the theory wrong—to have been erected on the site of a Roman building similar to the hall of the Imperial Palace at Milan which is today incorporated in S. Lorenzo. What-ever the merits of the theory, the Cologne trefoil became the hall-mark of a school. It is found in Great St Martin's and Holy Apostles at Cologne, and in the west choir of Mainz Cathedral. But there are also a few churches in the former province of Lower Lorraine which have the richly articulated east apse with ambulatory and a three-aisled transept, on the pattern of St Mary-in-Capitol, but not apses in the cross-arms, that is, traditional transept façades. The intention was, perhaps, less to preserve tradition than to achieve an effective exterior, for it thus became possible to add to the two west towers, not infrequently found in this area, an impressive tower over the crossing, as well as four small side-towers, two at each transept-end. The most magnificent example of this style has been preserved in Doornijk Cathedral, though unfortunately without the original choir-end. Its influence can be traced in the Early Gothic cathedrals of Noyon and Laon. Similarly, in St George at Limburg, whose seven towers, forming one rhythmic group, lift themselves into the sky like a Te Deum in stone, the native influences have been acknowledged and gratefully adapted. Dominant is the octagonal 39, 40 crossing tower with its slender spire, subordinated to it the two sturdy west towers and the transept-turrets, which were added to the original plan by way of an afterthought, the south turrets not being built until 1863–1865. The shortness of the nave contributes in no small measure towards this effect of compactness.

It is not certain whether Archbishop Hetti of Trier (814–847) did, in fact, dedicate a church on the site of the present cathedral. In 910, however, the endowment was founded by

43 Count Conrad Kurzbold, whose memory is honoured in a monument erected when the church was rebuilt. The rebuilding was begun about 1215 by Count Henry of Ysenburg (probably 1179–1220). After a number of alterations in the plan the church was dedicated in 1235. The severity and restraint of the twelfth century are thus not reflected in the building. From which-ever point of the compass one looks at it, the exterior has a bounteous beauty, which is, in spite of the fact that the stressing of towers as separate units is a frequent feature of Early Gothic churches, essentially that of Late German Romanesque as we find it, partly in simpler, partly in richer form in the west choir of Mainz Cathedral. The west façade is in itself a magnificent

40 achievement. The sturdy towers, which are divided into five almost die-shaped storeys, are effectively foiled by the arcading that runs across the whole façade above the ground floor, by the large round window, and in the two bell-storeys by the louver windows, taller in the uppermost storey. The choir has an ambulatory—on Romanesque-French lines, though with-

39 out radiating chapels. It is decorated by arcades along the ambulatory and upper walls of the choir. An unexpected feature is the use of buttresses and flying buttresses for the support of the interior vaulting—a use which, in spite of its restraint, already anticipates the Gothic style. It serves as exterior introduction to similar features in the interior.

41, 42 Outwardly and in its setting so German and Rhenish, this cathedral is almost French in its interior. The style that found its most magnificent expression at Laon is here reformulated. Originally the vaults were four-ribbed, borne by piers with shafts. Later the vaults were made sexpartite on the Norman pattern, and shafts rising from consoles placed over the subsidiary piers were added. The elevation of the nave, too, owes its inspiration to Early French Gothic, particularly to Laon. A wide gallery bears the stress of the vaults and opens in arcades towards the nave; this is surmounted by a blind triforium, and then the clerestory windows that reach right up to the vaults. The gallery was subsequently extended along the east parts, so that the choir now resembles that of Magdeburg Cathedral.

Immediately upon the completion of the interior the church was decorated with murals. These lost most of their value, however, in the course of restoration in the nineteenth century. Apart from the over-ornamented baptismal font, dating from about 1220, and the Kurzbold tomb, of which more below, the cathedral has preserved nothing of its original ornamentation.

IX. THE CATHEDRAL OF BAMBERG

When the ancient German tribes left their habitations in the east of Germany, wide stretches of country were left unpopulated and were occupied eventually by Slav tribes. It was left to Otto I to beat them back, having defeated the Hungarians in the battle of the Lech, and thus make possible the recovery and Christianization of ancient German tribal lands in Central and North Germany. The proudest commemoration of this success was the foundation

of the metropolitan cathedral of Magdeburg. Otto's successors made further gains. In the region of the Upper Main the area around Bamberg was freed from the Wends. Otto II gave the ancient castle to the Bavarian Duke Henry the Quarreller, father of the Emperor Henry II, who presented it to his wife Kunigunde as marriage-gift. When Henry had been made king in 1002 the royal couple gave up their possession of the castle church so that it might be made into a cathedral, and in 1007 Henry, having overcome the resistance of the Bishop of Würzburg, gained the consent of the German bishops and of the Pope for the foundation of a Bishopric of Bamberg, subordinate to the Archbishopric of Mainz.[19] In 1012 the cathedral was dedicated by the Patriarch of Aquileia assisted by over thirty bishops. The patron saints chosen were the Apostles Peter and Paul for the west choir and St George for the east choir. The church, Early Romanesque in style, had two choirs, a west transept, and the remains of a lower church under the west choir—probably part of the chapel of the old castle. After fires in 1081 and 1183 the building was restored according to the original plan. In 1201, after the canonization of the Empress Kunigunde, her relics were solemnly enshrined in the cathedral. And in the cathedral forecourt, in 1208, Otto of Wittelsbach murdered King Philip of Swabia, whose tomb stands among those of his Hohenstaufen forebears in the Cathedral of Speyer.

Not until the reign of Frederick II was the cathedral rebuilt in the style of the time. The driving force in this undertaking was the powerful Bishop Count Ekbert von Andechs-Meran (1203–1237), a widely travelled man, and one who must obviously have taken a personal interest in contemporary sculpture. For what other explanation could there be for the dismissal of his Romanesque sculptors in the middle of their work on the Princes' Portal (*Fürstentor*) and their replacement by a group of sculptors trained in France. His influence in the sphere of architecture is less noticeable. The master-masons, probably from the Upper Main area, who built the new cathedral, presumably to a large extent utilizing the old foundation-walls, gave the building a restraint and sobriety that link it with Würzburg Cathedral, for example, or St Sebaldus at Nuremberg and make it a product of the High rather than the Late Romanesque period. Thus the cathedral forms a striking contrast to the imaginative splendour of Rhenish architectural achievements such as the west choir at Mainz and the Cathedral of Limburg. At Bamberg there is no tower over the crossing and none of the exuberance of Romanesque ornamentation. More in keeping with the spirit of the early thirteenth century are the steep ribbed vaults of the interior which, at least in the nave, replaced an original flat roof—as is proved by clerestory windows, subsequently walled up, across which the ribs cut. Characteristic of the period, too, is the lofty west choir, built probably with the aid of Cistercians from Ebrach; and so, especially, are the octagonal upper parts of the west towers with their superimposed corner tabernacles. These are fairly close reproductions of the transept-towers of the Cathedral of Laon: even the oxen that had been portrayed at Laon in recognition of their hard labour in dragging stones are included. The tower-windows, excessively slender at Laon, are here, however, subdivided.

A reference, in 1219, to building operations on the cathedral refers doubtless to the east choir, to which a crypt was added. This was lengthened beyond the original plan during building. The two choir-bays were groin-vaulted. Screens, which will be discussed later, were added to the side-walls. The two sturdy towers, whose four lower storeys are among the oldest parts of the building, have entrance halls on the ground floor, and these are entered through two magnificent portals: the Adam Portal (*Adamspforte*) and the Portal of Mercy (*Gnaden-pforte*). In the course of the work on the east choir both portals were richly moulded, zigzag ornamentation being used for the Adam Portal. Originally no room was left for statues. The six statues that today frame the Adam Portal are late thirteenth-century work.[20] The group in the tympanum of the Portal of Mercy, however, portraying the Virgin between St Peter and St Paul, Henry II and Kunigunde, is purely Romanesque in character. Between the two towers the east apse stands out forcefully, semicircular below and polygonal above. Round shafts effectively emphasize the corners between the large, round-headed windows. Over them a frieze of round arches and a cornice are surmounted by an arcade with coupled shafts. A comparison with the east apses of Speyer and Mainz reveals the increased modelling of wall space which characterizes this choir. Yet it is a taut and restrained energy, far removed from the profusion of the contemporary west choir at Mainz.

Nave and aisles and transept were completed before 1229, having, like the Rhenish cathedrals, main piers with shafts from which spring the rib-vaults of the nave and transept, and intermediate piers for the support of the aisle-vaults. The simplicity of the west choir indicates the work of Cistercians from Ebrach, from where may also have come Wortwrinus, who is mentioned as "magister operis" in 1229. The upper parts of the west towers reveal a French influence—more decidedly, perhaps, than the later group of stone sculptures. Building was completed in 1237, and in the same year the cathedral was re-dedicated. Its ornamentation received rich additions in later years. Although much was removed without obvious reason during restoration in the nineteenth century, an abundance of Romanesque and Gothic sculpture of the early thirteenth century, and of monuments and memorials of later date, has been preserved.

X. OPUS FRANCIGENUM

The west choirs of Mainz and Worms and the Cathedral of Limburg-an-der-Lahn show that widening and rounding of the interior and compact, centralized grouping of the exterior were the aims of master-masons of the Late Romanesque period. In their achievement of this aim they drew inspiration from the architecture of the Late Roman age. As the basilican was the accepted form of Christian church architecture, and since the two-choir form—which was intended to reflect the interaction of imperial and papal power[21]—was so little in keeping

with the idea of central planning, master-masons of the Late Romanesque period sought to invest the east choir and its surroundings as far as possible with the characteristics of a centrally planned building by substituting an entrance hall for the west choir. When opinions diverged the dispute was as heated—though it received less note from historians—as that which later was to surround the completion of St Peter's at Rome. For the idea of the church as a cosmic symbol in the form of a centrally planned building is cherished by all liberal generations.

An artistic development totally different from that in Germany took place in the North of France. Nowhere did High Romanesque assume characteristics so austere and ascetic as in the Ile-de-France, the home of Scholasticism. But it was not only from Scholasticism, whose object it was to encompass all empirical knowledge within the rigid framework of belief, that the new French spirit grew. It was nourished no less by the mysticism of St Bernard (1091–1153). Great crowds gathered to hear his sermons and exhortations to deeper piety and stricter morality. Many joined the new Order of Cîteaux, which, upon his own entry into it in 1113, began to exercise a strong influence on the spirit of the age. The rules of the Cistercian Order, which are far stricter than those of the Benedictines, also cover the subject of church-building. They demand, for example, the stressing of the cruciform shape, the omission of towers and all forms of ornamentation, particularly the representation of fiendish beings. The influence of this ascetic mysticism is traceable in all French art of the time, merging, outside the monasteries, with that of Scholasticism. It is only against such a background that the artistic achievements of the first half of the twelfth century can be understood. Works such as the Stylites-like figures of the ancestors of Christ in the "porta regia" at Chartres, which seem to us stiff and lifeless symbols, must be approached on their own terms. The austerity of this artistic formulation in Northern France left no way open towards the freedom of Late Romanesque art, as it is preserved in Provence in the portals of St Trophime at Arles and of St Gilles. In the north it was more a case of the rigidity of the mid-century developing slowly and almost imperceptibly into the Gothic style.

For the Christian of the Middle Ages priestly guidance had been sufficient. It had offered him all the means of salvation. Within the firmly enclosing walls of the Romanesque church, symbol in stone of the spiritual structure of the heavenly Jerusalem,[22] he felt himself secure against death and the devil. It was St Bernard who first encouraged the individual to probe his inner being, to meditate and even be carried away by mystic experience. It was a step that had many consequences. It liberated the life of the emotions. The worshipper now became aware of the personal contribution which he could make towards the communal church service. The solid walls of the church became too restricting. His vision, seeking the immaterial, was hemmed in by the rafters of the roof, or a horizontal wooden ceiling. The desire for increased height, for taller supports and for vaults which appear to vanish into the distance made itself felt along the Middle Rhine and in Normandy at an early date, and proves that before and concurrently with St Bernard related forces were at work towards the same goal. The rational-istic nineteenth century considered stone vaulting to have been introduced solely because it

lessened the danger of fire. This consideration no doubt played a part in bringing about the technical advances which heralded the new style—a style which the French called "style ogival" after its basic innovation, the ogive arch, but which has retained the Florentine term of abuse "stile gotico"[23] intended to apply to all art between that of Antiquity and the Renaissance. But the decisive element of the new style was not the new technical skill but rather the new will, the new yearning for the immaterial, intangible; the new mysticism. Even in the Scholastic thought of the time, whose roots derive firmly from the earlier medieval period, the influence of mysticism can be traced.

Through the use of the rib-vault the weight of an entire vault could be conducted on to the corner supports. The stress was no longer borne by the wall along its entire length. In many cases buttresses attached to the wall sufficed to bear the pressure of the transverse and diagonal ribs. With the use of flying buttresses, however, the stress could also be conducted farther away from the main walls—over the aisle-roofs, for example. The spectacular buttressing of Gothic churches powerfully affects the beholder by virtue of its mighty dynamics, an expenditure of energy whose purpose is not evident from the exterior. Inside the church, on the other hand, the vaults in their dizzy heights appear almost unsupported. During the Romanesque period only square bays were constructed. In these bays the semicircles of the transverse arches attained, of necessity, a lesser height than did the apex of the diagonal ribs. If uniform arch-height was desired, then the diagonal ribs had to be sprung from a level below that of the transverse arches. In rare cases this was done, as in the *Paradies* at Maulbronn, where the effect is of a delightful interplay of forces. But this technique was too complicated to become a feature of the style. The juxtaposing of large numbers of bays, however, made the need for uniform arch-height imperative. It could only be met through substitution of the pointed for the semicircular arch; for the pointed, though perhaps less sturdy, is not fixed in height by its width. Thus the movable bay was created. These three technical innovations, the rib-vault, buttressing and the movable bay, enabled Gothic master-masons to create their miracles: their incredibly tall interiors, whose vaulting seems to dissolve into heaven itself and from whose gleaming glass walls a mystic force seems to emanate as though from a celestial source—"For the glory of God did lighten it";[24] and, in contrast to the mystic one-ness of the interior, the complex unity of the buttressing. The purest example of this style has been preserved in the Cathedral of Chartres.

But much still had to be accomplished in the country that created the Gothic style before Chartres Cathedral was completed. The weight of the vaults caused their constructors many problems. The efficacy of buttresses was at first not trusted, although they had proved their worth in ancient Byzantine art, and other means of strengthening the walls were preferred. Thus the four-storeyed elevation was developed by the school of Saint-Denis, consisting of an arcaded nave, galleries over the aisles—which appeared in Normandy as early as the eleventh century—a dark triforium, and small clerestory windows. This system is found in Saint-Denis itself (choir built 1140–1144), Noyon (c. 1160), Laon (c. 1170), in the choir to

Saint-Remi at Rheims (c. 1170) and at Châlons-sur-Marne (c. 1190). It has already been mentioned in the chapter on Limburg Cathedral and will be discussed again when we come to Magdeburg. Gradually the technique of buttressing was perfected, and the galleries became unnecessary as supports. The classic cathedrals were created: Chartres, Rheims, Amiens—their elevations consisting of tall, slender nave arcades; a triforium, the arcading of which was at first blind; and large clerestory windows with pointed heads. French choirs were constructed on the plan customary in France since the beginning of the Romanesque style, namely, with ambulatory, that is, a continuation of the aisles around the choir and with radiating chapels. The large transept emphasizes the cruciform shape of the ground-plan, and is generally three-aisled. The west façade is twin-towered, with three portals and a large circular window over the centre portal.

Although German master-masons recognized the technical advantages of the rib-vault and used it at an early stage, it was a long time before the complete system of features that make up the Gothic style became generally accepted. During the twelfth and early thirteenth centuries Germany remained on the whole untouched by the new mysticism. The Cathedral of Magdeburg, in its rebuilt version, is an isolated instance of Early French Gothic in Germany. The Minster of Freiburg reflects, in simplified form, the magnificent suffragan church of Strassburg; and Cologne Cathedral develops the ideas of the plan of Amiens. Parallel with these achievements in terms of French Gothic are attempts to give its spirit an independent, German formulation—in St Elisabeth's at Marburg (1236–1283)[25] and in the Liebfrauen-kirche at Trier (completed 1253). These will be discussed later. How strongly even the second half of the thirteenth century still felt Gothic to be a foreign style is borne out by a contemporary chronicle of Burkhart von Hall's in which he refers to the rebuilding of the collegiate church at Wimpfen, begun in 1269, as "opus francigenum".[26]

XI. THE CATHEDRAL OF NAUMBURG

Shortly after the foundation of the Bamberg Cathedral the Wends in the area of the Upper Main were Christianized and incorporated within the German Empire. Progress was slower around the Saale and Elbe. In 937 Otto I founded a monastery at Magdeburg in honour of St Maurice; and in 967 Magdeburg became an archiepiscopal see. In 968 its first archbishop, Adalbert, created the bishoprics of Zeitz, Merseburg and Meissen, but only that of Merseburg included a major Christianized area. It was, however, dissolved in 981. (The Sorbs, who had penetrated into this area after the *Völkerwanderung* remained heathens until far into the twelfth century.) Attacks by Wends on Zeitz necessitated the transfer of the bishopric to Naumburg in 1032, Zeitz retaining a collegiate chapter. The cathedral at Naumburg[27] was built on the site of a castle presented to the Church by the Margraves Hermann and Eckhart II

of Meissen, and was dedicated in 1044. It was a building of modest dimensions, about half as long as the later cathedral, but already with west and rectangular east choir and east transept. Two secondary apses branched off the main apse. A lower church took the place of the central section of the present east crypt, which was built in the twelfth century.

Bishop Engelhart (1207–1242) rebuilt the cathedral on a considerably larger scale. The crypt was widened, and a beginning made on the erection of a new nave in an unpretentious Late Romanesque style. The substructure of the four towers were built, and the octagonal east towers were erected as far as the upper cornices. The east choir with secondary apses was built on the plan of the old cathedral. When Bishop Engelhart died the east choir had been completed except for its polygonal end, and was probably already separated from the nave by a choir-screen. The nave had a horizontal ceiling. In spite of its four towers the cathedral was at that time an unpretentious building, with its severe east transept, small windows and sparse mouldings. Under Bishop Dietrich II of Wettin (1244–1272), however, the singularly beautiful west choir was built in the new style. In a brief of 1249 he promises all donors to the cathedral building funds inclusion into the "universal family" of the Cathedral Foundation and in its prayers. Donations must have been numerous, for work on the west choir and choir-screen, as well as on the famous founder-statues, was soon begun. At the same time the nave and aisles were vaulted. Alternating supports were used; that is, the square groin-vaults of the nave are supported by shafts attached to the main piers, while those of aisle-vaults are sprung from the intermediate piers. The building of the west towers was also continued. The northern one is unmistakably modelled on the Bamberg west towers, which in turn were inspired by the corner-tabernacles in the towers at Laon Cathedral. The southern one was completed on this pattern in 1894. The polygonal end of the east choir is in the conventional Late Romanesque style, and was not added until about 1300, when that of the west choir had already been completed. Both choirs have ribbed groin-vaults. The west choir was doubtless the work of a group trained in France, but is without French precedent. In order to heighten the effect of the large founder-statues placed along the walls of the polygonal end of the choir, only this part of the choir was glazed—in contrast, for example, to the contemporary Sainte-Chapelle in Paris. The wall-arcading along the sides of the choir is continued over the windows of the choir-end. This west choir is characterized by a striking unity of form and content. In this it is very different from the choir at Bamberg, where a lack of space prevented the Gothic sculptors from effectively placing their statues. In its essentials the west choir-screen seems to have been modelled on that at Mainz.

In the fifteenth century the east choirs were heightened and the northern west tower completed according to the original plan. Baroque cupolas were added. These have been preserved on the east towers. A fire in 1532 damaged parts of the vaulting of the nave and west choir, as well as carvings at the extreme end of the north frieze of the choir-screen, where the renovations are clearly visible.

XII. THE CATHEDRAL OF MAGDEBURG

Situated at a busy crossing of the Elbe, Magdeburg had been an important German trading centre ever since the time of Charlemagne. This significance is reflected in the large Benedictine monastery of SS. Peter, Maurice and Innocent with its rich store of works of art founded in 937 by Otto the Great and his wife Edgith, the daughter of Edward of England. Just before the decisive battle with the Magyars in 955 Otto had decided to make the monastery part of an archiepiscopal endowment, to which were to be subordinated the newly founded Wendic bishoprics. However, he was forced to postpone his plans until the deaths of the Archbishop of Mainz and the Bishop of Halberstadt, whose rigid insistence on their rights prevented the formation of the new see. It was ratified, however, at a synod held at Ravenna in 968. The first archbishop was Adalbert, who had been a missionary bishop in Russia.[28] Otto had already begun to replace the barely completed abbey-church by a far more splendid cathedral. Valuable Italian stone, whose beauty could still enrapture Bishop Bonizo of Sutri in 1085, was used as building material. The significance of the cathedral to Early Romanesque architecture has already been mentioned. During the eleventh century the crypts were enlarged and a sepulchre built into the northern east tower for the tombs of Otto and his first wife Edgith, who had died in 946. As at Cologne, the west façade opened on to a wide atrium. This led to a circular baptistery, dedicated to St Nicholas, which was burned down during an attack by Wends in 1012 and subsequently rebuilt. The massive cathedral stood, like that at Pisa, in a large open space outside the town. It witnessed great events: in 1179, for example, the visit of Frederick I, who came to pronounce judgment on Henry the Lion; and in 1199 the celebration of the feast of Christmas by Philip of Swabia and the Greek Princess Irene—of which Walther von der Vogelweide has given us a vivid description in one of his epigrams (*Sprüche*, 19, 5).[29] A few years later Otto's proud cathedral went up in flames. The fire broke out on the Good Friday of 1207, when Albrecht of Kevernburg (1205–1232), the new archbishop, had just returned from Rome, Pope Innocent III having at last confirmed his investiture and appointed him to the dignity of a cardinal. The building could have been restored. But Albrecht of Kevernburg, who had been educated in Paris and had witnessed the birth of the new style, wished his cathedral to be on the French pattern. In 1209, in the presence of Count Ugolino of Segni, Cardinal of Ostia, he laid the foundation-stone. On no other choir throughout the West of Germany is the spirit of Early French Gothic imprinted so clearly—even though in simplified German version—as on the presbytery of this imposing church by the Elbe.[30] It was completed for the most part within Albrecht's lifetime. Sedlmayr[31] sees a link between the relinquishing of the Romanesque style, characteristic of Hohenstaufen times, and the re-election after the murder of Philip of Swabia of the Guelph, Otto IV, who had been educated in France, and for whom a "royal church" would inevitably imply a Gothic church. Whether we agree with Sedlmayr's conclusion or not, it is undeniable that the influence of the cathedrals of Noyon and Senlis[32] is evident both in the exterior and the

104, 110

interior of this cathedral. The elevation of the nave, however, is not four-storeyed; the windows
111 are smaller; and there is a greater emphasis on the solidity of the walls. The piers of the choir
ambulatory are more massive. Some of the precious Italian pillars from the old cathedral
building were, incidentally, effectively set into them. The choir, a development of the semi-
decagon in outline, has a wide ambulatory and five polygonal radiating chapels. The use of
flying buttresses is avoided, on the model of the earliest buildings of the school of Saint-Denis.
The west part of the choir and the transept are rib-vaulted. The vaulting of the choir ambula-
tory, on the other hand, is proof of the inadequate skill of a master-mason to whom the technical
secrets of the French style were not familiar. The choir gallery, later called the Bishops'
112 Gallery (*Bischofsgang*), was built by a group of masons trained in the Burgundian Cistercian
style through their work on the neighbouring monastery of Walkenried, begun *c.* 1219.
From about 1240 onwards the original plan was considerably modified in the completion of
the transept and the two east towers. The triforium was omitted, and the windows of the
north and south walls of the transept made larger than originally planned. The central tower
planned on the model of Laon was omitted, and similarly the splendid design for the transept
façades was not executed. These do not bear comparison with the Limburg façades. The east
towers were raised no farther than the height of the choir parapet. The west façade was pushed
out considerably to the west, close to the then still standing baptistery. Some, at least, of the
statues originally planned for the west portal have been preserved—the magnificent statues of
119, 120 the Apostles Peter and Paul, for example, and that of St John the Baptist. The influence
of the earliest French Gothic style is visible in them. Shortly afterwards other sculptors,
working in a later style, carved the figures, presumably also intended originally for the
106 west portal, which were subsequently set into the Paradise Portal (*Paradiespforte*) of the
north transept.

Between 1240 and 1272 transept and nave were completed in a highly simplified, German
Gothic style. It has already been mentioned that the original plan was extended westwards.
In addition to this the aisles were widened to an unusual extent, and the supports of the nave-
arcading halved, that is, the arches made doubly wide. Although the gallery and triforium
109 were omitted, the windows had to be kept small and narrow because of the high, gabled roofs
of the aisles. Thus the general effect of the nave and aisles is as German and Late Gothic as
that of the choir is French and Early Gothic. There is no inconsistency, however, in the
buttressing, of which the designers were sparing throughout.

The old baptistery was not dismantled until 1310, after which date building was begun
on the west façade, whose two massive towers appear to stifle the more richly ornamented
central section ending in a gable. A row of blind arcades in the second storey is the only
103 ornamentation that stretches across the whole façade. The cathedral was dedicated in 1363,
after which building operations were interrupted. The towers were completed between 1477
and 1520. It is significant of the age that in 1520 Cardinal Albrecht of Brandenburg, Arch-
bishop of Mainz and Magdeburg, wrote to Luther that much as matters of faith were near

to his heart he had not yet found the time to study his, the monk's, writings. The Middle Ages, when cathedrals were built to honour and glorify God, were over.

XIII. THE CATHEDRAL OF COLOGNE

Shortly before his death Archbishop Rainald of Dassel (1159–1164), the chancellor and intimate friend of Frederick I, fulfilled the latter's wish that he should bring the relics of the Three Magi from Milan to Cologne. Their presence shed a new mystic radiance on the Carolingian cathedral, and at the same time created the need for a golden shrine worthy of their significance. Archbishop Rainald's successor, Philip of Heinsberg (1167–1191), entrusted the task of fashioning a shrine to Nicholas from Verdun, who had carved the pulpit, completed in 1181, in the collegiate church at Klosterneuburg. The shrine, the fruit of long years of toil, has all the splendour of Hohenstaufen classicism. Around 1200 Otto IV, who had repeatedly met with a friendly reception in Cologne in the course of his varied life, gave so generous a donation towards the completion of the shrine that he was represented as patron, with the inscription "Otto rex", next to the Three Magi on the façade—an honour which was not his due and which had no such profound effect on the form of the work as his re-election was subsequently to have on Magdeburg Cathedral; for Nicholas adhered to his style. The completed shrine, in its turn, required a building worthy to house it. And, in fact, Archbishop Engelbert I of Berg (1216–1225) was already contemplating the building of a new cathedral. Had building operations been begun during the reign of Frederick II a Late Romanesque style like that of the west choir at Mainz would probably still have been used. But a quarter of a century elapsed before, in 1247,[33] the Cathedral Chapter decided on rebuilding. In 1248 Archbishop Conrad of Hochstaden (1238–1265) laid the foundation-stone. The first plan was drawn by the German master-mason Gerhart, who was also the first architect. On his death around 1280 his place was taken by one Arnold, who was succeeded, at the latest in 1308, by his son John. He, in his turn, was replaced by Rutger around 1331. Already at the end of the thirteenth century the choir was glazed, and in 1332 it was dedicated by Archbishop Henry of Virneburg (1306–1332). At the same time the shrine of the Three Magi found its final resting-place in the central choir chapel. By the time of dedication the sculptures and choir-stalls had also been completed, and the tombs of former archbishops transferred to the chapels. Later, the choir-screens were painted. In 1333 Petrarch visited the choir and subsequently wrote admiringly of the new building.[34]

Whereas the choir of Magdeburg Cathedral reflects the style of Early French Gothic, the plan of Cologne Cathedral and the choir, completed in 1322, show a strong High Gothic influence from the Ile-de-France and Picardy. Gerhart had undoubtedly been trained in Germany. The solidity of the walls reveals the German tradition; and the weakness of the

imitation of French forms is evidence of the predominance in Cologne of the intellectual forces of Scholasticism that drained them of their emotional vigour. French art-historians are unanimous in their agreement on this point. Louis Gonse says:[35] "The cathedral is a gigantic, terrifying work. . . . To judge by size and visible splendour alone, it is one of the seven wonders of the world. But not for one minute would the man of taste equate its mathematical precision with the depth of emotion, the vigour and powerful grandeur of French cathedrals." The five-aisled choir and three-aisled transept are modelled on Notre Dame; the mid-thirteenth-century ornamentation on the Sainte-Chapelle. Gerhart must have made a very careful study of the ground-plan of the Cathedral of Amiens, which was still under construction at the time, for that of Cologne follows it fairly accurately where choir and transept are concerned. There is, however, no resemblance at all in the superstructures. The west façade, whose massive towers leave no space for the customary rose-window in the centre, is without precedent in France.

Although William of Holland was present when the foundation-stone was laid in 1248, shortly after his election as German king, Sedlmayr[36] sees in the cathedral a "royal church" erected in honour of Richard of Cornwall, brother of Henry III of England, crowned by Conrad of Hochstaden at Aachen. With the death of Conrad IV the Hohenstaufen dynasty approached its end. The Church of St Kunibert is the last Hohenstaufen building along the Lower Rhine.

With a length of 472 feet and an area of 66,370 square feet, Cologne Cathedral is not only one of the largest but also one of the most uniform and perfect of High Gothic churches. Its ground-plan is that of a five-aisled basilica with three-aisled transept and five-aisled choir. The choir-end is seven-sided, with ambulatory and seven radiating chapels. The choir, built in the course of seventy-four years, is the only part of the cathedral completed during medieval times, and only in relation to it can the separate parts be evaluated. The five-sided choir chapels are separated by massive double-arched flying buttresses which bear the stress of the choir-vaults. The buttresses are richly pinnacled and canopied; the arches have quatrefoil tracery. The choir-windows, four-lighted and with quatrefoils in the heads, fill the entire wall space between the shafts. The pointed arches and tall, slender clustered pillars of the nave-arcading; the deep translucence of the choir-windows, the triforium, and the clerestory-windows; the figures placed against the pillars; the High Altar and the choir-stalls, and the frescoes on the screens—all this renders the interior an unusually perfect and sustained example of High Gothic. And although it must be admitted that in the austerity of its overall design it lacks the French lightness and grace, yet it is more French in spirit than any other German building.

As against the artistic significance of the choir the remainder of the cathedral has a symbolical value for the German mind. After the dedication of the choir in 1322 work was begun on the south arm of the transept. By 1388 its elevation had proceeded as far as the height of the triforium and was taken into use. And by the middle of the century, too, the foundations

of outer aisle-walls and the lower courses of the supports for the nave-arcading had been raised far enough to reveal the gigantic extent of the cathedral's ground-plan. A master-mason by the name of Michael, first mentioned in the cathedral documents in 1353, was at that time working on the south tower. By 1437 it had been erected as far as the belfry. From then onwards building operations slowed down, and came to a complete standstill in 1560 as a result of the economic decline of the town and a changed taste in matters of design. The tall choir and the isolated south tower, a crane for lifting stones still on its roof, now became a characteristic feature of the town, frequently represented by artists. Not until 1735, under the Elector Clemens August, were necessary restorations undertaken. The ensuing preoccupation with the spirit of the Middle Ages, together with the erroneous belief that the Gothic style was of German origin, and the discovery of the original façade plans in 1814 and 1816 form the context within which the Romantics Sulpiz Boisserée, Friedrich Schlegel, Joseph Görres and August Reichensperger sought completion of the cathedral. After the fall of Napoleon, Joseph Görres was the first to demand this. In 1816 Karl Friedrich Schinkel was commissioned to investigate the state of the building. It was finished between 1842 and 1880 by Ernst Zwirner (d. 1861) and his pupils after the original plans. Thus, apart from the choir and the sub-structure of the south tower, the whole cathedral is the work of nineteenth-century Romanti-cism. The massive towers and the omission of a central rose-window—features of the original plans for the elevation—distinguish the west façade to its detriment from French High Gothic 123 façades. These mistakes are not redeemed by the tracery-ornamented spires. A more funda-mental lack of judgment is revealed in the unimaginative repetition of individual architectural features; it is in this that the new parts most clearly manifest the spirit of the nineteenth century. 125 Nevertheless, in spite of these shortcomings—generally conceded nowadays—this cathedral, the largest church in Germany, will always impress not only by virtue of its symbolic signifi-cance but as a work of art. For if this were not so, how could the young, art-loving Jacob Burckhardt have called it "the revelation of an unparalleled and divine genius"?

XIV. GERMAN GOTHIC ARCHITECTURE

We have no difficulty in explaining the close relationship between Cologne Cathedral and French High Gothic cathedrals when we remember the common racial origin of the peoples between the Seine and the Lower Rhine. They share a mingling of Celtic, Roman and Frankish blood and have preserved to our own day a mutual flexibility of mind. Their languages have separated because the longer and more onerous Roman occupation of Gaul was more conducive to the survival of the Latin language there than in the Rhine area. On the artistic level, however, the original link was maintained: at various periods far-reaching parallels can be shown to exist.

If, then, Cologne Cathedral nevertheless differs in its overall effect from those of Chartres, Rheims and even Amiens, there is this additional reason: it was precisely during the middle of the thirteenth century, when the choir was begun, that the influence of Scholasticism, emanating from the personality of Albertus Magnus (1193–1280), approached its zenith. And what could have been more in keeping with the spirit of Scholasticism than to rationalize a style whose very charm, during the Early period, lay in its unselfconsciousness?

The Cathedral of Cologne is a unique feature of German architecture. In the rest of Germany the development has been different, and has varied from province to province. On the whole the influence of mysticism was strong, if somewhat late. If St Bernard paved the way for the Gothic style in France, then the Franciscans and Dominicans exerted an equally profound influence on architecture, and particularly on the other arts, in Germany.

It has already been pointed out that the Late Romanesque style predominated in Germany until the end of the Hohenstaufen dynasty. The choir of Magdeburg Cathedral is a rare instance of Early French Gothic in Germany, just as Cologne Cathedral is one of the most perfect examples of High Gothic architecture. During the latter half of the thirteenth century Germany became receptive to the dynamic style which had been developed in the North of France a hundred years earlier. The new style spread eastwards through various channels of communication and in a simplified version. A considerable contribution towards this spread was made by the Cistercians, for Gothic vaulting met their demands for strong, fire-proof buildings. Buttressing was reduced to a bare minimum, as is proved by a comparison of Rhenish Gothic Cistercian churches with choir ambulatory, such as that at Heisterbach (1202–1237), its sister church at Marienstatt (1222–1227) or that at Altenberg (begun 1255)[37] with Cologne Cathedral. But throughout Germany, and not only in Cistercian buildings, acceptance of the Gothic style implied simplification. This is strikingly illustrated by the large churches built by the Alemannic peoples of the Upper Rhine area. In Hohenstaufen times the bishopric of Strassburg extended on both sides of the river and embraced a population that had a common language and a common temperament. The Gothic style did not reach Alsace before 1230, and it is the right-bank rather than the left-bank Rhenish hinterland that first adopted the style. After a fire in 1176 the east parts of Strassburg Cathedral were built in Late Romanesque style, with large proportions and Hohenstaufen splendour. Incidentally, the German word *Münster*, derived from the Latin monasterium, is generally used to indicate not a monastery church but rather any magnificent church building, whether cathedral or parish church. The vaulting of the south transept (c. 1230–1240) springing from the angel-pillar already reveals an exact knowledge of the technicalities of Gothic vaulting, a knowledge which, as at Limburg-an-der-Lahn is used to create Romanesque architecture. Not until the nave and aisles were erected (c. 1250–1275) was a pure Gothic style introduced. "The master-masons must have followed their calling for a good many years in the Ile-de-France and in Champagne. The adopted French form and the underlying German spirit are combined, not like two different-coloured threads in a shimmering tapestry but like two alloyed metals.

There is not a single individual feature that could not equally well be the work of a French mason; yet the general impression is not French: the proportions, the rhythm, the spirit pervading the whole—all these are German."[38] Width and height of vaulting were in the proportions of the equilateral triangle frequently encountered in German Romanesque architecture, whereas the interiors of French High Gothic cathedrals are much higher in proportion to the width. At Amiens the relationship of nave width to height is 13·5:42; at Strassburg 16·4:31·5. All individual features, including the nave-arcading and consequently also the windows, are conceived within the context of this relationship. At Strassburg the windows, as well as the glazed triforium, have preserved the whole wealth of their stained glass. For Sedlmayr their royal figures are proof of the fact that the cathedral is another "royal church" —that of Alphonso of Castille.[39] The buttressing is only single-arched. The lower parts of the twin-tower façade, begun around 1282, were designed by one Erwin, a master-mason who had no doubt learned his skill at Saint-Nicaise, Rheims. The façade with its magnificent rose-window and the vertical emphasis of its shafts has exerted a very strong influence on Alemannic building to the right of the Rhine, as have also the nave and aisles with their un-French proportions. Their influence is visible in the cathedral at Freiburg-im-Breisgau; in the Church of the Knights Templars at Wimpfen-im-Tal, whose master-mason did not—as is stated in the contemporary chronicle of Burkhart von Hall—come from Paris but from Strassburg; in the Lady Chapel at Rottweil with its triple-portalled tower; and in St Mary's at Reutlingen. In Alsace itself, on the other hand, thirteenth- and fourteenth-century master-masons sought to give a more self-willed expression to the French Gothic spirit.

If Rhenish Franconia has produced a cathedral whose every detail is French, then the essentially independent spirit of Alemannic buildings reveals itself in their very proportions, which are Hohenstaufen until well into the fourteenth century. It is also evidenced in the relatively early preference given to the hall church over the Gothic basilica.

This history of the hall church has yet to be written. Every Romanesque crypt consists of several aisles of equal height. Large rooms, for example monastic chapter-houses, refectories and dormitories, are similarly subdivided. In Byzantine architecture there are early examples of this use of space in churches. An isolated example occurs at Paderborn in the Bartholomew Chapel dating from 1017. Impure forms of the hall church with heightened naves, tunnel-vaulted or covered with shallow domes, were built in Anjou and Poitou, and from there the style spread to Westphalia.[40] Isolated instances are also to be found in the surroundings of Regensburg, at Prüll and in the Cistercian church at Walderbach.

The earliest example of a true three-aisled hall church is the Cathedral of St Pierre at Poitiers,[41] begun in 1162 though the west section was not finished until the fourteenth century. It has square bays covered in the choir by groin-vaults, and in the rest of the church by eight-ribbed Plantagenet vaults springing from slender piers. The flat choir-end has three shallow apses. The light, airy building is without parallel, and bears a closer resemblance to secular architecture than to the domed-bay halls of Poitou. It forms a striking contrast to the large

basilican cathedrals of Northern France. Again the style spread to Westphalia: the nave and aisles of Paderborn Cathedral (*c.* 1233–1267) and the Minster of Herford are modelled on the cathedral at Poitiers. The same influence is evident in other Westphalian and Lower Saxon churches, the earliest example being the nave and aisles of St Elisabeth's at Marburg, begun in 1255. From Marburg the style spread to Hessen and the Middle Rhine area, and possibly also to Southern Germany. The earliest examples are St Thomas at Strassburg (*c.* 1230–1250), which was rebuilt as a hall church around 1325; the nave and aisles, completed in 1330, of the Church of the Holy Cross at Schwäbisch-Gmünd;[42] the Church of Our Lady at Esslingen; and the substructure of the collegiate church at Herrenberg. The exquisite hall choir of the Cistercian church at Heiligenkreuz in Lower Austria (1288–1295) is of still earlier date. This was followed at short intervals by the magnificent Cistercian hall churches at Neuberg in Steiermark (1327–1344) and at Zwettl (1343–1348).[43] No attempts have so far been made to ascertain how the idea developed in the Cathedral of Saint-Pierre at Poitiers reached Austria, nor what relationship exists between Austrian Cistercian buildings and the Church of the Holy Cross at Schwäbisch-Gmünd, where a hall choir with ambulatory and low radiating chapels, very similar to the choir at Zwettl, was begun in 1351 by Heinrich Parler of Cologne, the father of Peter Parler, who built the Cathedral of Prague. After the earthquake of 1356 Johann, a brother of Peter Parler, carried out the reconstruction of Basel Minster, and subsequently, in 1359, supervised the building of the choir of Freiburg Minster. The Freiburg choir, with basilican ambulatory and radiating chapels, clearly indicates the influence of the Prague Cathedral choir—as does also the new east choir of Augsburg Cathedral begun in 1356. In Bavaria, choirs with ambulatories were not built before the early fifteenth century, and are mostly the works of Hans Stethaimer.[44] Their most magnificent example is the exceedingly tall hall choir of the Franciscan church at Salzburg begun in 1408, the German counterpart of the Cathedral of Beauvais—although at Salzburg the influence of mysticism is greater, owing to the slower development of the style in Germany. This effect is created by an excessively slender clustered pillar in the central bay of the choir ambulatory: from the dark, heavy Romanesque nave the eye travels towards it, and the High Altar before it, yet is unable to follow its progress into the immense height of the choir-vault.[45] The hall church predominated in Bavaria for a further century. Instances occur also along the eastern boundary of Swabia in the stately parish churches at Dinkelsbühl and Schwäbisch-Hall, Nördlingen and Lauingen; whereas in Württemberg a smaller version of the domed-bay type became the general rule. Hall churches exist also in Franconia along the Main, where hall choirs were added to St Sebald and St Lawrence at Nüremberg; and throughout Northern Germany from the west to the extreme east. And so it may be said that among larger buildings from the Wiesenkirche at Soest to St Mary's at Danzig the three-aisled hall church is without doubt predominant. The basilican form occurs only in Hanseatic east coast towns in churches modelled on St Mary's at Lübeck. Choir ambulatories with radiating chapels are not, however, a feature frequently encountered in North Germany: only during the reign of Charles IV

(1347–1378) over the margraviate of Brandenburg did French forms penetrate into the North from Bohemia.

The characteristic "German" form of the choir was that in which the three aisles ended in apses, as in the Early Middle Ages, although these were now polygonal. Occasionally the nave extension was nothing more than a presbytery. A study of the plans of Gothic churches reveals an increasing simplification. The transept is omitted and the cruciform shape of the ground-plan thus lost. Buttressing is reduced to a minimum; and in the hall church it is in any case not used. But, above all, the groin-rib begins to lose its function as vault support. The stained-glass walls at first retained their deeper significance, but towards the end of the Middle Ages, when the fervour of mysticism began to decline, they were used merely as decoration. Later still, the windows were reduced in size and the walls made more massive. Once more the walls bear the stress of the vaults directly, in so far as it is not borne by piers or basilican nave elevations. In most cases ribs are replaced by flat tunnel-vaults decorated with mouldings of stone, fired clay or merely stucco in the shape of stars or nets. To the abstract patterns of circles and arcs, trefoils and quatrefoils of which Early window tracery consisted are added plant-like forms woven into unintelligible patterns, which filled not only window-spaces but also spread over the face of buttresses or any other surface, sometimes running over entire walls like ivy. This form of tracery is characteristic of North German Gothic brick buildings and of orna-mental stone gables like those on St Stephen's Cathedral in Vienna or St Catherine's at Oppenheim. The interiors of these Late Gothic churches have richly carved stone choir-screens. A profusion of movable ornaments now replaces the solemnity and functional splendour of earlier church interiors. Altars, previously decorated with golden or gilded bronze frontals or retables, particularly the High Altar in the choir or the altar in the nave, are decorated with a wooden superstructure filled with figures, with folding painted doors, and sometimes painted throughout. Some of the large churches have preserved their orna-mentation—the two main churches at Nuremberg, for example—so that even today a comfort-ing atmosphere of warmth emanates from their altar-pieces, especially if old stained-glass windows have been preserved as well. Chancels, fonts and choir-stalls were as profusely decorated, and on feast days figured tapestries were added.

Underlying and conditioning the transformations that took place from the thirteenth to the sixteenth centuries within the Gothic style are decisive changes in the religious and later also in the social outlook of the time. The decline of the Hohenstaufen dynasty, whose splendour had been reflected in both art and poetry, brought with it the disruption of many previously unquestioned relationships. As has already been said, it was St Bernard who paved the way. When the sense of security in accepted belief was challenged the resultant crucial phase influenced all relationships between ruler and ruled. Just as the weakening of monarchical power increased that of wordly and spiritual rulers immediately subordinate to it, so, after bitter struggles, these in their turn lost their power over the emancipated burghers of the towns. And hardly had victory confirmed the burghers' newly awakened sense of power than the

guilds began the struggle within the towns for equality of status with the nobility. The power of the towns increased very considerably, particularly of those that achieved immediacy. Since it was the cherished aim of the proud victors to record their achievement in enduring terms, there came into being during the thirteenth and fourteenth centuries strong town-walls and gates and frequently, as in Italy, towers, massive town halls and other civic buildings. Above all, town churches so large and with such lavish outfits that the proud burghers of the time called them minsters—though they had none of the characteristics of a monasterium—were

136, 158 built. These churches are frequently characterized by large single west towers. Among the most famous of these are the towers of the minsters at Freiburg and Ulm, of the Lady churches at Rottweil and Esslingen, St George's at Nördlingen and St Martin's at Landshut. However, there are also numerous examples of the French twin-tower façade with rose-window over the portal, as exemplified by the Church of St Lawrence at Nuremberg. The basilican and the

142, 160 hall church form are both used to an equal extent. The minsters of Freiburg and Ulm are basilicas, whereas St Martin's at Landshut, built by Stethaimer, possesses not only one of the highest façade towers completed during the Middle Ages but also a three-aisled hall choir of incredible height, similar to that of the Franciscan church at Salzburg. These hall-church interiors convey, particularly if one has entered the church by a side-portal, a curiously bewildering impression, similar to that evoked by the two-choir cathedrals of the Early Middle Ages. "This irrationality of form corresponds to the irrationality which is characteristic of the German mind in general."[46] When this lack of clarity becomes extreme, as in Austrian Cistercian choirs or in churches built by Stethaimer, then the rhythm of the closely spaced supports, psychologically if not visually perceived, has the power to induce a state of profound introspection.

In Italy and Germany French Cistercian mysticism was superseded in the thirteenth century by that of the Franciscan and Dominican Orders, with its more direct emotional appeal. Within the Dominican Order the rapid change from the Scholastic theories of Albertus Magnus to the wholly introspective mysticism of Meister Eckhart took place most drastically in Cologne. In Constance the new influence emanated from Eckhart's pupil Heinrich Seuse; in Strassburg from Tauler. Mention must also be made of the part played by the convents: Unterlinden at Colmar, Adelhausen near Freiburg-im-Breisgau, Töss and St Katharinenthal in northern Switzerland, Maria Mödingen near Dillingen—to mention only a few. The spirit which informed these preachers and religious communities was alive, too, in large sections of the burghers. The architecture of the Mendicant Orders in the towns did not at first in any way reveal the new spirit. Their buildings are characterized only by solidity and massiveness. St Paul at Esslingen, for example, the oldest Dominican church in Germany, is a basilica without towers or transepts, groin-vaulted, with sturdy piers and thick walls pierced by small windows with pointed heads. The churches of the Barefoot Friars at Freiburg, Esslingen and Regensburg still have flat wooden ceilings. The Dominican church at Regensburg, however, is modelled on the pattern of Esslingen. Gradually the height of the interior was increased, as

is shown by the Dominican churches at Erfurt, Colmar and particularly at Gebweiler. And the choir of the Franciscan church at Salzburg derives as much from the spirit of mysticism as does the Hohenlohe tomb in the Cathedral of Bamberg. 72

XV. FREIBURG MINSTER

The town of Freiburg was founded in 1091 by Duke Berthold II of Zähringen at one end of the important road which led from Villingen through the Black Forest to the Rhine plain. The rich silver-mines in the vicinity of the town attracted workers of precious metals; and in 1120 Duke Conrad granted it civic rights which proved exemplary for many of the surrounding towns. The little "oratorium" within whose walls St Bernard called upon men to join the crusades in 1146 was, as excavations in 1932 have shown, a three-aisled basilica without transepts and with three semicircular east apses. This first parish church soon proved too small, and during the reign of Berthold V (1186–1218), the last of the Dukes of Zähringen, it was decided to build a larger church. Plans were made for a Romanesque, groin-vaulted basilica with gallery, conceived in terms of the "metrical" system, similar to the new cathedral building at Basel, begun in 1185.[47] It was an audacious undertaking to build the parish church of a still unimportant town on the pattern of the cathedral of a large bishopric. It is not surprising that building operations at Freiburg began to flag around 1230, whereas the new Basel Cathedral was virtually completed by 1235. The choir at Freiburg, not having to accommodate a chapter-house, was designed as a simple polygonal apse. On the other hand, the oblong crossing with its eight-ribbed vault is flanked by square groin-vaulted transept-arms, the northern one of which still shows the three-lighted arcading of the gallery that was to run all around the nave. The octagonal Romanesque lower storeys of the two so-called "cock towers" 138 stand in the angle between choir and cross-arms, in Swabian manner. Ornamentation is rich, and includes sculptured friezes which bear a close resemblance to those at Basel.[48]

After the death of Berthold V his large domain was divided among his inheritors. The family estates in the southern Black Forest and in the Baar came under Count Egeno of Urach, and his sons divided them into the counties of Freiburg and Fürstenberg. In 1368 the town of Freiburg came under Austrian rule, and remained thus until 1805. Because of the disputes of the inheritors after the death of Berthold V, building funds for the minster were cut off until about 1250. By this time the Gothic style had penetrated as far as the Upper 142 Rhine area. Freiburg master-masons were not unaware of the structural advantages of Gothic vaulting, and a close affinity existed from the very beginning between the builders of the nave at Freiburg and Strassburg. The proportions of the vaults at Strassburg (based on the equilateral triangle, as discussed on page 33), which so markedly distinguish the cathedral from French High Gothic cathedrals, were imitated at Freiburg. This entailed the widening of the

aisles, so that their bays became square and almost as wide as those of the nave. The nave-vaults were heightened. Piers, shafts, capitals, the moulded arcadings against the walls, and the aisle-windows are modelled on Strassburg. The elevation of the nave, however, is as sombre as that of Magdeburg Cathedral: there is no triforium, in contrast to Strassburg, and the windows are small and niggardly. The flying buttresses are single-arched as at Strassburg, but their ornamentation is more austere. Before the completion of the four west bays building

136 operations were begun on the west tower. In spite of frequent alterations of design, this tower is of a rare beauty and has been the source of frequent imitations, particularly in the nineteenth century. It symbolizes the modest standing of a parish church as aptly as the twin-tower façade enhances the dignity of a cathedral. It is free on three sides, in contrast to Romanesque single towers which, like that of St Thomas's at Strassburg, are incorporated into the façade. The quadrilateral substructure incorporates a richly ornamented entrance hall and, above it, a chapel dedicated to St Michael (cf. page 6). The superstructure, beginning at ridge level of the nave, is octagonal, with corner-turrets; its windows are slender, with pointed heads. Its 377-foot-high spire is ornamented throughout with tracery and has been called "the boldest

137 declaration of independence of an art-form serving a utilitarian purpose".[49] Simultaneously with the completion of the main tower towards the middle of the century Gothic spires were added to the two choir-towers. A document dated 1347 from the papers of the Knight Johannes Schnewlin refers to the donation of the western nave-windows; it had not been possible to complete these simultaneously with the building of the tower.

Perhaps it was due to Johann Parler having been called to Basel to repair the damage sustained by the cathedral choir during the earthquake of 1356 that he was commissioned with the building of the choir of Freiburg Minster. According to an inscription in the north portal, building operations had already been begun in 1354. The deed appointing Johann to the position of master-mason for the duration of his life is dated January 8, 1359. The choir, much too large for a parish church, is entirely in the style of the contemporary east choir of

143 Augsburg Cathedral and has the same basilican cross-section. The six-sided ambulatory radiates outwards into polygonal chapels separated from each other by the piers. Outside, the slender arches of the flying buttresses span the chapel roofs; and the chapels are continued past the choir along the aisles as far as the east towers. Building funds dwindled during the constant disputes between the burghers and their overlords, and among the overlords them-selves, leading finally to the ceding of the town to Austria in 1368.

More than a century of Habsburg rule over the town passed before, under Archduke Sigmund (1458–1490), the Graz master-mason Hans Niesenberger continued the building of the minster. Having lost the favour of his patrons by the acceptance of numerous other commissions he was forced to relinquish his position in 1491. The choir was not dedicated until 1513. Johann Parler's plan was preserved in its essentials, and the choir cannot be denied its place among the most pleasing of German Late Gothic architectural achievements. The High Altar by Baldung and the abundance of late medieval altar works in the chapels lend

it a particular charm. A Renaissance choir-screen which now stands in the cross-arms, and the arcade of the south transept façade built in 1620 by Michael Glück are among later additions to the wealth of the minster. When the episcopal see was removed from Constance to Freiburg and archiepiscopal jurisdiction conferred upon it in 1827 the minster's proud lay-out and splendid choir found belated justification.

XVI. THE CATHEDRAL OF REGENSBURG

During the Marcomannic war in 178, Marcus Aurelius built a fortified legionary camp, the Castra Regina, with a sector for the civilian population, which probably already had its Christian community. The camp was laid out by the banks of the Danube opposite the point of confluence of the Regen, through whose valley a road led to Bohemia, the country of the Marcomans. In the light of Eugippus's account of the life of St Severinus, written in 511, it seems probable that in the Roman settlements along the Danube Christianity survived the upheavals of the *Völkerwanderung*. During the time between 489 and 493 remnants of the Marcomans who had settled in Pannonia in 396 moved into the country between the Lech and the Isar. They were followed by further contingents reaching the Upper Palatinate from Bohemia. They now called themselves Baii, Bavarians, probably in remembrance of the Celtic Boii, in whose former territory they had lived.[50] Already in the days of St Ambrose they had been partially Christianized. Under the Austrasian King Theudebert (534-548) they were incorporated without a struggle into the kingdom of the Franks, who had been Christianized since the time of Clovis. Their dukes of the House of Agilolfinger, who were not challenged by the Franks, built their castle in the north-east wing of the fort at Regensburg (Ratisbon).

Not until 739 did St Boniface, in agreement with Duke Odilo, succeed in organizing churches in Bavaria, which until then had enjoyed complete independence.[51] Regensburg was among the towns which were raised to the dignity of episcopal sees. The first bishop was Gaubald, abbot of St Emmeram, and the first reference to the cathedral, which was dedicated to St Peter, occurs in 778. According to a document of the year 932, the cathedral was situated near the Porta Praetoria, the Danube gateway of the Roman encampment. In 994 the funeral rites for St Wolfgang were celebrated within its walls. At the beginning of the eleventh century, however, it was replaced by an Early Romanesque cathedral, valuable information about which was obtained during excavations in 1924 and 1925. "The Romanesque cathedral was a three-aisled basilica with piers and a flat ceiling, two choirs, a west transept without clearly defined crossing, and probably with two west towers, the northern one of which has been preserved."[52] It is probable that a crypt was situated under the west choir, which was dedicated to the Virgin. The cathedral was 262 feet long, a considerable length. The aisles were so wide that the transept-walls did not project beyond them. The east front was flat, and the east choir,

dedicated to St Peter, consisted of a semicircular apse; the west choir was probably rectangular. This characteristically Bavarian, somewhat heavy cathedral was built by Bishop Gebhard I (995–1023), the successor of St Wolfgang (972–994). The latter had no head for matters of policy. Shortly after his consecration in 973 he was pushed into renouncing the rights of the see in Bohemia; and later, in compliance with a request of the Archbishop of Salzburg, Friedrich von Plain, he relinquished the dignity of abbot of St Emmeram which had been linked with the episcopate since the days of Gaubald. Neither of these concessions pleased his successor, though they appealed to the pious Duke Henry of Bavaria (born in Regensburg or the nearby Abstatt) who had once been his pupil. And in the autumn of 1002, when he rode as Henry II into a Regensburg waiting to acclaim him, golden times seemed about to begin for the town. In point of fact, various church buildings in the town, such as the Ober-münsterkirche, owe their existence to his endowments, and the scribes and goldsmiths in the monasteries, whose outstanding achievements the king knew well to esteem, enjoyed his lively encouragement. On the subject of Henry II's relationship to the cathedral building, however, historical sources are uninformative. Gebhard left those who were immediately concerned to oppose the creation of the bishopric of Bamberg; but when this new diocese was finally placed under the archbishopric of Mainz the prospect of making the bishopric of Regensburg into a German archbishopric for Bohemia, an aim which had already suffered a serious set-back through St Wolfgang's sacrifices, was finally shattered. As though in confirmation of this fact, Henry II made over a considerable part of the ducal estates in Regensburg to the Bishop of Bamberg. In the meantime Gebhard completed his cathedral and the cloistered court to the north, the middle area of which served as a place of interment; the rectangular St Stephen's Chapel, which still stands today; and finally the baptistery dedicated to St John, which was connected to the west choir by an arcade. This, like the baptistery at Mainz, was not centrally planned and was in 1127 similarly endowed as a collegiate church. A later addition is the All Saints Chapel, connected to the burial-ground, erected between 1155 and 1164 as funeral chapel for Bishop Hartwich II, Count of Ortenberg. It is of great clarity of design. The die-shaped substructure has a semi-cylindrical apse on each of its four sides; the interior of the octagonal tower is domed. The purity of this form, evolved relatively seldom during the Middle Ages and in antiquity, can be fully appreciated by studying the splendid developments —for example, the west choir of Mainz Cathedral—of which the idea of the four-conchal centrally planned building is capable. The chapel had not yet been erected when Barbarossa came to Regensburg in 1155 to invest Henry the Lion with Bavaria, and imposed a heavy fine on Bishop Hartwich who had exercised his new jurisdiction prior to imperial investment. It owes its fame above all to the murals, dating from the time of building, which cover the walls and domed ceiling, and represent the opening of the Last Judgment according to the Office for All Saints. The altar apse, a photograph of which is reproduced in this book, is devoted to illustrations of the sealing of the twelve tribes (Rev. 7, 4–8).[53]

Following fires in 1152 and 1176, the cathedral was restored; and on the Saturday of the

first Lent week of 1187 the new bishop, Conrad III, was consecrated in the presence of Frederick I.[54] Further rebuilding was completed in 1254, but after a fire in 1273 the cathedral had to be entirely rebuilt. The Hohenstaufen age had passed, and with it the Romanesque style that had enriched Bavaria and in particular Regensburg with so many important churches.

In 1275, Bishop Leo, a member of the Tundorf family (1262–1277), laid the foundation-stone of the new cathedral, which extended farther on the west and south sides: the new main choir and the north side-choir occupied the entire site of the old cathedral, so that the old north façade tower, which had been left standing, now adjoined the new choir. The northern corner of the new west front almost touched the old baptistery. The designer of the new plan was doubtless familiar with High Gothic forms at Strassburg and possibly also with Burgundian buildings, and knew well how to blend a style still foreign to Bavarians with the traditional ground-plan. "The transept remains within the vanishing-line of the main body of the church, and the choir merely continues the latter, ending traditionally in three now polygonal apses, the centre one of which is pushed out farther eastwards by the interposition of a bay."[55] In form the building is High Gothic, apart from a small number of innovations enforced by the ground-plan. The polygonal main choir-end was designed to create the impression of an ambulatory, for a triforium separates two rows of windows, those of the lower row 150 extending from edge to edge of the piers, while those in the upper row are narrower. This scheme could not be continued along the choir-walls, since these are adjoined by the side-choirs and by the substructures of two low east towers, which contain chapels. The transept with its 151 gabled cross-arms was to be surmounted by a low octagonal central tower, of which only the portion under the present-day roof has been preserved. Had it been completed, the exterior of the choir, with its sparing use of buttressing and the two east towers, would have looked very different from the choir of Cologne Cathedral, which dates from the same time. The east part of the cathedral was completed within barely fifty years. Already under Bishop Nicholas of Stachowitz (1313–1340) the choir-windows were glazed. Subsequently, however, building proceeded more slowly owing to the continued constitutional disputes within the town and diminished cathedral funds. Nevertheless, the five-bay basilican nave was completed according to the original plans, recalling the minster at Strassburg. A moderate use of buttressing on the exterior proved indispensable owing to the anticipated stress of the nave-vaults, these being 150 for the most part not yet completed. Inside, a triforium, blind except along the transept façade, accompanies the relatively wide-arched arcading of the nave. It is separated only by a string-course from the large clerestory windows that completely fill the width of the bays. The aisle-windows are set fairly high to accommodate ambulatories along the aisles, and chapels on the north side. The twin-tower façade shows Strassburg influence in the skilful proportioning of the middle section to the towers, in the retaining of the three-portal feature and in the effective use of shafts, characteristic of the Strassburg school. Completion took place within the Late Gothic period. The south tower was begun around 1340. In 1380 an agreement was reached with the canonry of St John, by virtue of which the baptistery was taken down, after another

41

church to replace it had been built farther away from the cathedral, and work was begun on the north tower. (In 1456 Conrad Roritzer added to his commitments at St Lawrence, Nuremberg, the supervision of the Regensburg Cathedral building on which he had previously worked as a master-mason.) Two plans on vellum among the cathedral documents are ascribed to Roritzer. One of these is for a single-tower façade. The other, which is likely to have been the one that was originally used, is for a twin-tower façade, with a rose-window like that at St Lawrence, Nuremberg, and a gable similar to that of the Frauenkirche at Nuremberg, but without porch before the centre doorway. During the time of his supervision the main portal was constructed, with the porch which was not in the original plan; the window-storey of the north tower, as well as the vaulting of the tower substructure and of the adjoining bay of the north aisle, dated 1464. Although the master-mason's advice was frequently sought, as for example in 1462 in connexion with the Cathedral of Vienna and in 1474 on the question of the vaulting of the Frauenkirche at Munich, his name does not occur among the papers of the famous conference of master-masons at Regensburg in 1459. After his death (*c.* 1480) his position was taken over by his son Matthew, who had previously followed his calling in various towns; and he, in his turn, was succeeded (*c.* 1495) by his brother Wolfgang, who was executed in 1514 during political tension between the town council and the burghers. Following Conrad Roritzer's death, building operations had been restricted to the slow erection of the façade and the completion of the vaulting; they stopped entirely in 1530. During the ensuing centuries only essential restorations were carried out, although between 1684 and 1729 the interior was refashioned in Baroque style. In 1834 and the following years, however, all traces of this were removed so conscientiously by Ludwig I, who was as keen an admirer of the Gothic—allegedly German—style as of the Classical, that today the cathedral appears almost bare. Even more detrimental to its appearance as a whole was the elaborating (1860–1872) of the west towers on the pattern of the façade tower of Freiburg Minster. A lithograph by Domenico Quaglio, dated 1820, shows both these rich Late Gothic towers finishing at the horizontal end of the third storey; that is, level with the point of the ornamental gable.[56] The conventional additions have considerably detracted from the outstanding and unique charm of this façade.

149

XVII. ULM MINSTER

The earliest historical record of Ulm is the founding in 600 of a missionary church of the Franks *"unser frowen enund veldz"* for heathen Alemannic settlements around the confluence of the Blau and the Danube. A Carolingian palace was built at this point, and in 813 Charlemagne gave the Danube bridge-head to the monastery of Reichenau, which was later to aim at still further possessions. Under Barbarossa the parish was granted municipal status

in 1165; and in the fourteenth century, after heavy struggles between the growing guilds and the town nobility, its time of glory began. In 1376, when the town's area had increased fourfold and its fortifications had been renewed, the Swabian league of towns was brought into being within its walls. During the rebellion of the towns against the Imperial Crown, a siege of Ulm by the aged Charles IV was successfully repulsed, and the Imperial Vogt, Count Ulrich von Wirtemberg, defeated near Reutlingen in 1377; while the heavily resented patronage of the monastery of Reichenau over the Ulm parish church was revoked in 1387.

After the parish church of Ulm had been repeatedly altered and new portals added in the fourteenth century, it was still situated outside the town, to the north of the strong town-walls, as the burghers were forced to notice to their sorrow during the siege of 1376. However, already in the summer of 1377, as the Zürich Dominican friar, Felix Fabri (d. 1502), describes in detail, the foundation-stones were laid in the gardens of the Barefooted Friars and of neighbouring houses for a new St Mary's Church of considerable size[57]—the word "minster" was not applied to the church until the following century. An account dated 1387 makes mention of payments to "master Hainrich, master Michel and master Hainrich, who has been newly appointed to his position".[58] The assumption that these references are to members of the Parler family was confirmed in 1897 by the discovery of a tombstone bearing the angle-piece sign of the Parler family. Nevertheless, divergent opinions are held on their genealogy.[59] But quite apart from these questions, it is obvious that the older Heinrich who produced the 1377 plan was well acquainted with the Holy Cross Church at Gmünd. The wall with the triumphal arch at the east end of the nave proves the planner's intention to imitate, without transept, and on a considerably larger scale, the Gmünd hall-church form with wide nave and narrower aisles. But for the vaults, the aisleless, twin-towered east choir was completed before 1391. However, it does not approach the splendour of the choir and ambulatory of the choir at Gmünd, which is closely modelled on that at Zwettl, begun in 1343. 157
160

In 1392, after the younger Heinrich had gone to Milan, Ulrich of Ensingen was appointed master-mason at Ulm. Ulrich, who was barely thirty years of age, was probably a native of the neighbouring village of Einsingen and had no doubt spent his years of apprenticeship working in the cathedral choir at Ulm—an assumption confirmed by the fact that his sign is derived from the Parler one. As has so often happened when one master succeeds another, he considered the work of his predecessors to be unacceptable and decided to substitute something completely different. The hall-type nave with narrow aisles which had been planned was replaced by a basilica with three aisles of equal width. And whereas probably no west tower had been intended—as it is likely that the original façade design was modelled on that at Gmünd—Ulrich now began the erection of a massive west tower. This was considerably taller and larger than that at Freiburg, without, however, being less original in form, as is proved by a plan in the Victoria and Albert Museum, London, dated 1493.[60] That Ulrich was a man of strong will and fiery temperament is shown by his subsequent activities in Milan. The second Heinrich who worked at Ulm had accepted an offer in place of Ulrich at the

Milan Cathedral in 1391, but had resigned his office in dissatisfaction in the following year. This news had no sooner reached Ulrich than he asked leave of absence—a favour readily granted by patrons who thought highly of him and were full of understanding for the pride and vigour of their master-mason. In Milan his self-possession gained him a good position in spite of his lack of knowledge of the language. It was not long, however, before quarrels developed. Ulrich thought that the central choir-window should be larger and of greater significance than the others. But the "fabbrica del Duomo", consisting of eighty masons, instituted by the art-loving Count Galeazzo Visconti, demanded that Ulrich should adhere to existing plan. The capitals of the pillars, executed against the advice of Ulrich in quite un-Gothic style, were a further cause of friction and even aroused the anger of Jacob Burckhardt centuries later. In the books kept by the group we read that he was not willing to work according to the plans of others: "dixit quod non volebat". He returned to his own country after an absence abroad of less than half a year. The position of master-mason for life, which had presumably been granted him when his office at Ulm was renewed in 1397, left him so much spare time that in 1399 he accepted, concurrently with his commitments at Ulm, the supervision of the north tower octagon of Strassburg Minster and in 1400 the completion of the west parts of the Frauenkirche at Esslingen. Nothing is more characteristic of him than his treatment of the Strassburg façade. A sensitive master-mason would have relieved the thirteenth-century third storeys of the towers of the obstructing intermediate part added in 1365 above the rose-window, and would have completed the towers according to the original plan. Ulrich, on the other hand, considered his task to lie in the creation of an impressive symbol—one that should put Ulm in the shade. And so the north tower was raised to its giddy height asymmetrically and regardless of the substructure, accompanied by four side-turrets spiralling up on their own. The 446-foot-high spire added after Ulrich's death (1419) by Johannes Hültz of Cologne would have won the approval of the dead master.

The generation around 1400 was harsh and hard; it inaugurated a new phase of Late Gothic which has incorrectly been described as "soft". Such a description applies more accurately to the second half of the fourteenth century. Consider the boldness with which Ulrich began work on his tower at Ulm, not even calculating accurately the distance to the choir or the pier intervals. And how steely and sharp in form are its lower storeys begun by him, although not completed until after his death; the slender porch and, above, the tall

159 windows, designed to bring in the light formerly supplied by the rose-window. The tower was built of resistant sandstone; the walls of the main body of the church of unpretentious brick, with a minimum use of buttressing. It is almost incredible that they were able to withstand the stress of the heavy vaults that were added in the course of the years. The piers of the nave-arcading had to be placed more closely than had been foreseen, but even so it is surprising that they supported the vaults of the over-wide aisles for a whole century. The simplest forms of vaulting were used; whenever possible, groin-vaults. Only the choir, vaulted in 1449, has a net-vault. The stress of the nave-vaulting was to be offset by the buttressed clerestory walls.

The latter formed large unarticulated spaces between the nave-arcading and the small, high clerestory windows. "Ulrich aimed at enhanced dimensions without regard for harmonious proportions. Similarly, he gave no thought to elaborating the ground-plan. His minster remained a simple South German parish church, but on a vast scale. With pardonable pride the inhabitants of Ulm referred to their minster as the container of that at Strassburg."[61]

The proportion of length to width at Strassburg is 377:107·6 feet; at Ulm 464:147·6; the height of the tower at Strassburg is 466; at Ulm 528 feet. To judge the minster at Ulm by its present condition is, however, to do it an injustice. The large endowments given by generations of Ulm families filled the interior with works of art. Little of its rich ornamentation, however, was left after the storming of the church by iconoclasts on the midsummer's day of 1531, when over sixty altars and a large number of single statues and other works of art were destroyed. Since then the minster has seemed bare; and we must be content to imagine its former splendour from a small number of frescoes, the windows in the Besserer Chapel and in the choir, the tabernacle, the font, the choir-stalls, the capitals and the stone carvings on buttresses and portals, particularly on the main portal and on the porch face.

The minster was not completed until the sixteenth century. Ulrich was succeeded by his son-in-law Hans Kun (1417–1434), and he in his turn by his son Kaspar (1434–1446). They built the west hall with its large windows—by 1434 the tower had been raised to the height of the nave-vaults—and the chapels framing the choir: the Besserer Chapel around 1420, the Neithart Chapel around 1445. Ulrich's son Matthäus Ensinger (1395–1463) and the latter's son, Moriz, devoted themselves to the urgent task of vaulting the entire interior. Work on the tower was taken over in 1474 by Matthäus Böblinger of Esslingen. During the twenty years of his activity at Ulm he erected the pier in the south-west corner of the tower in 1478, built the third storey according to Ulrich's design, and finally produced a new plan for a more elaborate octagonal storey and a taller spire. He omitted, however, to strengthen the east piers of the tower, which had been too slight from the very beginning. In 1493 dangerous cracks appeared in the masonry and he was dismissed in disgrace.[62] In October of the same year twenty-eight expert masons were invited to Ulm to confer on steps to be taken in view of the damage. As the discussions proceeded the town mason of Augsburg, Burkhard Engelberg from Hornberg, who at the time was building the large Benedictine church of St Ulrich at Augsburg, won the confidence of the Ulm masons, and was appointed master-mason at Ulm. He accepted this position in addition to his commitments at Augsburg, and held both offices until his death in 1512. He carried out the strengthening of the substructure of the west tower, and also recognized the growing danger inherent in the excessive stress of the wide aisle-vaults. These were taken down, and an additional middle row of slender supports placed along the length of the aisles, thus dividing them into two. The double aisles were then covered with light star-vaults. After these restorations building activities ceased. In 1543 they were formally closed by a decision of the town council. From then onwards the vast, slowly weathering structure lay brooding over the surrounding houses like a hen over her chickens.

The restoration zeal of the nineteenth century abruptly destroyed this quaint characteristically Upper Swabian picture. The peculiar attraction of medieval buildings lies in their picturesque relationship to their immediate surroundings. In the nineteenth century the delightful little church of the Barefoot Friars in front of the minster was taken down together with adjacent buildings. A large empty space was left before the minster, which considerably detracts from its previous effect of vastness. After the roof had been secured by means of a heavy iron structure, the light buttressing of the walls became inadequate and the brick walls had to be strengthened. It is sad that this was done by the addition of a series of identical Gothic flying buttresses of sandstone that give the impression of having been cast in a mould, and 156, 157 completely destroy the Upper Swabian character of the building. The completion of the three towers was the final touch in the work of metamorphosing the old, venerable minster into a neo-Gothic church.

XVIII. THE FRAUENKIRCHE AT MUNICH

In 1158 Henry the Lion, Duke of Bavaria since 1155, took by force the seat of Bishop Otto of Freising, together with its bridge over the Isar at Föhring. He rebuilt the bridge farther upstream in his own territory near an old monastic settlement. The costs of rebuilding as well as of laying a road for the export of salt from Reichenhall, which had been raised to town status, were met by the bridge-toll, to which Henry soon added a market-toll and coinage-duty Bishop Otto, the uncle and chronicler of Barbarossa,[63] but ill and near death, no longer had the strength to protest effectively to the Emperor against this deed of violence And so Munich grew in size. It passed from the possession of the Guelphs into that of the Wittelsbach family, and became the seat of the Upper Bavarian dukes in 1255. Under the generous patronage of Ludwig the Bavarian, who in 1319 began to build the town-walls within which the town was content to grow until the nineteenth century, Munich soon outstripped its Bavarian rivals and emulated the large imperial towns. And although it remained loyal to its princely overlords, its burghers gained considerable liberties during the constitutional struggles of the fourteenth century. Their pride is reflected in the town's parish churches, the oldest one, St Peter's, receiving mention as early as 1169. In 1271 the Church of Our Lady was raised to the dignity of second parish church.

The building was heavily damaged during the Second World War. Excavations begun in 1946 in the east parts have revealed that the church was completed long before 1271. The remains of a three-aisled Romanesque basilica with alternating supports were brought to light. Its presbytery had been enlarged into a choir with polygonal end—probably to receive the tomb of Empress Agnes, the first wife of Ludwig the Bavarian, and therefore not later than 1322. In view of the growing population and the increased sense of pride of the burghers it is

surprising how long a delay elapsed before the church was enlarged; particularly when we recall what stately buildings Hans Stethaimer, a contemporary of Ulrich of Ensingen, had given to Bavarian towns. When at last the decision was reached to rebuild the church the fashion for this haughty style had passed. No master-mason of the second half of the fifteenth century would have been capable of so proud an architectural achievement as St Martin's at Landshut, the capital of Lower Bavaria. Nevertheless, the burghers wished to have a church which should compare with the largest new churches of other towns. They could expect no aid from Duke Sigmund, who renounced his title in 1467 in favour of his brother, Albrecht IV, and later employed his modest income for other foundations of considerable artistic value, for example, the church at Pipping in 1478 and the Schlosskirche at Blutenburg in 1488, both situated along the western outskirts of present-day Munich and preserved with the almost entire wealth of their ornamentation.

Jörg von Halsbach, known as Ganghofer, proved a trustworthy and able master-mason. His church is large, solid, somewhat unpretentious, with two mighty façade towers which to 170 this day have remained a characteristic feature of Munich. The years from 1468 until 1470 were spent in taking down the old church, and during this time Jörg was sent to Augsburg and Ulm to receive further training in his craft. St Ulrich's at Augsburg did not prove a very profitable model, since Valentin Kindlin from Strassburg had only begun the church in 1467. It subsequently proved to be of unsound construction. Ulm Minster was more profitable from Jörg's point of view, even if for no other reason than that it was built mainly of bricks, the building material which he himself thought to use. However, although both these churches were basilican in form, Jörg followed the example of Stethaimer. On his return to Munich, he began the construction of the outer walls and the piers of the interior, which were completed in 1473. He had in the meantime been appointed town mason and had also been commissioned with the building of the town hall (1470–1474). During this time a conference was called by the church committee to decide on the form of vaulting to be used. It was attended by such well-known master-masons as Moriz Ensinger of Ulm and Conrad Roritzer of Regensburg. The star-vaults constructed upon their advice were completed in 1477. The Straubing carpenter Heimeran constructed the enormous roof-frame, using 140 raft-loads of wood; and by 1478 the church was completed in its main architectural features, although the means for fitting it out were lacking. An indulgence from Pope Sixtus IV in 1479 resulted in so heavy an influx of funds that not only was the church finally completed—using the retables and stained glass of the old church—but sufficient money was left over to purchase gilt cloth from Venice for vestments. The church was dedicated in 1492. In 1494 it was raised to the dignity of collegiate church through the initiative of Duke Albrecht IV. And when Jörg died in 1488, even the towers had been completed as far as their crowns of masonry. The copper Romance domes were added in 1512. In the Sendling Chapel under the south tower a red marble tombstone preserves the memory of the master-mason.

The Frauenkirche at Munich,[64] with its length of 358 feet, is the last of the great Bavarian

47

hall-type churches. Churches by Stethaimer are airier and give a greater effect of slenderness. They are of earlier date and reflect the uncompromising idealism of their designer. At Munich 172 the pillars are more massive and placed closer together. The nave, 102 feet high, is slightly wider and very slightly higher than the aisles. As there is no transept, the aisles are continued in the choir ambulatory. This is five-sided and presumably modelled on Stethaimer's choir ambulatory at St Jacob's, Straubing. Chapels are situated in the spaces between the interior buttresses. Their height is just less than that of the aisles, so that the upper aisle-walls are visible above the sloping chapel roofs. This feature is peculiar to churches of the Inn area, and it is probable that Ganghofer's attention was drawn to it by Master Michel Sallinger of Pfarrkirchen during the conference of master-masons held at Munich. The lower storeys of the towers are quadrilateral and subdivided only by means of heavy string-courses and pilaster-170 strips at the corners. At the level of the roof-ridge two octagonal storeys with corner-buttresses 171 are superimposed, terminated by a sturdy ring of pointed arches surmounted by the Romance domes. The valuable items of the interior ornamentation were safely stored during the Second World War. Unfortunately the richly carved choir-stalls were overlooked. These had been completed in 1502 by Erasmus Grasser, who had previously carved the magnificent imperial 173, 174 tomb of Ludwig the Bavarian. The most beautiful of the half-length figures have nevertheless been preserved. But already before the Second World War the interior had suffered many a loss. Much was destroyed at the beginning of the seventeenth century when Peter Candid's "Benno" arch was built in, together with other Late Renaissance additions; and much, too, during the years of neo-Gothic restoration from 1858 until 1867. Nevertheless the massive, austere building, that in 1817 became the Cathedral of the new archbishopric of Munich-Freising, has survived even the ravages of the last war.

XIX. ROMANESQUE STONE SCULPTURE

We have inherited only a fragmentary portion of the carvings in stone and wood, the bronze casts, items of goldsmiths' work, frescoes, stained-glass windows and tapestries with which the interiors of medieval churches were ornamented. A few of the major works left to us are reproduced in this volume and will convey something of their quality. And although Early Romanesque art is not represented—its best examples being in the field of book illumination, goldsmiths' and ivory carvers' work and bronze casts—the contrasting qualities of the twelfth and early thirteenth centuries stand out clearly. The conflict between Imperial Ruler and Pope is reflected in the architecture of the time and even more distinctly in its sculpture. The vitality of Early Romanesque gestures and facial expressions is chilled into immobility during this time of struggle. Artistic expression becomes strictly formalized.

The sculpture-framed portals of Saint-Denis and Chartres—deeply impressive proclamations of the dominion of Christ—had no parallel in Germany at the time of their creation, before the middle of the twelfth century. Cluny was the centre from which the new asceticism radiated, under the impetus of renewed exhortations by Benedict of Aniane, and later strengthened and spread still further by Bernard of Clairvaux. Its effect on French as well as on German art was to devitalize it. What was organic and life-like is replaced by formal outlines. The sculptor has limited and well-defined motives. One of the most important of these is the illustration of the victory of heavenly over evil powers. The bronze figure of Archbishop Frederick of Wettin (1142–1152) in Magdeburg Cathedral stands on the tomb with the same stiffness of bearing that characterizes the ancestors of Christ in the "porta regia" at Chartres; and all the individuality of feature that distinguishes the face cannot undo the essential rigidity of the whole figure. The console supporting the statue is a medieval representation of the ancient Greek statue of a boy removing a thorn from his foot, and is intended to symbolize the defeat of heathendom.[65] The representations of fiendish beings were mainly the work of travelling Lombard masons, whose influence can be traced from S. Michele at Pavia[66] and other churches of the Po valley to the cathedrals of Speyer, Mainz and Worms, and from there as far as Lund.[67] Unquestionably these carvings reveal the survival of an ancient Germanic delight in legendary beings—as they also do in England; but even in those rare instances where scenes from Germanic myths are portrayed, such as Fafnir's murder at the hands of Sigurd, or Sintram being saved by Thidrek, they must be regarded as symbolizing the victory of heavenly over devilish powers.[68] Bernard of Clairvaux preached zealously against these figures, but with little success.

German sculpture continued to be characterized by an excessive austerity until after the investiture disputes; that is, until after the beginning of Gothic forms. Whereas the statues in the south portal of Chartres Cathedral are already much less rigid in form, those modelled upon them and carved from about 1230 onwards for the west door of the Cathedral of Magdeburg—the first German portal intended to be framed by statues—but later placed against the piers of the Bishops' Gallery are still in the lifeless style of the mid-twelfth century.

At the time when French Early Gothic was gloriously unfolding, the Late Romanesque style developed in Germany, revealing itself partly in imitation of classical models and partly in a barbarous Romanesque "Baroque". Whereas the classical form reached its most perfect expression in goldsmiths' work—the shrine of the Magi at Cologne, for example—stone carvers produced savage and disjointed forms, in which the spirit of the time of the *Völkerwanderung* comes partly to life again. These forms recur at the end of the Gothic phase in the High Altar shrine at Breisach and Zwettl. The main works produced by this Late Romanesque style in Germany are the south portals of the cathedrals at Münster and Paderborn, and even the capitals carved between 1209 and 1216 for the choir ambulatory at Magdeburg show its influence. Greater restraint is visible in the memorial to Count Conrad Kurzbold (d. 948), the founder of St George's at Limburg—a tombstone, on which lies the figure of the founder,

116, 117

12, 13
29
30, 31
36

119, 120

113, 114

43

49

borne by the figures of cathedral canons and of animals. It was carved almost at the same time
as the tomb of Pope Clement II at Bamberg, but unlike the latter does not anticipate the
Gothic style. The same tendency towards a formulation more restrained than that of the portals
at Münster and Paderborn is visible in the prophets and apostles along the choir-screens of
the St George's choir at Bamberg. The large group of masons whose work they are had begun
with the Portal of Mercy, but their highest achievement lies in the pairs of apostles and
prophets of the choir-screens. Subsequently they produced the left side of the Princes' Portal,
but were then replaced by a younger group.

70, 71

55–58

53

XX. THIRTEENTH-CENTURY SCULPTURE

Whereas in Germany mid-Romanesque austerity developed into the classical style or the
turbulent "Baroque" of the Hohenstaufen age, in the Ile-de-France this same rigidity evolved
into a new, delicate mobility. This is distinguished fundamentally from the materialistic
formulations, based on antique forms, of classical Romanesque in that it is inspired by an
entirely new spiritual outlook, by emotions which have been liberated. The first signs of the
new feeling reveal themselves around 1180 in the death and resurrection of the Virgin in the
portal of Senlis Cathedral, and the fully developed style in the transept façades of Chartres
Cathedral around 1210. From Chartres the style soon spread to Strassburg and Lausanne.
The figure of St Anne on the post of the centre portal of the north transept at Chartres is an
instance of direct Byzantine influence, and the group of the Visitation on the west portal of
Rheims Cathedral clearly shows that Gothic sculptors also drew their models from classical
antiquity. Around 1220 the style reached its zenith in the sculptures of Rheims and Amiens.
The confidence, directness and lucidity of these carvings correspond to the "claritas, integritas,
consonantia"[69] which St Thomas Aquinas recognizes not only as characteristic of artistic
beauty but also as indicative of harmony between our earthly condition in the present and our
heavenwards-striving soul.

The statues created around 1230 for the west portal at Magdeburg, with their sharp folds
of drapery, represent a first unsuccessful attempt to introduce the new French style in Germany.
The additional statues, carved when the figures were finally placed into the choir gallery, show
a significant relapse into the Late Romanesque style[70] both in proportions and forms. Equally
self-willed is the interpretation of the style of Rheims by the second Bamberg group of stone
carvers, constituted around 1230.[71] It is difficult to understand how the two high-handed
bishops of the House of the Counts of Andechs and Meran found the time and the means
to ornament the cathedral so richly and even to supervise the work—Ekbert (1203–1237)
spent many years abroad, as he was suspected of complicity in the murder at Bamberg of
Philip of Swabia. But, equally, it is obvious that the dismissal of the first group of sculptors

119, 120

and their replacement by a Gothic group was not fortuitous. The new group was confronted by heavy tasks: the completion of the Princes' Portal with its imposing figures from the Old and New Testaments, the statues of the Romanesque Adam Portal, the Visitation group, the rider, the angel, St Denis, the tomb of Pope Clement II—to mention only the most important items. The number of sculptors engaged on the work was considerable. Presumably the Princes' Portal was the first of these to be taken in hand. It is enlightening to compare the prophets and apostles in the jambs on the right-hand side with their pre-Gothic 53 counterparts on the left. Full insight into the characteristics of the new school is afforded by the Last Judgment in the tympanum. The fact that its sculptor was influenced by the pre- 52 Gothic prophets in the choir-screens is proved by the over-emphatic facial expressions and gestures, qualities not found in French sculpture or even in the contemporary Last Judgment at Mainz. The drapery, too, although essentially in the High Gothic style, is nevertheless not quite free from the unrestraint and confusion of Romanesque "Baroque". This is again borne out by the seated figure of Abraham next to the portal, bearing Lazarus and other saved souls in his lap. But even the most famous of the Bamberg statues, particularly the two badly positioned figures of the Visitation, reveal this fusion of two styles. Dehio[72] has already pointed 64, 65, 67 out that the group of the Visitation in the west portal at Rheims must be regarded as partly modelled on Greek drapery, Roman versions of which could still be found in the thirteenth century in the old Roman town of Rheims. But even greater than the difference between Classical Antique and French Gothic forms is that between the French drapery—appearing to follow the contours of the body—and the German with its elaborate and unnatural folds; and, not least, that between French and German renderings of facial expression. Where among the rarely grotesque art of the West would one find such another instance of over-emphatic characterization as in the figure of Elisabeth, the old woman who gazes sibyl-like into the distance? And, apart from these considerations, what could be more German than the far, enraptured gaze of the mysterious rider which makes him a symbol of German chivalry? His 68, 69 identity, incidentally, remains unsolved: in taking it to be that of Conrad IV, who greatly admired the epic tales of his century, Dehio leaves out of account the fact that Conrad was only nine years old when he became king in place of his father in 1237, the year when the figure was completed. On the other hand, none of the royal figures at Rheims, which the sculptor had undoubtedly studied, seem so strikingly to be embodiments of Parsifal as Wolfram depicted him; and even the statue of the Emperor Otto, which was directly modelled on the Bamberg rider, lacks this particular resemblance. The last sculptures completed by the Rheims-trained group were the figures of Henry II and Kunigunde, Adam and Eve, and 47–51 the Saints Peter and Stephen. These figures were placed into the Romanesque south-east portal without being organically incorporated. Splendid and significant as are the four clothed figures, those of Adam and Eve appear to overshadow them. The Last Judgment in the 52 tympanum over the Princes' Portal contains some small-scale unclothed figures of resurrected mortals, but the carving of naked figures larger than life-size required a temerity found only

59–62 rarely in the thirteenth century. Of even greater significance than the bodies, however, are the heads of the statues in the Adam Portal, and still more magnificent and mature are the figures of the Chosen Church and the Rejected Synagogue which were finally added to the Last Judgment of the Princes' Portal.

The differences between Early and High Gothic sculpture stand out clearly if the mature splendour of these statues is compared with the austere, over-slender figures carved at about the same time (around 1230) for the south transept portal at Strassburg—figures in which the tradition of the group responsible for the transept façades at Chartres lives on. [73] Further works of the group working at Bamberg include the statues of St Denis and of the angel who 63 offers him his martyr's crown, as well as the tomb of Bishop Suitger of Mayendorf, who held office in Bamberg from 1040 to 1046. At the instance of Henry III the latter had been elected Pope, becoming Clement II, but already in 1047 he had succumbed, his efforts to eradicate simony having imposed too great a strain on him. In accordance with his wishes he was buried at Bamberg. The cathedral fire of 1183 damaged his memorial, which was replaced by a marble tomb with the reclining figure of the Pope carved in sandstone. When the tomb was restored after the Thirty Years War it was relegated to the east choir. The figure of the Pope now stands upright. It bears an obvious relationship to the statues at Rheims—for example, to St Sixtus in the Sixtus Portal—and also to the Bamberg St Denis, and must be the work of a sculptor of the main Bamberg group. On the tomb a composition whose freedom of design is unusual for the thirteenth century depicts Christ with the Lamb of God, the dying Pope, a river of Paradise and the cardinal virtues. [74] The style of these figures recalls that of the Princes' Portal; the independent treatment of the composition justifies the assumption that the arrangement on the original sarcophagus was repeated.

At Mainz a group of sculptors, likewise trained at Rheims, was active at the same time as the one at Bamberg. The fragments of the two choir-screens indicate their completion before the dedication of the cathedral in 1239. The west choir-screen was destroyed in 1683. Its two sections of relief-work had portrayed the Last Judgment. Among the most important fragments 11 are the group with the restored head of St John—the original head, found in 1926, is in the Cathedral Museum—which was placed, probably in the eighteenth century, into the tympanum 21, 22 of the south-east portal; and the group in the cathedral cloisters of the blessed and the damned, 20 of which the youthful head with the banded hair, now in the Cathedral Museum, probably formed a part. [75] A relief of St Martin yielding up his coat, now in the parish church at Bassenheim near Coblenz, bears so close a relationship to the west choir-screen sculptures that its origin from Mainz is taken for granted, and it is thought that it may well have formed part of the west choir decoration. [76] The group of sculptors responsible for the west choir-screen evoked the nobility and restraint of French High Gothic more directly than any other group of German sculptors. Of much lower artistic merit is the Atlas figure preserved in the Cathedral Museum, the only fragment whose origin can be ascribed with certainty to the east choir-screen.

Having completed the ornamentation of the west choir at Mainz, possibly at the beginning

of the fourth decade of the century, the group was called to Naumburg.[77] Although the main work on the west choir at Naumburg was not begun until 1249, it is unlikely that Bishop Dietrich II delayed preparatory work once he had taken up his office in 1244. The intention underlying the design of the choir was that it should perpetuate in stone the memory of founders recalled verbally in the Office for the Dead; that it should sustain prayer for the souls of Bishop Dietrich's predecessors, the founders of the cathedral from the Houses of Billung and Wettin, who had died two centuries previously. The idea was novel. The fact that the bishop commissioned the best group of sculptors then active in Germany gives proof of his discerning artistic judgment. Succeeding generations owe him one of the most important creations of German sculpture.

Like that at Mainz, the Naumburg choir is separated from the rest of the church by a choir-screen, but—in contrast to Mainz—the sculptures of this screen do not merge into a single, unified portrayal of the Last Judgment. The painting above the entrance represents the Judge of the World surrounded by the symbols of His power, and an inscription whose final verse reads: "Dura sit an grata, tenet hic sententia lata", reaffirms that His Judgment is irrevocable. All the screen sculptures are symbols of this Judgment, with the overwhelming Crucifixion group, the symbol of the sin of mankind, at the centre; while the adjacent scenes of the Passion each present the idea of sin and atonement in a different way. The stained glass of the choir, which has undergone considerable restorations in the course of time, portrays the Lord in the company of His judges, the representatives of the Church Triumphant. And against the clustered shafts that run up the walls between the windows stand the founder-statues, proud embodiments of German chivalry, but aware here of the heavenly judgment awaiting them. This applies particularly to the two figures in the choir-head, behind the High Altar, whose guilt makes a special claim on the intercession of prayer: Ditmar of the House of Billung, who was accused in 1048 of high treason against Conrad II and was killed in ordeal by single combat; and Thimo of Küstritz of the House of Wettin, who killed an opponent in a tournament. They now stand face to face, as though opposing each other— Ditmar concealing his sword behind his shield as though in readiness for a blow, Thimo looking downward in barely restrained anger. Between them stands Count Sizzo, bearded, shouldering his sword and regarding Ditmar with displeasure; and the youthful Count William of Camburg, who turns his head away from the murderer. Thimo's sword bears the redeeming inscription: "qui dedit ecclesie septem villas". Under the transverse arch stand the two founders with their wives: Margrave Eckhart of Meissen, proud and manly in bearing, and his wife Uta, gazing into the distance, the collar of her cloak raised up to her cheek as if to ward off some approaching danger; and opposite, less severe in bearing, the youthful pair, Hermann and Reglind, symbols of German epic and lyric, of heroic tale and Minnesong. Four other founders complete the proud group: Conrad (the head has been restored) and Berchta,[78] in widow's garb, holding an open prayer-book; and finally Dietrich with the noble Gerburg.

82–89

97

98

99, 100

95, 96

92–94
101
91, 90

Few would deny that in their clear-cut corporeality and spiritual depth the choir-screen sculptures and the founder-statues are the most perfect of German High Gothic sculptures; and few would deny that the group of sculptors who carved them also produced the west choir-screen at Mainz. But the spirit of youth that emanates from the Mainz sculptures and gives them their peculiar charm has fled; the Naumburg sculptures are more mature, and more passionate. Nothing at Mainz equals the intensity of sorrow in the face of St John in the Naumburg Crucifixion group; or the veiled, far gaze of Uta. And although the statues at Rheims and Amiens, which belong to the same phase, are magnificent and full of nobility, yet they do not possess the range of individual expression of the Naumburg figures.

During the period before the middle of the thirteenth century only Magdeburg produced
119, 120 sculpture comparable to that of the founder-statues at Naumburg. After a first unsuccessful attempt to create a figure-framed main portal, work on the cathedral proceeded steadily. The delightful "Noli me tangere" in the tympanum over a door in the south section of the choir ambulatory was completed within the lifetime of Archbishop Albrecht. Its sculptor may well have aquired his skill in the south transept of Strassburg Minster. The ensuing hard struggle of the burghers for greater independence, culminating in 1241 in archiepiscopal recognition of an "universitas burgensium" provided the ferment out of which was created the monument of the town's founder. This is the earliest equestrian statue in Germany to be placed in the open air on a market square, and bears a relationship to the Bamberg rider statue similar to that existing between the Naumburg and Mainz choir-screen carvings. The sculptor very probably belonged to the Bamberg group. A considerable number of works in Magdeburg
118 Cathedral have been ascribed to him, including the powerful figure of St Maurice wearing
115 full armour, in the Kilian Chapel; and the small group of Christ and His crowned Bride, the Church, ill-placed in the bare Holy Sepulchre Chapel. The Church and the Synagogue, originally intended for the west porch, can be ascribed with some certainty to a pupil of this sculptor, and still reveal Romanesque "Baroque" tendencies in the accumulated drapery folds at the base of the figures, although they are of later date than the Bamberg statues.[79]

106-108 The delightful statues of the Wise and Foolish Virgins owe their existence to a renewed attempt to complete the west portal. When the portico, completed around 1240, was taken down soon after 1300 they were transferred to the Paradise Portal. These ten slender, girlish figures are worthy companions of Reglind and Uta, in their long girdled robes that fall in smooth folds or are gracefully draped; with their rich, wavy hair around faces whose expressions encompass every emotion, from gladness to the deepest sorrow. They are without precedent in Germany, as is the idea of carving on so large a scale these figures taken from the Last Judgment.

German High Gothic sculpture reached its zenith towards the middle of the thirteenth century. Of the sculptures produced during its gradual decline in the latter half of the century those revealing a French influence stand out clearly. This intrinsic inequality is well illustrated by the two large figures of the Virgin and Child on the inner and the outer side of the centre

post of the main portal at Freiburg. The beautiful interior statue is a logical development of the west portal at Strassburg; that is, it derives from the French style that was introduced around 1280 into the Last Judgment portal of the west façade. The exterior figure, though it dates from only a few years before 1280, is less elegant, more primitive, and characteristic of late thirteenth-century German work uninfluenced by French models.[80] Typical features are the drapery that gives no hint of the outline of the body, the fact that the Child is clothed, the deep waves of the hair, the heavy crown and the half-smiling mouth within the serious face. Another example is the group of the Annunciation at Regensburg, carved by the self-willed sculptor who created the tomb of St Erminold at Prüfening (1283).[81] Here again the human form loses its natural attributes in the process of artistic transformation, and the directness and serenity of High Gothic are replaced by a restricting severity. From this development can be traced immediately that of the fourteenth century.

Memorial statues were in most cases carved soon after the death of the person represented. They can therefore be accurately dated, and are of great help to the historian. Thus the memorial of Rudolf of Habsburg (d. 1291) in the Cathedral of Speyer is linked with the Virgin and Child on the exterior of the centre post at Freiburg by virtue of the similarity of the hair-waves and the heavy crown.

The influence of French High Gothic was sustained in the works of sculptors trained in France. It is reflected in the sculptures of the side-portals at Strassburg begun around 1280; and in the work subsequently produced by the same sculptors on the portico walls and along the inside west wall at Freiburg. The south portal of Worms Cathedral forms part of the same development. The magnificent statues, completed in 1322, placed against the piers of the choir at Cologne are among the last examples of the style.

The plates in this book do not suffice to render an account of the subsequent rich development of Gothic sculpture in Germany. Under the influence of religious mysticism sculpture becomes increasingly abstract. The tombs of Peter of Aichspalt (d. 1320), Archbishop of Mainz and of Frederick of Hohenlohe (d. 1352), Bishop of Bamberg, mark the beginning and the peak of this phase, which also includes the charming tympanum (1356) of the Birth of Christ, transferred from the old church into the minster at Ulm.

This somewhat austere phase was followed after the Black Death by a time of weakness and unrestraint, which would quite correctly have been described as a "soft style". The St Peter's Portal at Cologne (c. 1385), a photograph of which is reproduced in this book, is characteristic of this period. Soon, however, as was evidenced in the work of Ulrich of Ensingen, a new upward trend, a general return of vigour and of firmer standards, set in. Sculptural forms once more became imbued with life. Examples of this decisive change around 1400 are the tombs of the Archbishops Frederick of Saarwerden (d. 1414) at Cologne and Conrad III of Daun (d. 1434) at Mainz. The Carrying of the Cross on the tomb of Dean Burgmann (d. 1443) in the Cathedral of Speyer is a postponed manifestation of the same process.

The many-sidedness of Late Gothic art is one of its most striking features. In the Upper
146 Rhine area, the beauty of the Freiburg shrine of the Magi (1505) by Hans Wydyz, and of the
147 Locherer altar (1520–1524) by Sixt Gumpp, contrasts with the uncouth Gothic "Baroque"
of the retables at Breisach and Niederrotweil. The stone-carved entombment (*c.* 1490) at
37, 38 Worms by Hans Seyfer of Heilbronn reveals more distinctly perhaps than the Heilbronn
High Altar shrine the influence of Strassburg, and bears a relationship to the works of Tilman
Riemenschneider of Würzburg. The latter wrought the large tomb (1499–1513) at Bamberg,
75, 76 intended as a founder-monument, representing Henry II and Kunigunde and scenes from
their lives in relief-carvings. The impressive Entombment (*c.* 1495) by an unknown master
26 was transferred from the Liebfrauenkirche to Mainz Cathedral, where is to be found the
23 monument of James of Liebenstein (d. 1508), Archbishop of Mainz. It is attributed to the
Mainz sculptor Hans Backoffen, but bears little resemblance to his usual extravagant style.

The carving from the fourteenth century onwards of large, richly ornamented choir-stalls
of oak brought about a significant development in the art of wood-carving. Although these
choir-stalls were created mainly for cathedrals, monastery churches and collegiate churches,
they were occasionally used to ornament large parish churches, for example, Ulm Minster
and St Martin's at Memmingen.[82] Among the earliest of these in Germany are those at
131–133 Cologne, completed in 1322 and skilfully restored in the nineteenth century, and those at
73, 74 Bamberg (*c.* 1350). The fusion of the carpenter's and the wood-carver's skill as revealed by
these two works was tacitly accepted by the guilds of most towns, although in Constance, for
example, a division of the two kinds of work was demanded. In the fifteenth century, orna-
mentation became more extensive and included busts on pew-ends. At Ulm, Jörg Syrlin was
164–169 entrusted with the entire production of the choir-stalls, which he completed between 1469 and
1474.[83] They are the most significant of Late Gothic creations, both in construction and orna-
mentation. Those at Constance, influenced by Nicholas Gerhaert of Leijden, are equally full of
invention;[84] and there is no dearth of more modest works, like the two rows of seats ornamented
173, 174 with dorsal busts in the Frauenkirche at Munich, which Erasmus Grasser carved for the newly
endowed collegiate church and completed in 1502.[85] Other expressions of the wood-carver's
art towards the end of the Middle Ages are altar shrines and single carvings. The large statue
of St Christopher in the Frauenkirche at Munich is one of the most significant works of
Bavarian Gothic "Baroque", and Hans Leinberger of Landshut the most famous exponent
of the style.

REFERENCES

1 Th. K. Kempf, *Die Ausgrabungen am Trierer Dom,* from Neue Beiträge zur Kunstgeschichte des ersten Jahrtausends, I, I, 1952, p. 91.

2 A. v. Gerkan, *Der Umbau der Kirche St. Gereon zu Köln,* from *loc. cit.*

3 F. Blanke, *Columban und Gallus,* 1941.

4 Richard Koebner, *Venantius Fortunatus,* 1915.

5 W. Veeck, *Die Alamannen in Württemberg,* 1931.

6 Julius Baum, *La Sculpture figurale à l'époque mérovingienne,* 1937; Niels Åberg, *The Occident and the Orient in the Art of the seventh Century,* 1943.

7 W. Pinder, *Die Kunst der deutschen Kaiserzeit,* 1933, p. 60.

8 Jean Hubert, *L'art préroman,* 1938; Edgar Lehmann, *Der frühe deutsche Kirchenbau,* 1949.

9 A. Verbeeck, *Westchorhallen,* 1936.

10 Otto Doppelfeld, *More Romano, Die beiden karolingischen Domgrundrisse von Köln,* Kölner Domblatt 1954, pp. 33 et seq.

11 Albert Hauck, *Kirchengeschichte Deutschlands,* II, 5th edition, 1935, pp. 594 et seq. A. Werminghoff, *Die Beschlüsse des Aachener Konzils im Jahre 816,* Neues Archiv für ältere deutsche Geschichtskunde, XXVII, pp. 605 et seq. Jos. Hecht, *Der romanische Kirchenbau des Bodenseegebiets,* 1928, pp. 24 et seq. Hans Reinhardt, *Der St. Galler Klosterbau,* 1952.

12 Louis Blondel, *Les Basiliques d'Agaune,* Vallesia, III, 1948.

13 Paul Clemen, *Die romanische Wandmalerei in den Rheinlanden,* 1916, p. 749.

14 W. Meyer-Schwartau, *Der Dom zu Speyer,* 1893. Rudolf Kautzsch, *Der Dom zu Speyer,* Städel-Jahrbuch, I, 1921, pp. 75 et seq. B. H. Röttger, *Die Kunstdenkmäler der Pfalz,* III, Stadt und Bezirksamt Speyer, 1934.

15 Philipp M. Halm, *Studien zur süddeutschen Plastik,* I, 1926, p. 176.

16 Rudolf Kautzsch und Ernst Neeb, *Die Kunstdenkmäler der Stadt und des Kreises Mainz,* II, 1919. Rudolf Kautzsch, *Der Mainzer Dom und seine Denkmäler,* 1925.

17 Rudolf Kautzsch, *Der Wormser Dom,* 1938.

18 Ferdinand Luthmer, *Die Bau- und Kunstdenkmäler des Regierungsbezirks Wiesbaden,* III, Kreis Limburg, 1909.

19 Albert Hauck, *Kirchengeschichte Deutschlands,* III, 5th ed., 1920, pp. 418 et seq. Wilhelm Pinder, *Der Bamberger Dom und seine Bildwerke,* 1927.

20 The statues have recently been brought into the interior.

21 F. Unterkircher, *Vom Sinn der deutschen Doppelchöre,* Diss. Vienna, 1941.

22 Hans Sedlmayr, *Die Entstehung der Kathedrale,* 1950, pp. 120 et seq.

23 Ernst Gall, *Die gotische Baukunst in Frankreich und Deutschland,* I, 1925.

24 H. Lichtenberg, *Die Architekturdarstellungen in der mittelhochdeutschen Dichtung,* 1931. H. Sedlmayr, *op. cit.,* p. 137.

25 R. Hamann and K. Wilhelm-Kästner, *Die Elisabethkirche zu Marburg,* I, 1924.

26 *Monumenta Germ. Hist.,* XXX, 1, 1896. Ad. Zeller, *Die Stiftskirche St Peter zu Wimpfen im Tal,* 1903, p. 10.

27 Wilhelm Pinder, *Der Naumburger Dom und seine Bildwerke*, 1926.

28 Hauck, *op. cit.,* pp. 108 *et seq.*

29 *Walther von der Vogelweide*, ed. Karl Lachmann, 6th ed., I, p. 19. Gustav Ehrismann, *Geschichte der deutschen Literatur bis zum Ausgang des Mittelalters,* II, 1935, p. 24.

30 Walther Greischel, *Der Magdeburger Dom*, 1939.

31 Hans Sedlmayr, *loc. cit.,* pp. 470 *et seq.*

32 E. Gall, *loc. cit.,* pl. 77, 81.

33 Paul Clemen, Heinrich Nau and Fritz Witte, *Der Dom zu Köln,* 1937. *Der Kölner Dom,* Festschrift zur Siebenhundertjahrfeier, 1943.

34 Francesco Petrarca, *Epist. famil.* I, ep. 4. J. J. Merlo, *Bonner Jahrbücher,* LXXIV, p. 125.

35 Louis Gonse, *L'art gothique*, 1891, p. 346.

36 Hans Sedlmayr, *op. cit.,* p. 471.

37 Henri-Paul Eydoux, *L'Architecture des Eglises cisterciennes d'Allemagne*, 1952, pp. 77 *et seq.*

38 Georg Dehio, *Geschichte der deutschen Kunst,* II, 1930, p. 36.

39 Hans Sedlmayr, *loc. cit.,* p. 472.

40 Georg Dehio, *loc. cit.,* I, 1930, p. 278.

41 Julius Baum, *Romanische Baukunst in Frankreich,* XVIII, 1928, pp. 49, 290.

42 Otto Schmitt, *Das Heiligkreuzmünster in Schwäbisch Gmünd,* 1951.

43 Paul Buberl, *Die Kunstdenkmäler des Zisterzienklosters Zwettl,* 1940.

44 E. Hanfstaengl, *Hans Stethaimer,* 1911.

45 E. Hanfstaengl, *op. cit.,* p. 38, pl. 20.

46 Kurt Gerstenberg, *Deutsche Sondergotik,* 1913, p. 9.

47 Peter Meyer, *Schweizerische Münster und Kathedralen des Mittelalters,* 1945, pp. 21 *et seq.*

48 Friedrich Kempf, *Das Freiburger Münster,* 1926.

49 Georg Dehio, *loc. cit.,* II, p. 46.

50 Rudolf Noll, *Frühes Christentum in Oesterreich,* 1954, pp. 53 *et seq.*

51 Albert Hauck, *Kirchengeschichte Deutschlands,* I, 6th ed. 1922, pp. 342 *et seq.* Ludwig Schmidt, *Die Westgermanen,* I, pp. 194 *et seq.*

52 Karl Zahn, *Der Dom zu Regensburg,* 1929.

53 J. A. Endres, *Beiträge zur Kunst- und Kulturgeschichte des mittelalterlichen Regensburg,* 1925, pp. 80 *et seq.*

54 W. v. Giesebrecht, *Geschichte der deutschen Kaiserzeit,* VI, 1895, p. 154.

55 G. Dehio, *loc. cit.,* II, pp. 60 *et seq.*

56 Zahn, *op. cit.,* fig. 30.

57 Felicis Fabri *Tractatus de civitate Ulmensi,* ed. G. Veesenmeyer, Bibliothek des Literarischen Vereins, vol. 186, 1889.

58 E. Mauch, *Bausteine zu Ulms Kunstgeschichte,* III, 1870.

59 O. Kletzl, art. "Parler" (Thieme-Becker, Allg. Künstlerlexikon, XXVI).

60 Friedrich Carstanjen, *Ulrich von Ensingen,* 1893, pl. XI.

61 G. Dehio, *loc. cit.,* II, p. 155.

62 Hans Klaiber, *Der Ulmer Münsterbaumeister Matthäus Böblinger,* 1911.

63 H. Karlinger, *Studien zur Entwicklungsgeschichte des spätgotischen Kirchenbaus im Münchner Gebiet,* 1908.

64 W. v. Giesebrecht, *op. cit.,* V, 1880, pp. 134 *et seq.* A. Hauck, *op. cit.,* IV, 5th ed., 1925, pp. 500 *et seq.*

65 J. Baum, *Die Malerei und Plastik des Mittelalters in Deutschland, Frankreich und Britannien,* Handbuch der Kunstwissenschaft, 1930, p. 268, pl. 270.

66 Gino Chierici, *Le Sculture della Basilica di San Michele maggiore a Pavia,* 1942.

67 Monica Rydbeck, *Skånes Stenmästare före 1200,* 1936, pp. 96 *et seq.*

68 Wera von Blankenburg, *Heilige und dämonische Tiere,* 1943. J. Baum, *Darstellungen aus der germanischen Götter- und Heldensage,* Eranos-Jahrbuch, XVII, 1950.

69 Anton Dvořák, *Kunstgeschichte als Geistesgeschichte*, 1924, pp. 73 *et seq.*, quotation from the *Summa*.

70 W. Greischel, *Der Magdeburger Dom*, 1939, figs. 62–65.

71 Hans Jantzen, *Deutsche Bildhauer des 13. Jahrhunderts*, 1925. Wilhelm Pinder, *Der Bamberger Dom und seine Bildwerke*, 1927.

72 Georg Dehio, *Kunsthistorische Aufsätze*, 1914, pp. 91 *et seq.*

73 Hans Jantzen, *op. cit.*, 1925, pp. 38 *et seq.*

74 A. Freiherr von Reitzenstein, *Das Clemensgrab im Dom zu Bamberg*, Münchner Jahrbuch der bildenden Kunst, 1929.

75 Otto Schmitt, *Der Kopf mit der Binde, Oberrheinische Kunst*, IV, 1932.

76 Otto Schmitt, *Das Mainzer Dommuseum und die deutsche Bildhauerkunst des 13. Jahrhunderts*, 1939.

77 Wilhelm Pinder, *Der Naumburger Dom und seine Bildwerke*, 1926. H. Beenken, *Der Meister von Naumburg*, 1939. Peter Metz, *Der Stifterchor des Naumburger Doms*, 1947.

78 Herbert Küas, *Die Naumburger Werkstatt*, 1937. It is shown that the statue generally known as Gepa is that of Bertcha to which reference is made in the patron's letter.

79 W. Greischel, *op. cit.*, figs. 106, 107, here dated most improbably as fourteenth century.

80 Otto Schmitt, *Gotische Skulpturen des Freiburger Münsters*, II, pls. 140, 141, 185–187, 1926.

81 Adolf Feulner and Theodor Müller, *Geschichte der deutschen Plastik*, 1953, p. 184.

82 Walter Loose, *Die Chorgestühle des Mittelalters*, 1931, pp. 119, 127, 136, 139.

83 J. Baum, *Die Ulmer Plastik um 1500*, 1911. G. Otto, *Die Ulmer Plastik der Spätgotik*, 1927.

84 L. Fischel, *Nicolaus Gerhaert und die Bildhauer der deutschen Spätgotik*, 1944. J. Eschweiler, *Das Konstanzer Chorgestühl*, 1949.

85 Ph. M. Halm, *Erasmus Grasser*, 1928.

LIST OF PLATES

NAUMBURG

Cathedral of St Peter and St Paul, 77–101

MAGDEBURG

Cathedral, 102–120

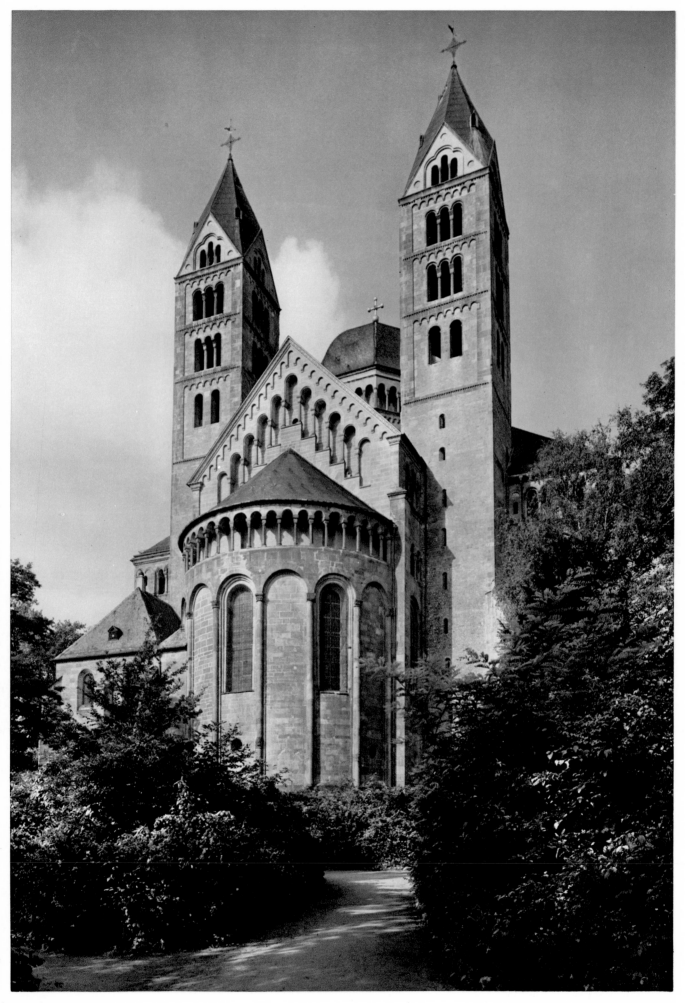

SPEYER

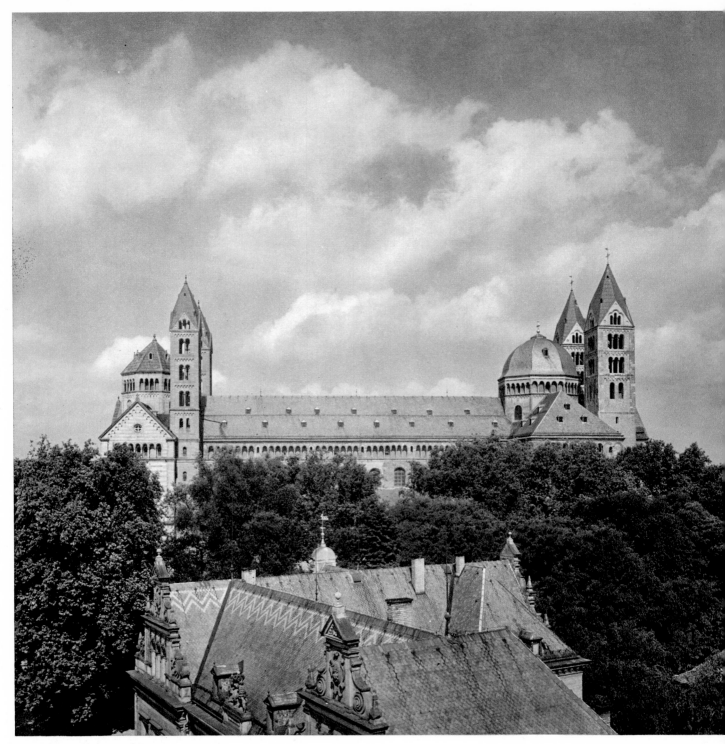

SPEYER

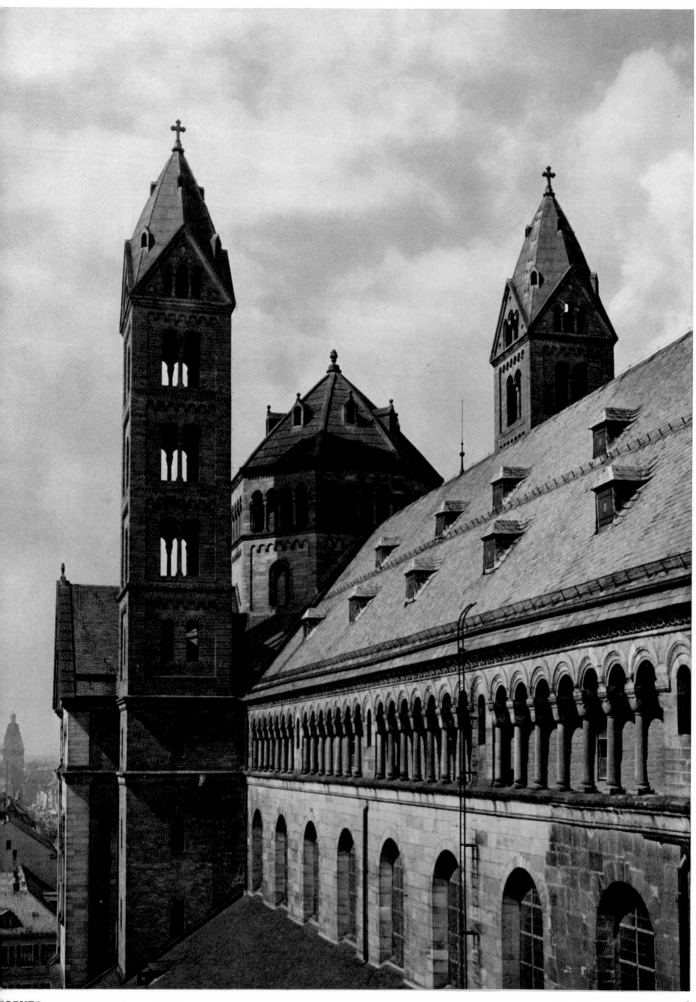

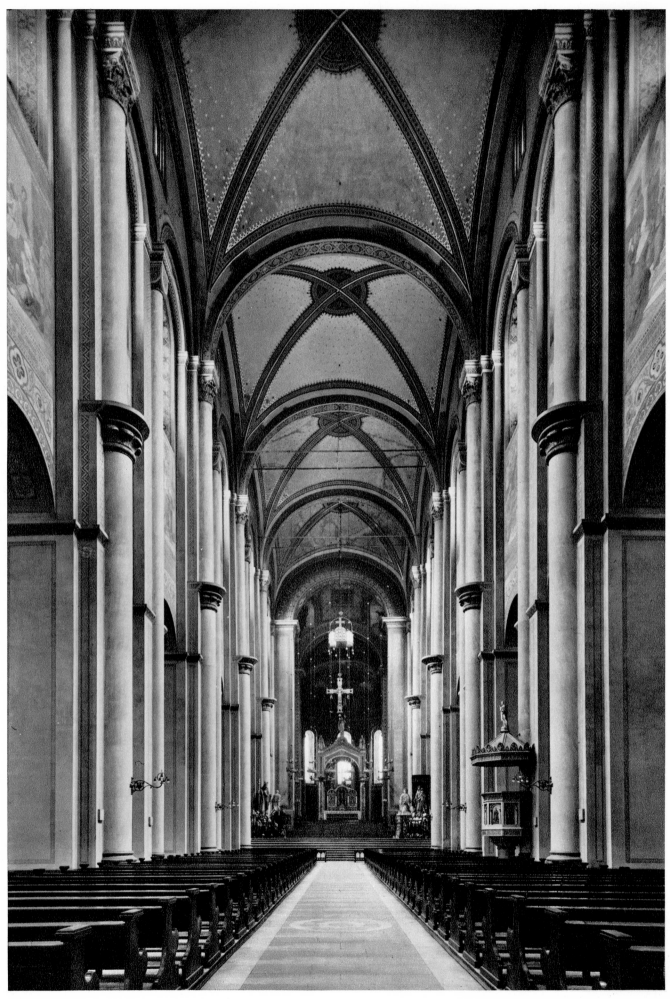

SPEYER

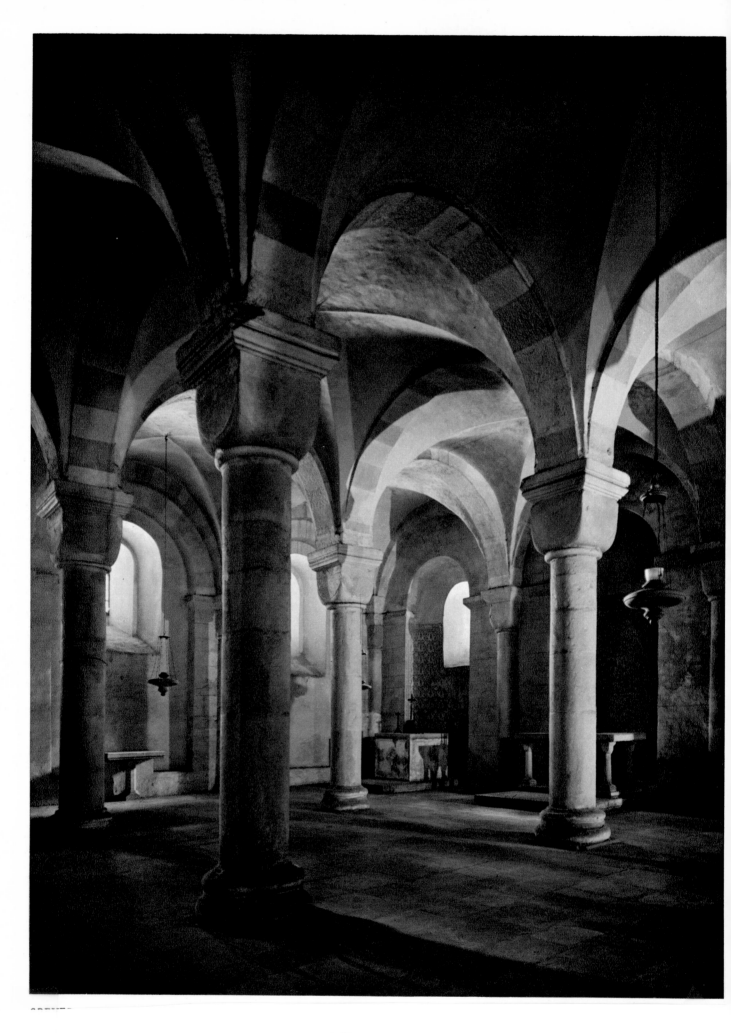

The crypt of the cathedral of Speyer.

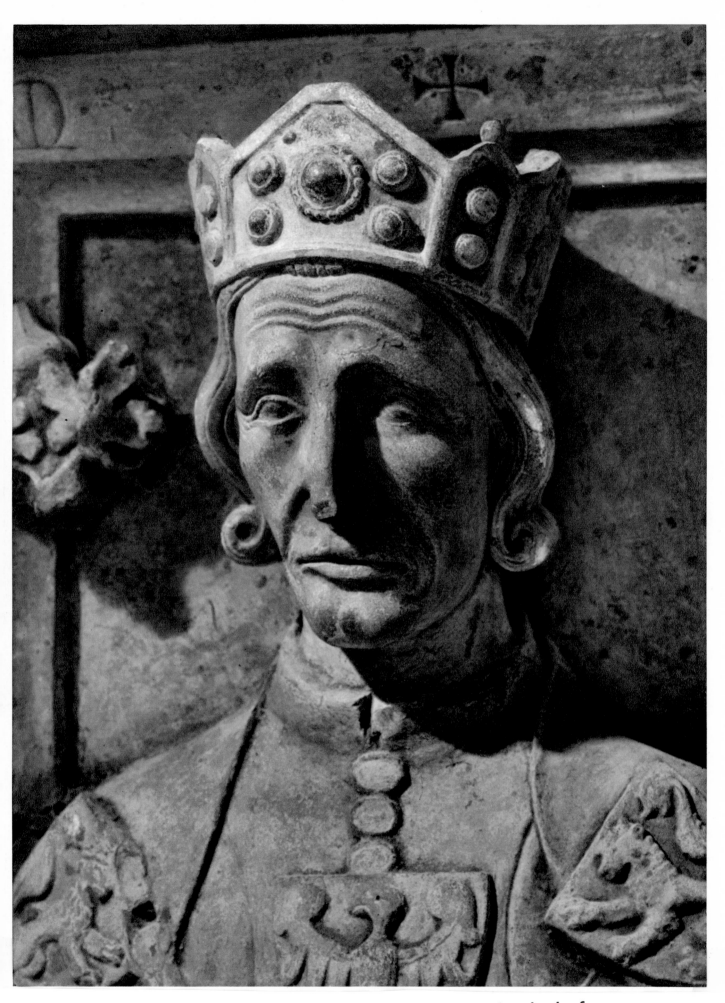

Rudolf I's image over his gravesite in the cathedral of Speyer.

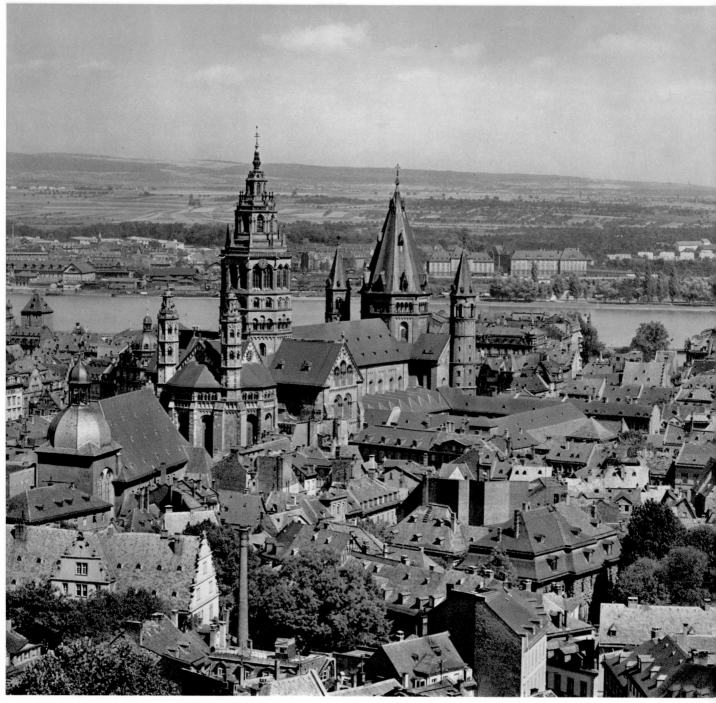

MAINZ

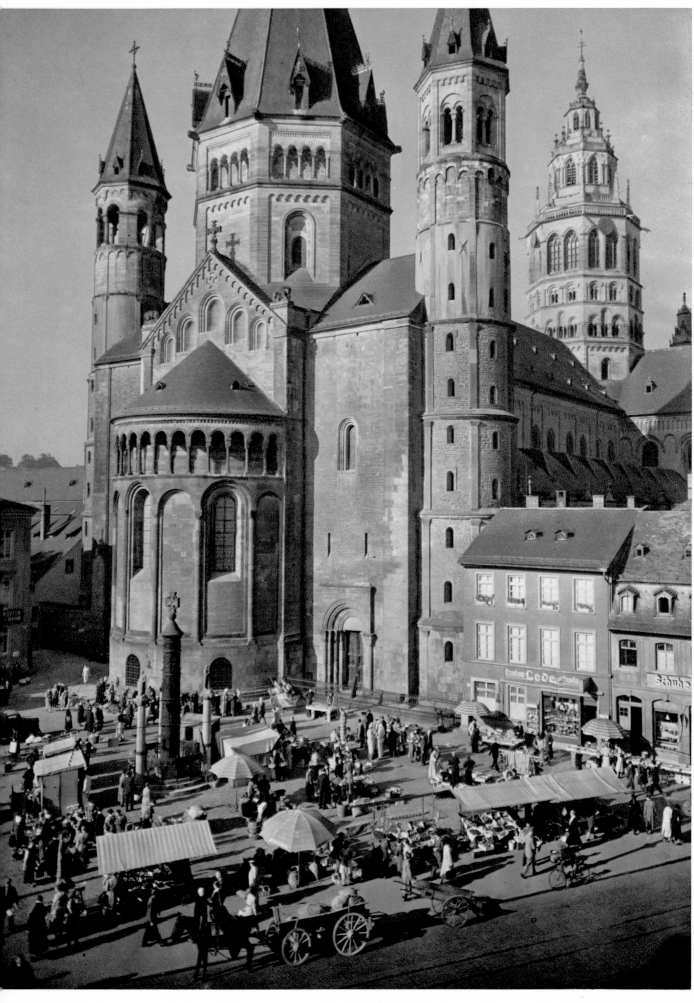

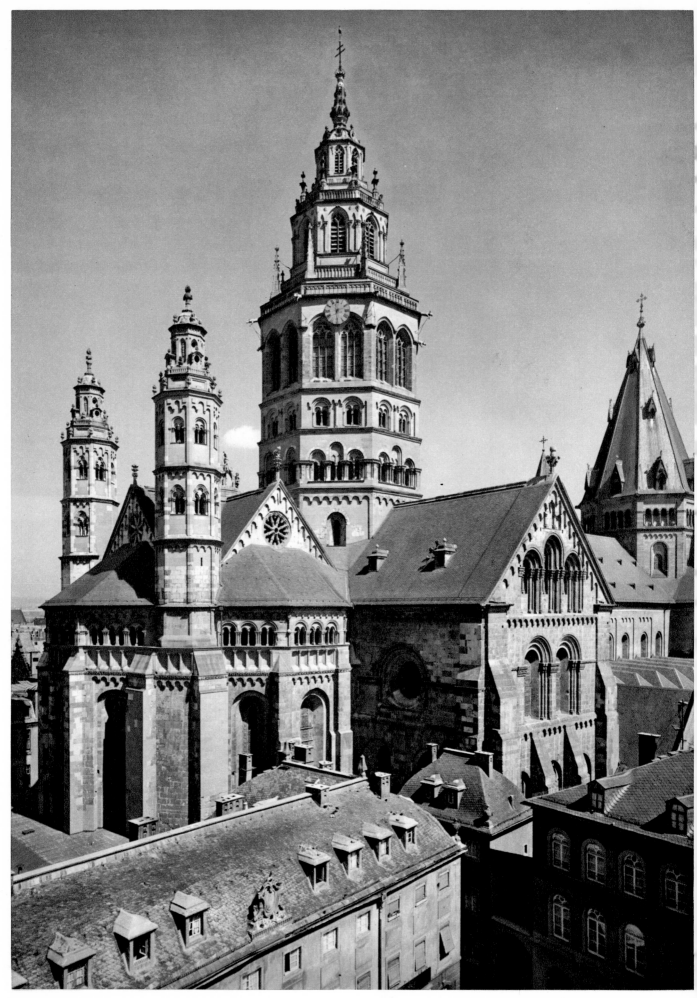

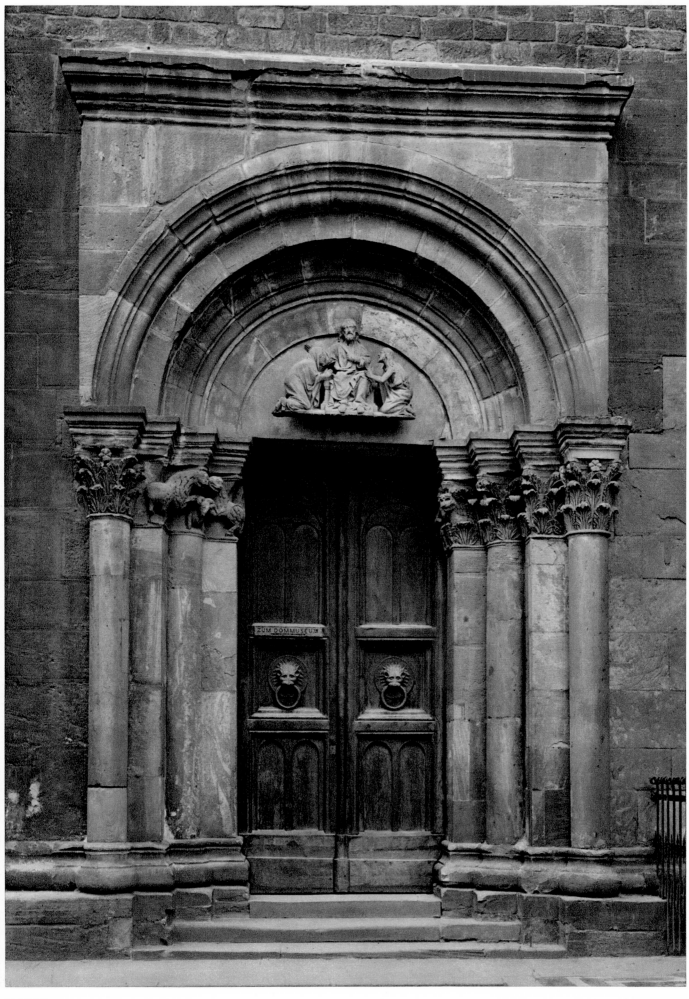

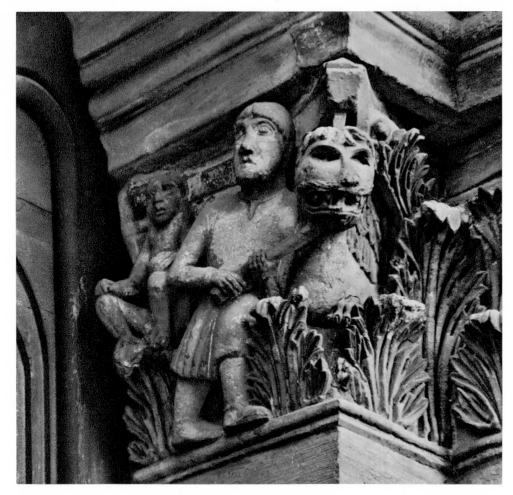

12

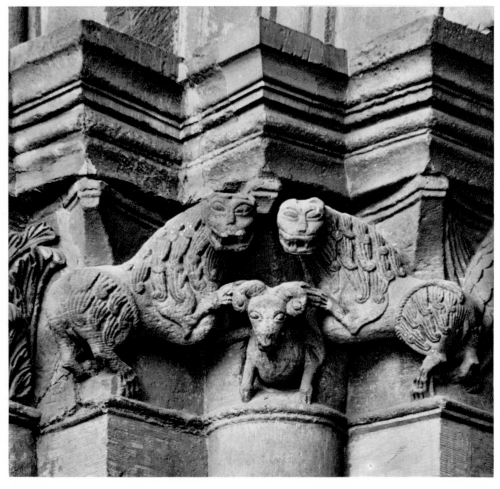

MAINZ

13

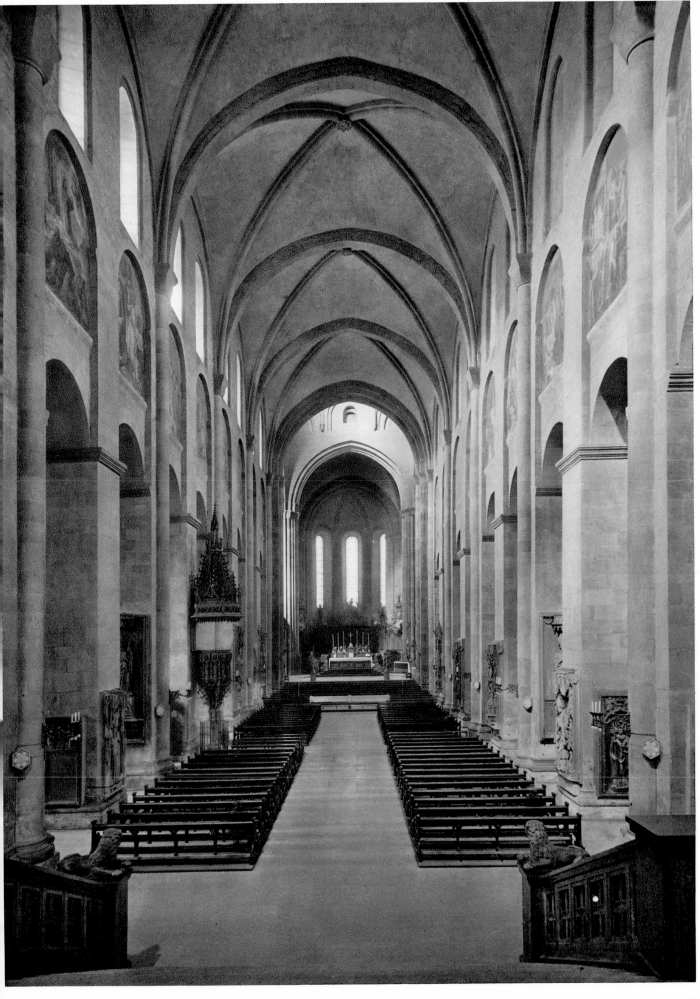

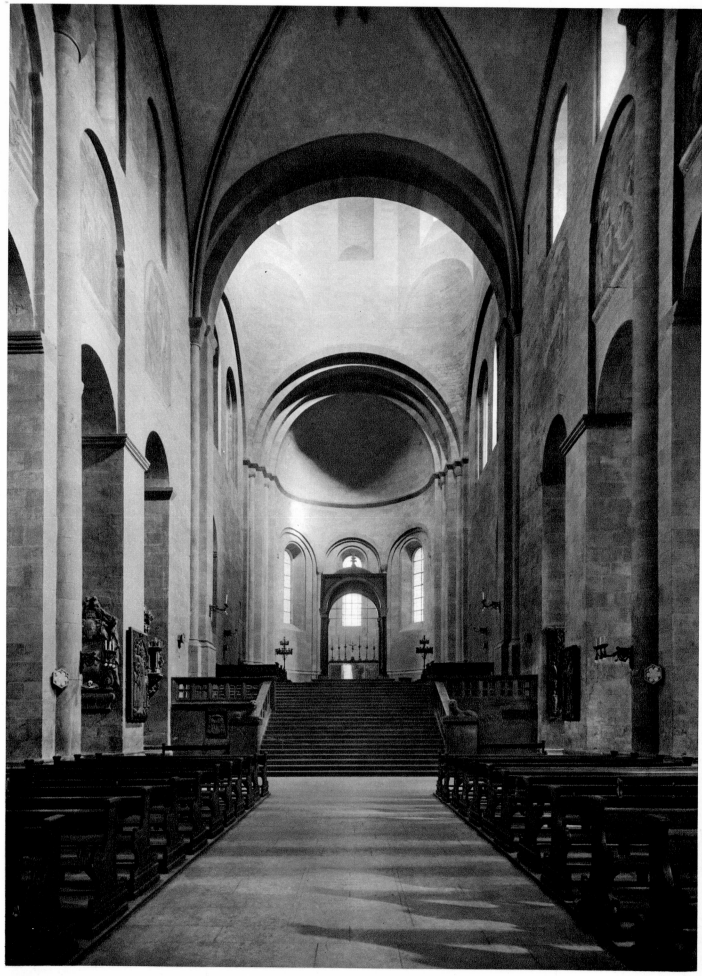

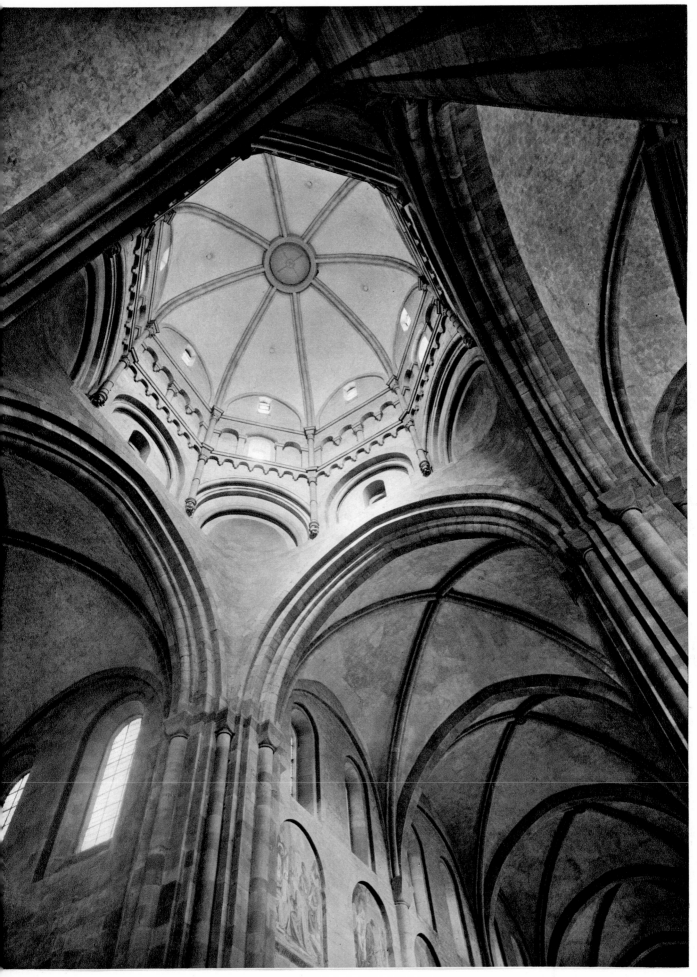

MAINZ

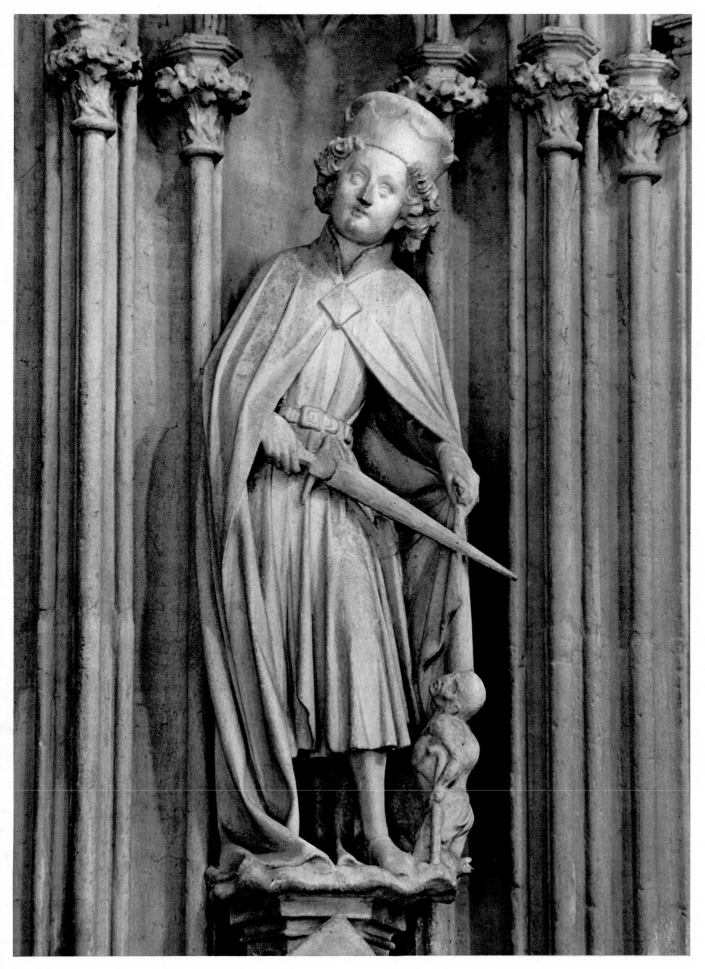

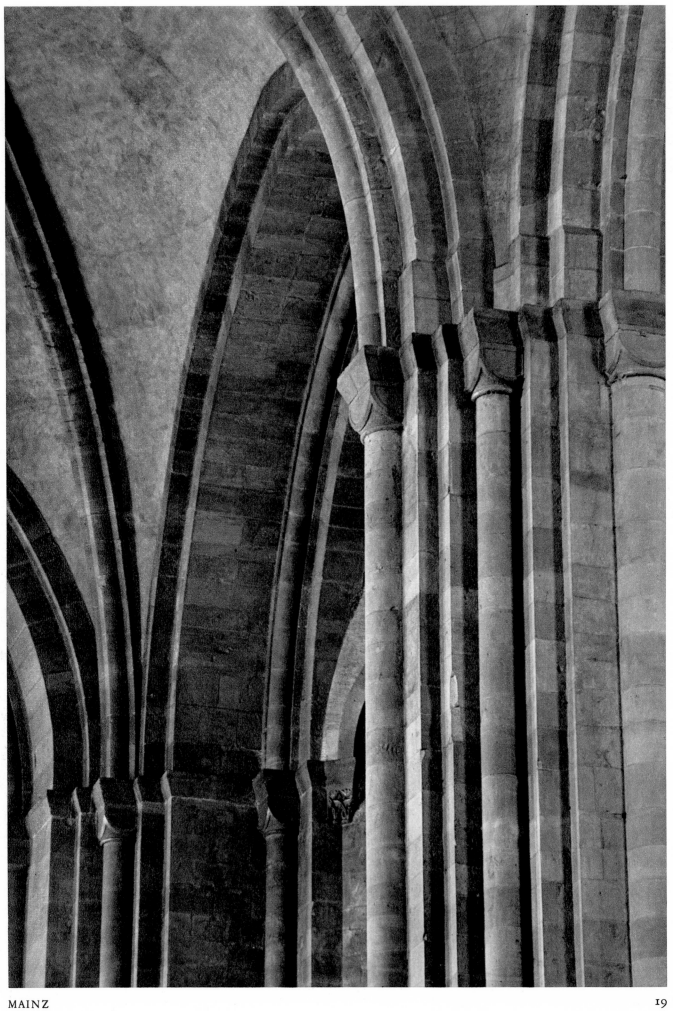

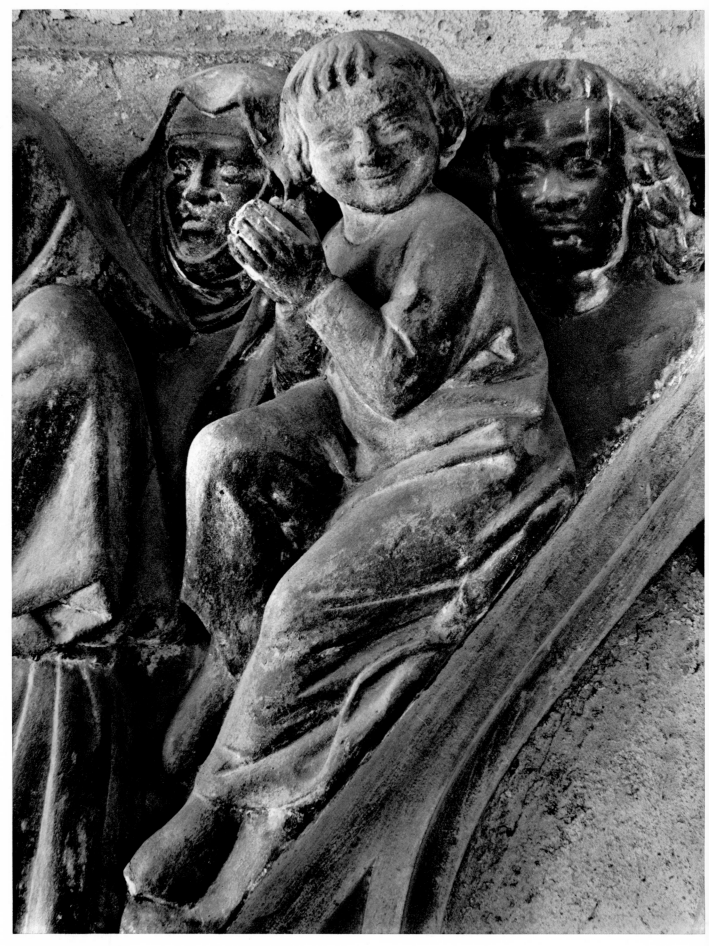

MAINZ

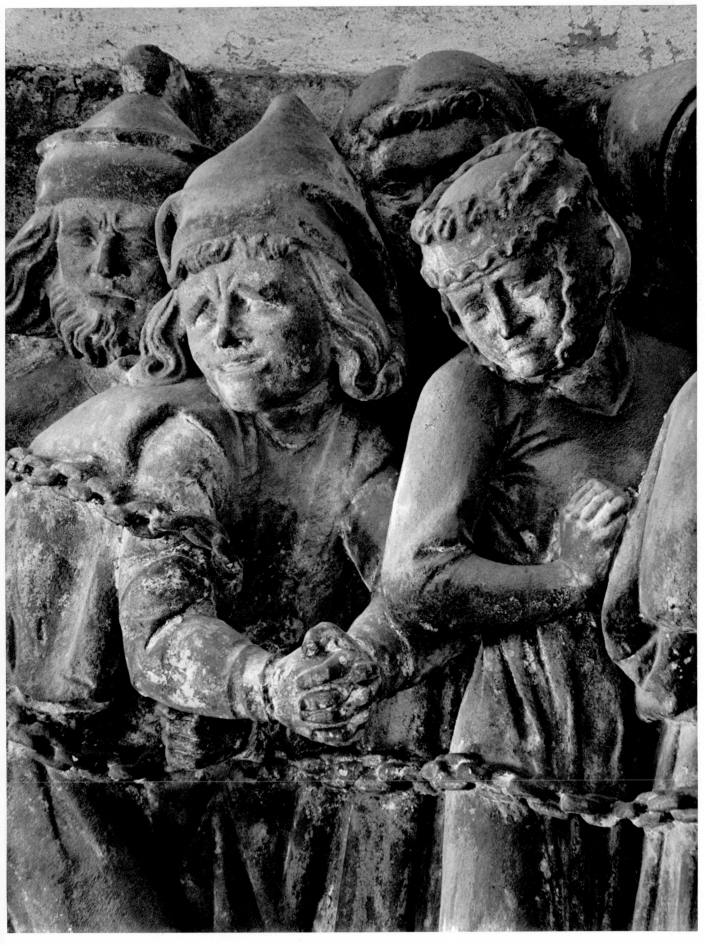

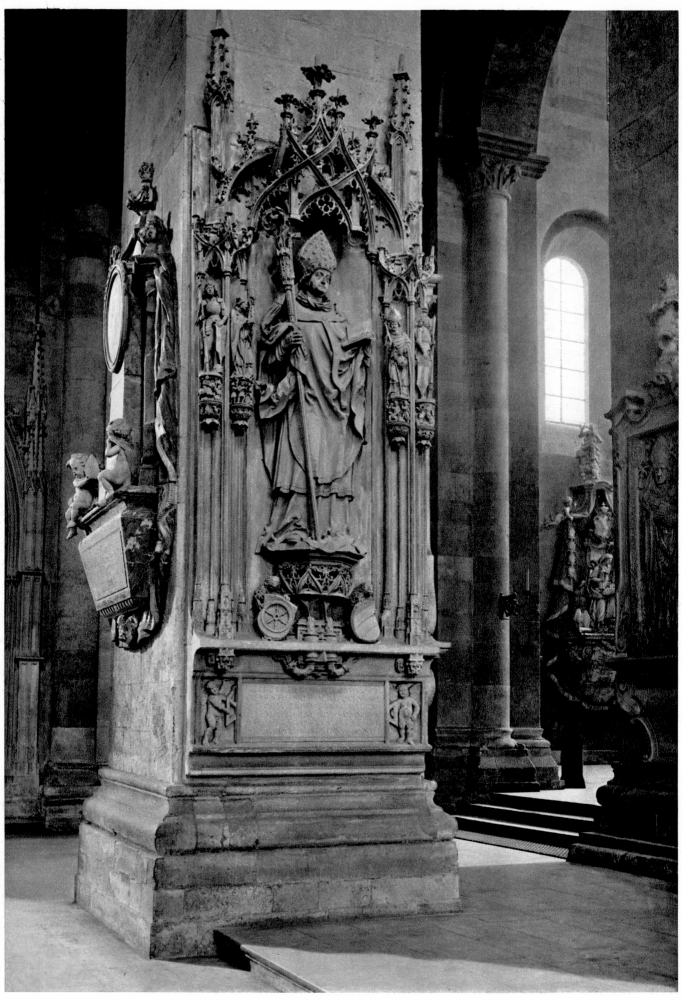

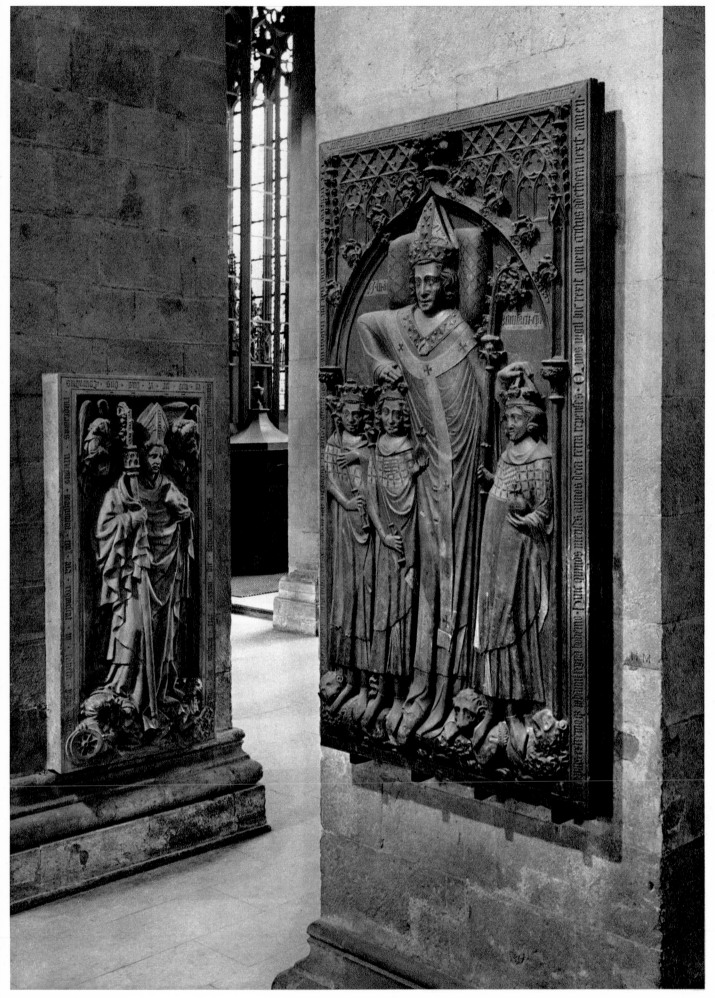

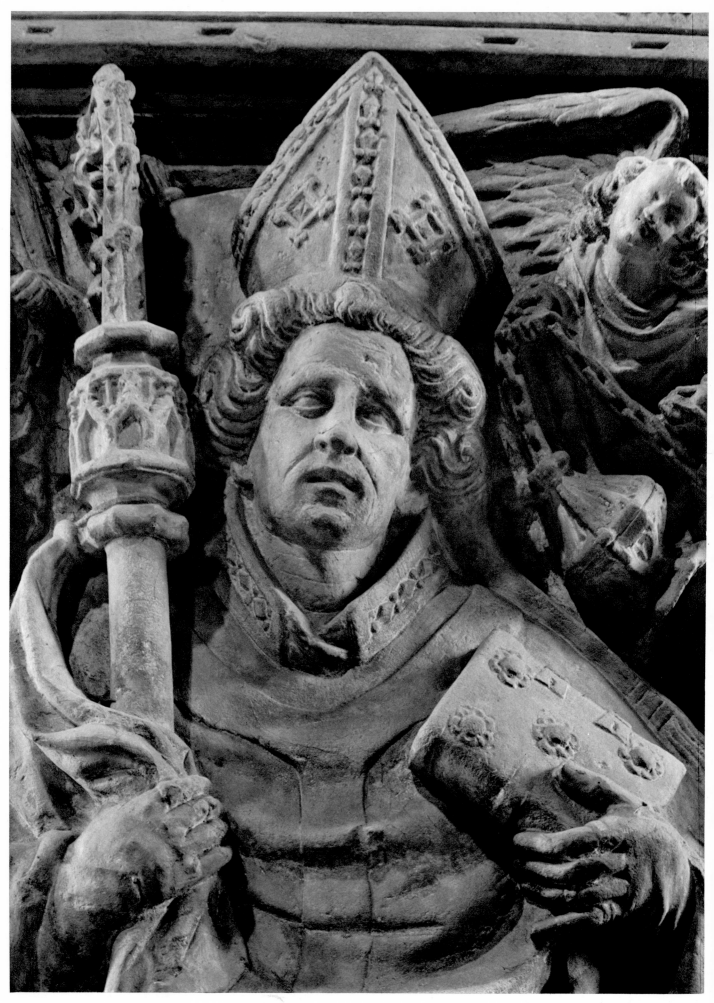

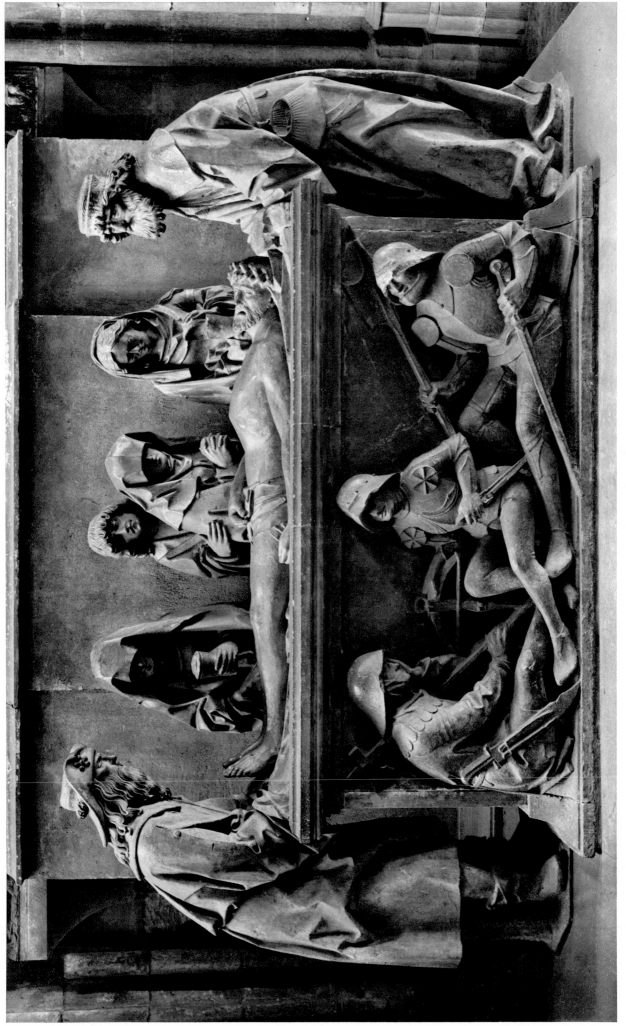

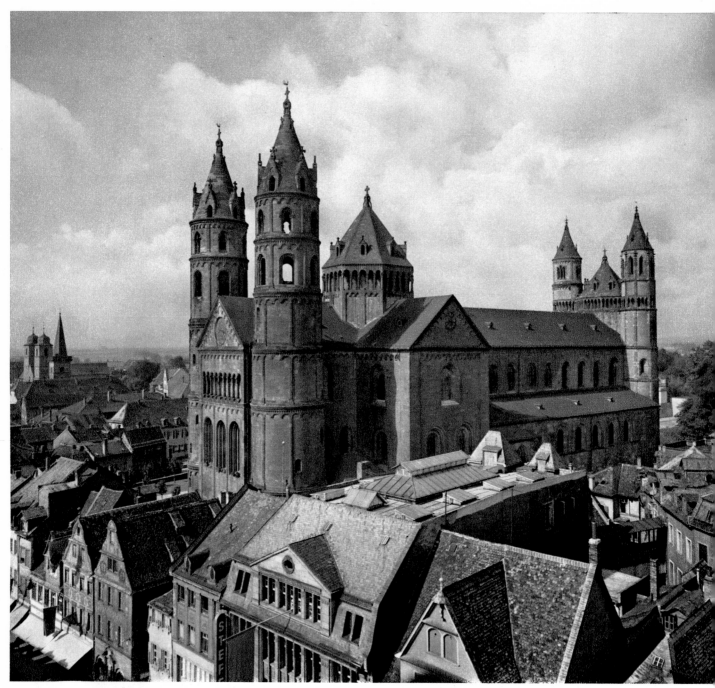

WORMS

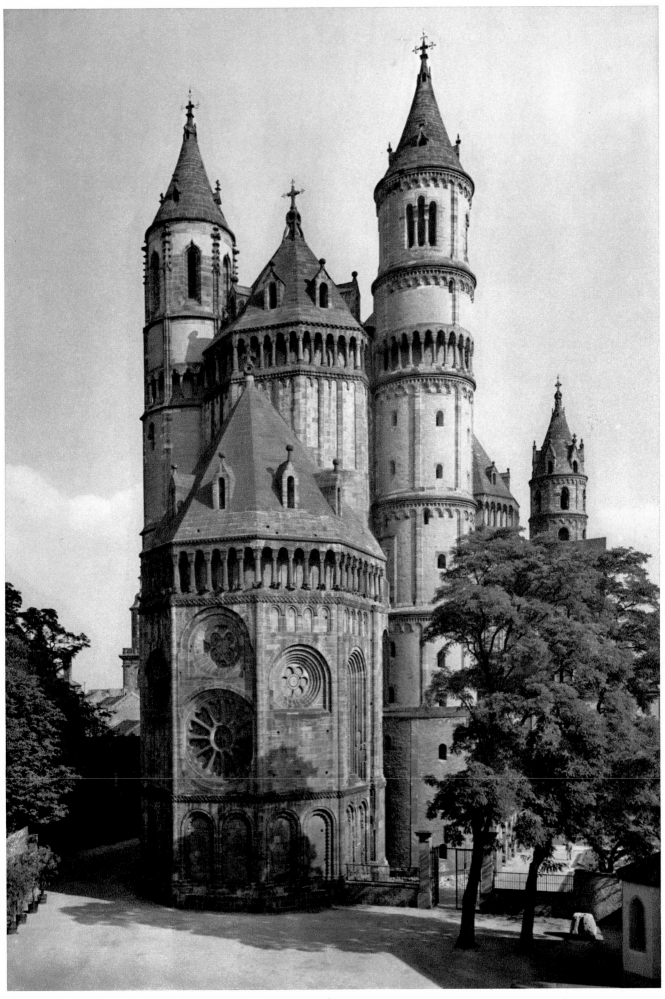

WORMS

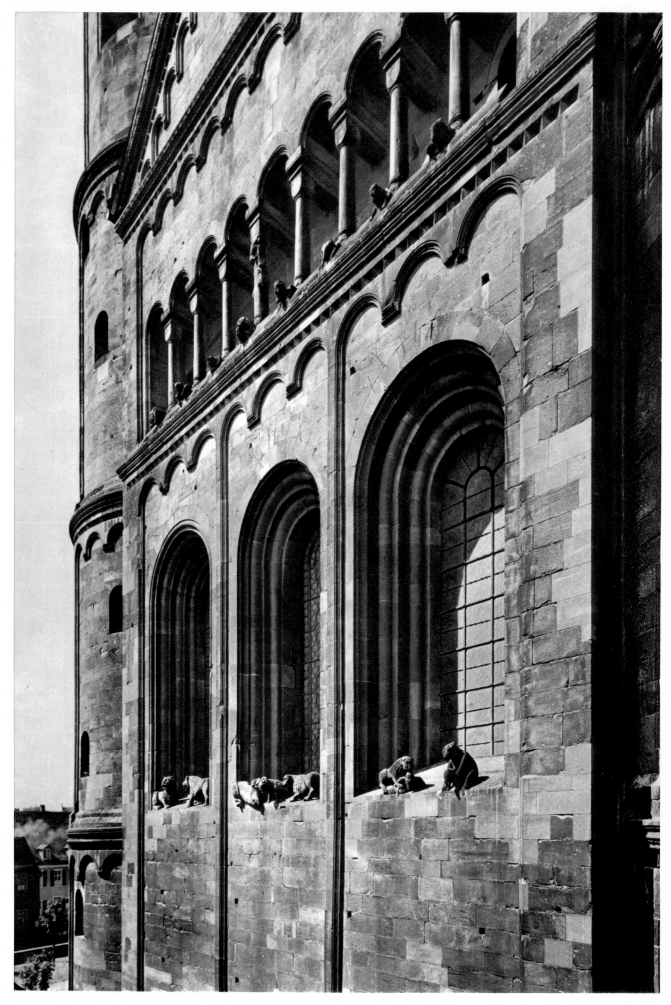

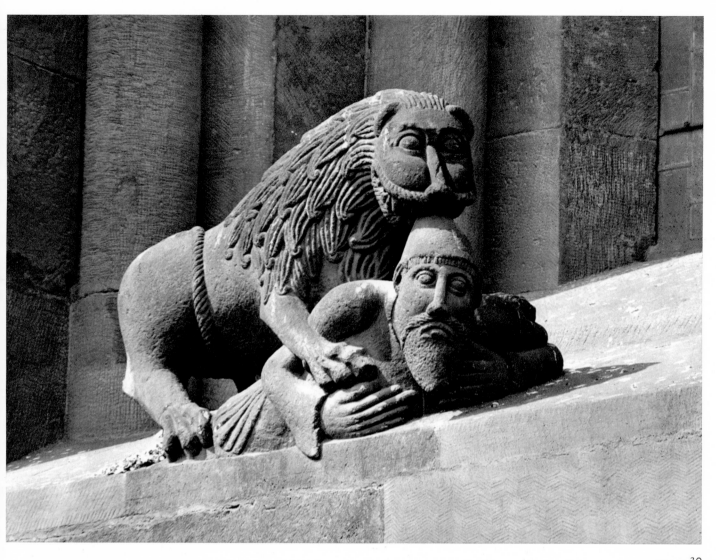

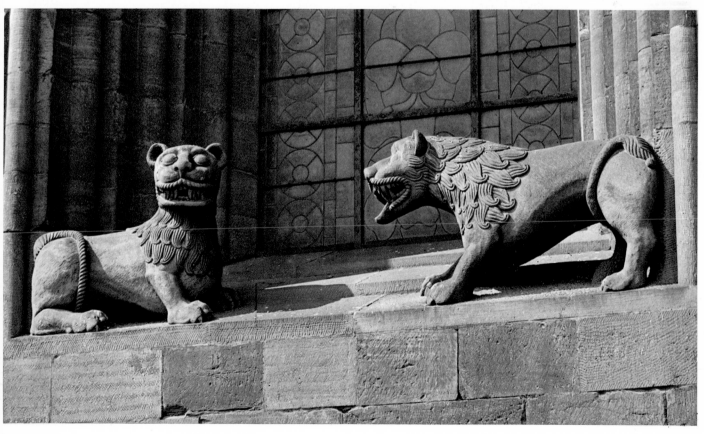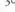

WORMS

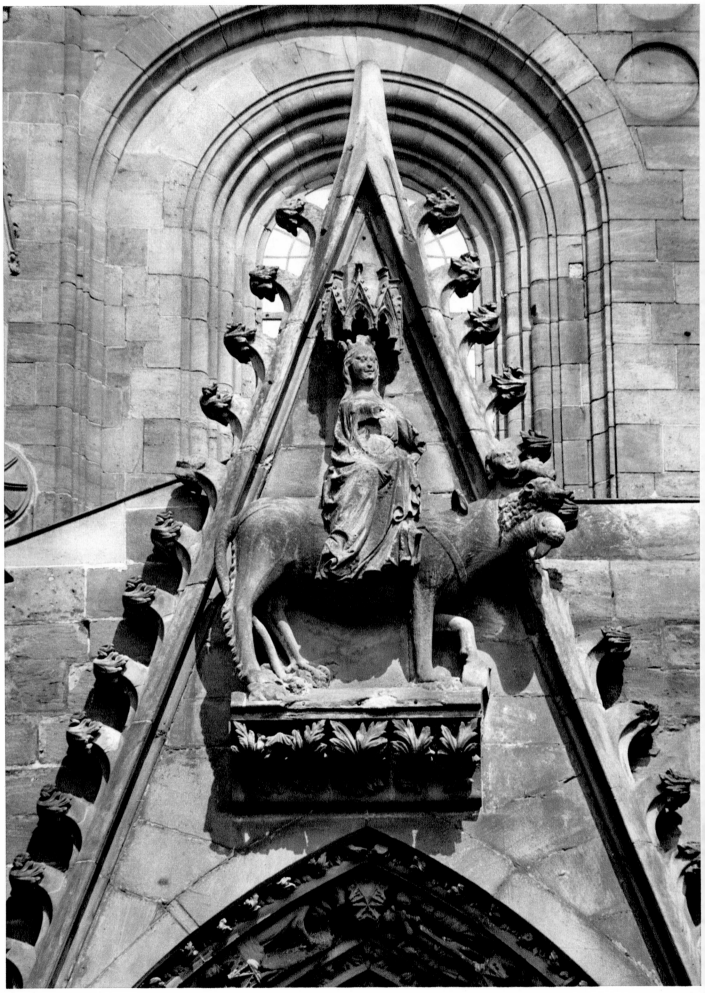

WORMS

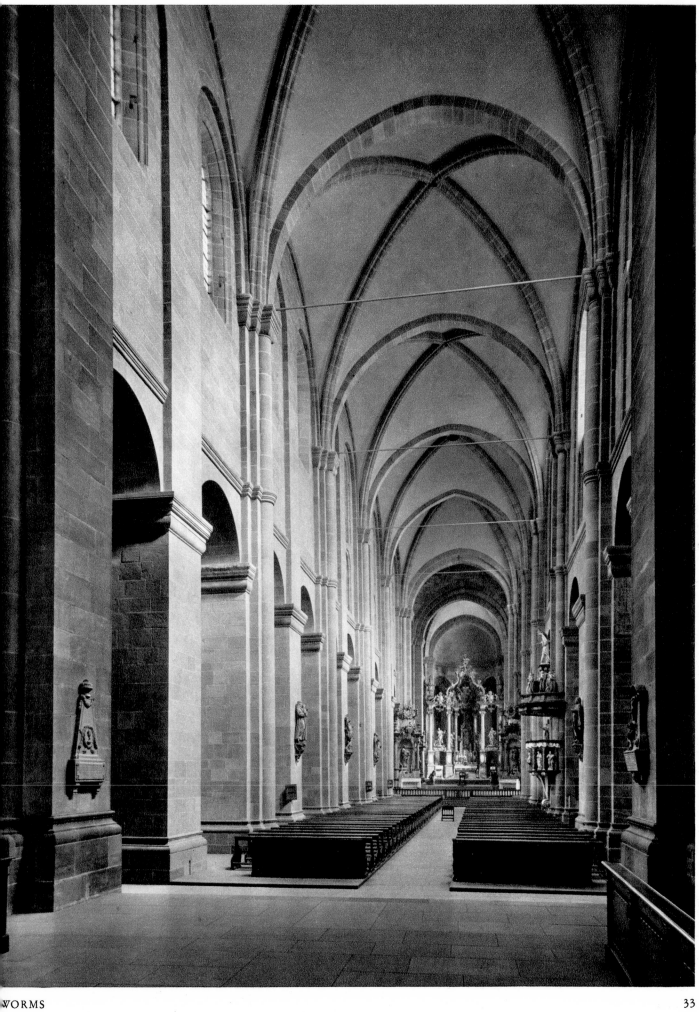

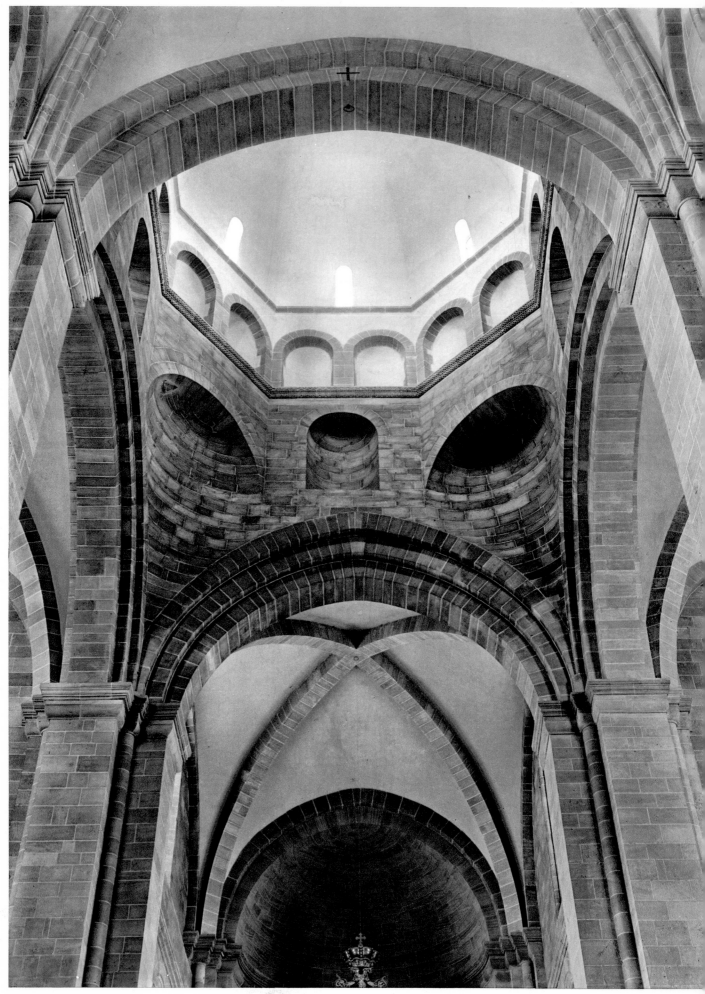

WORMS

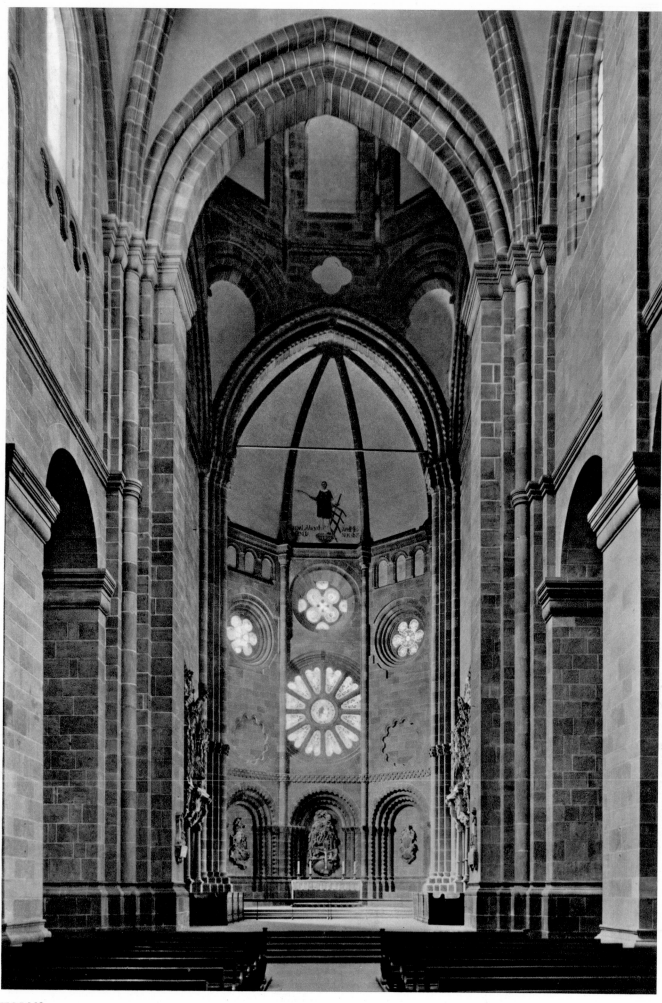

WORMS

37

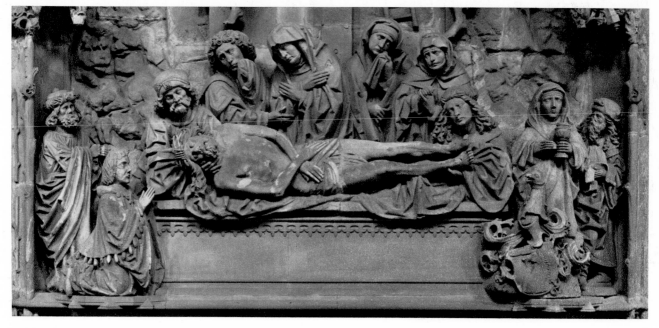

WORMS

38

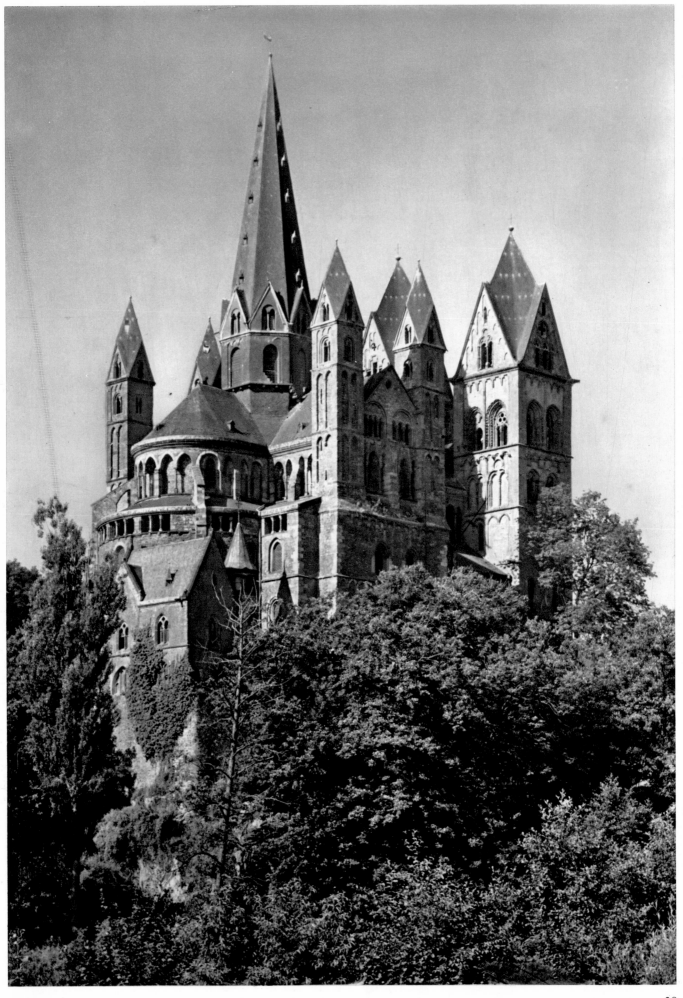

LIMBURG

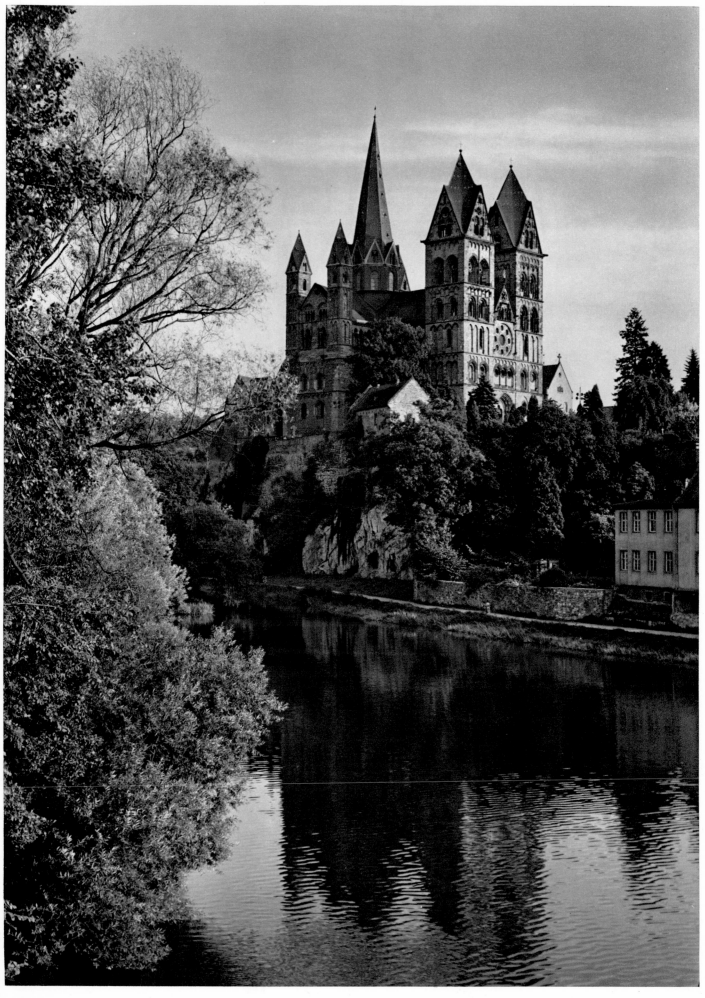

LIMBURG

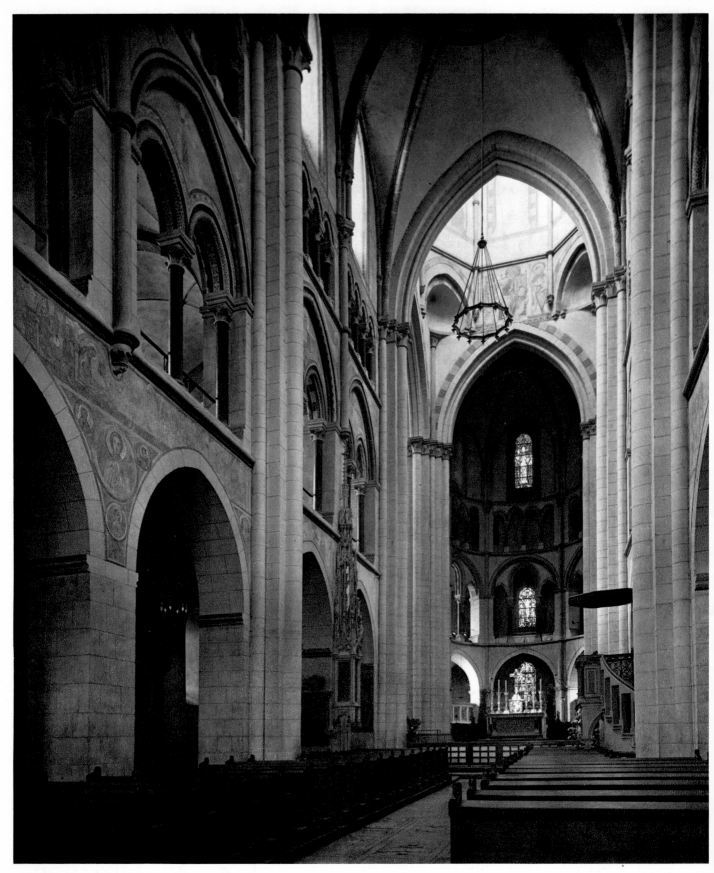

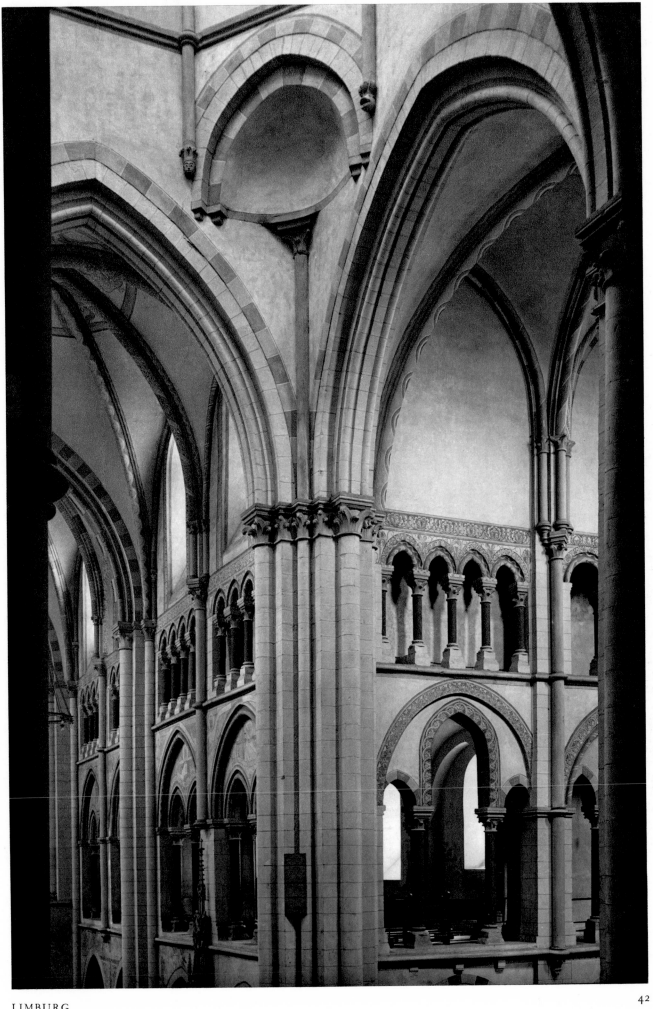

LIMBURG

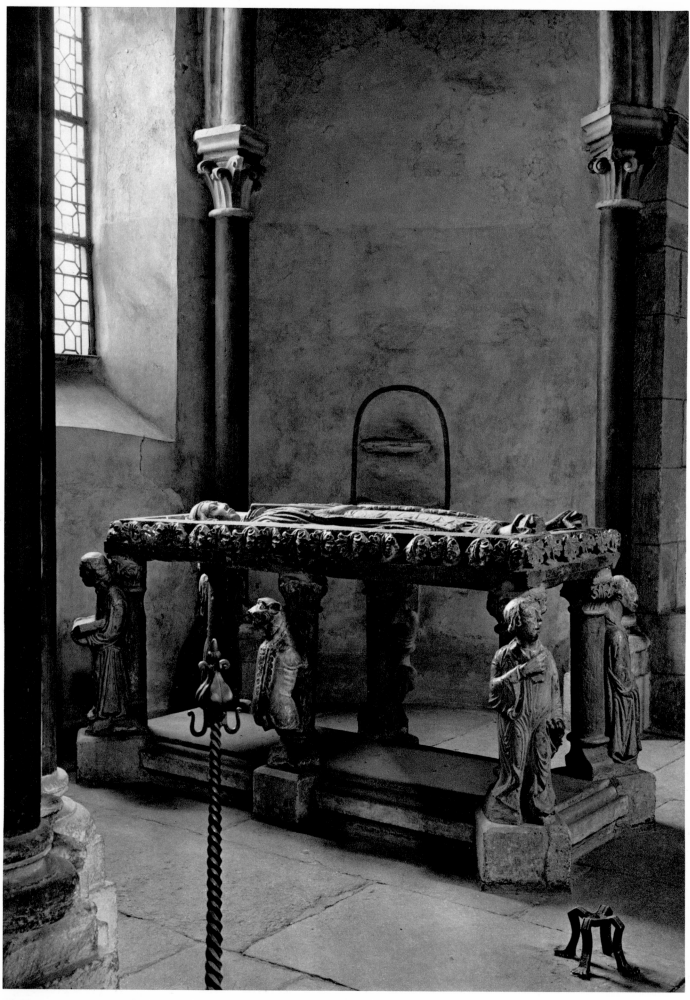

LIMBURG

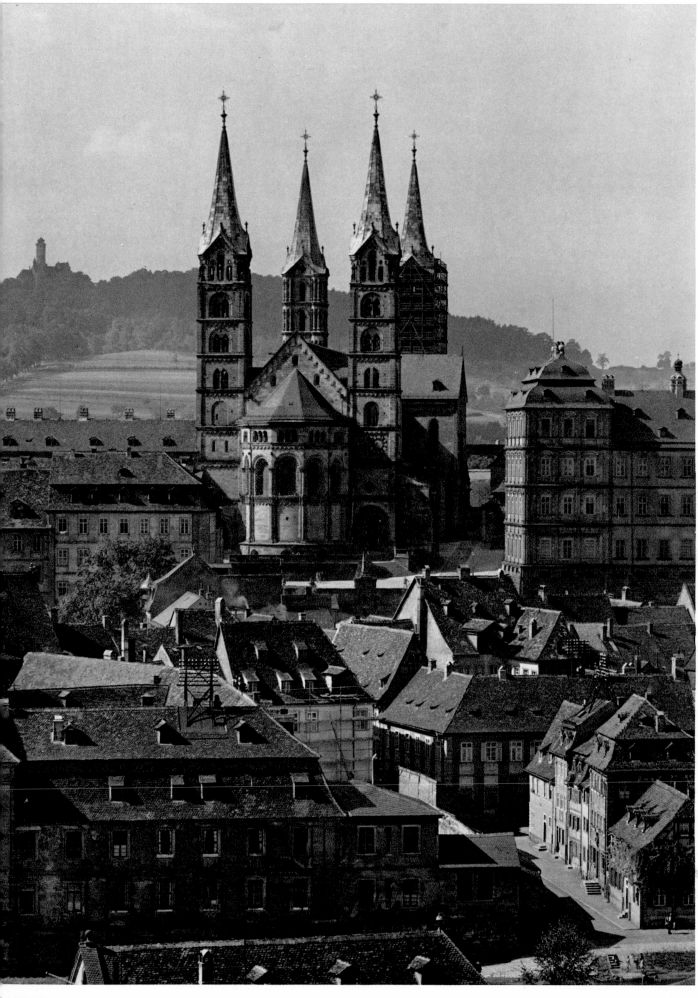

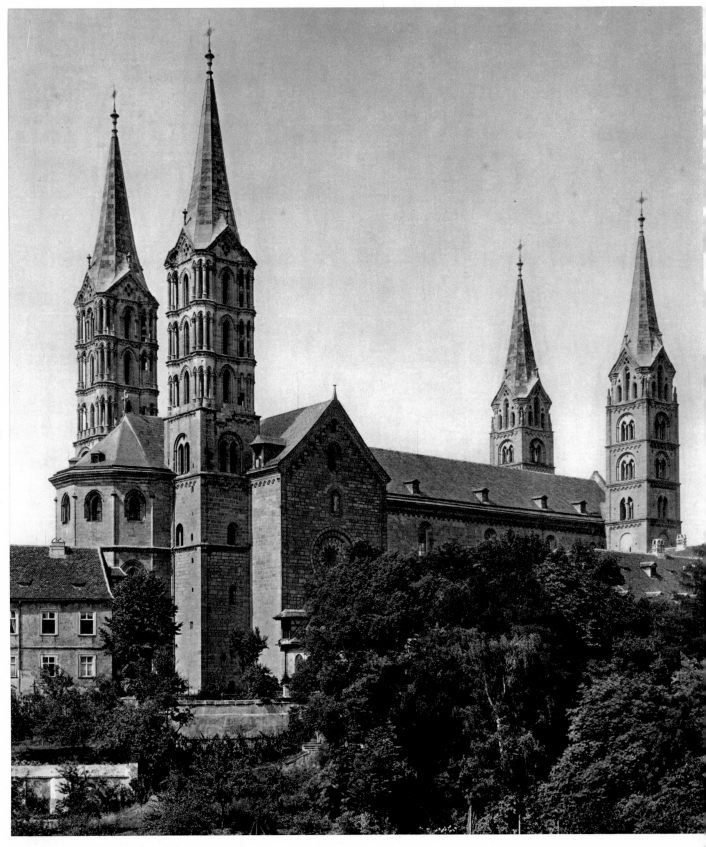

BAMBERG

4

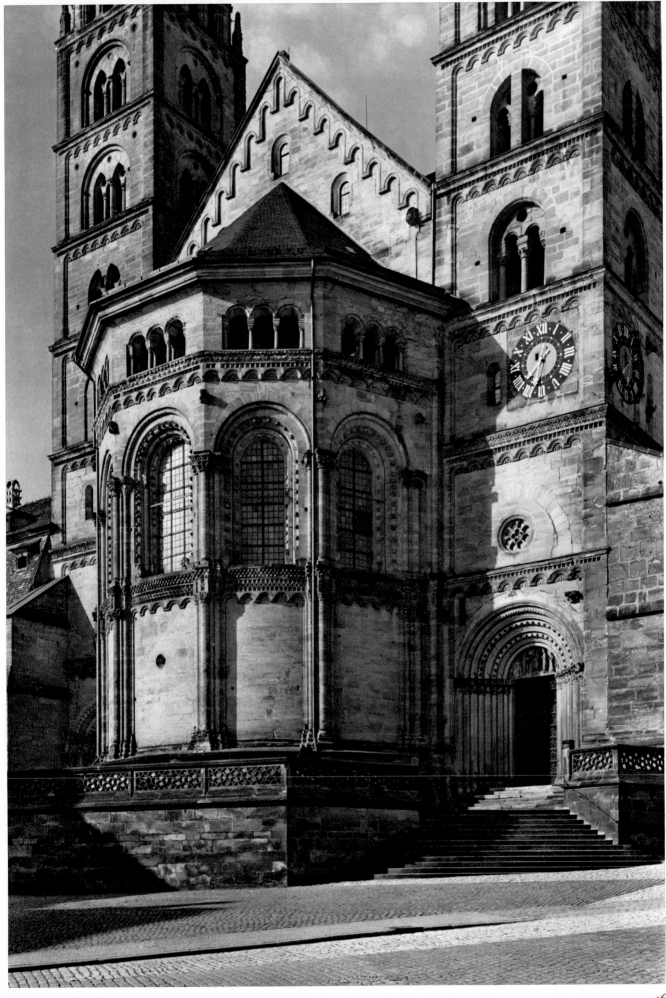

BAMBERG

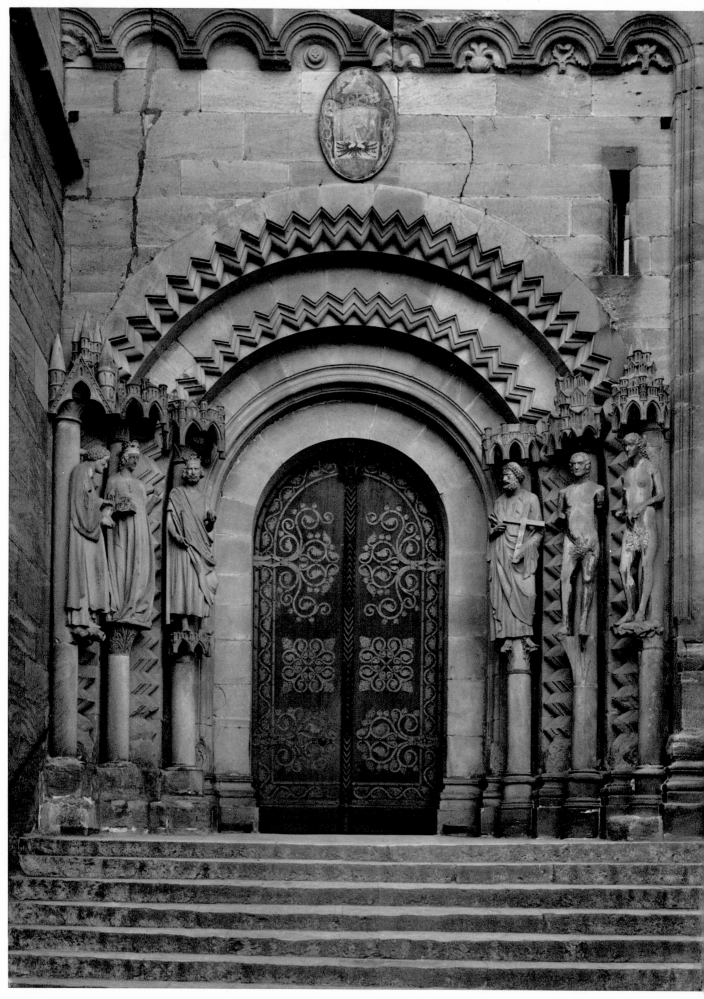

BAMBERG

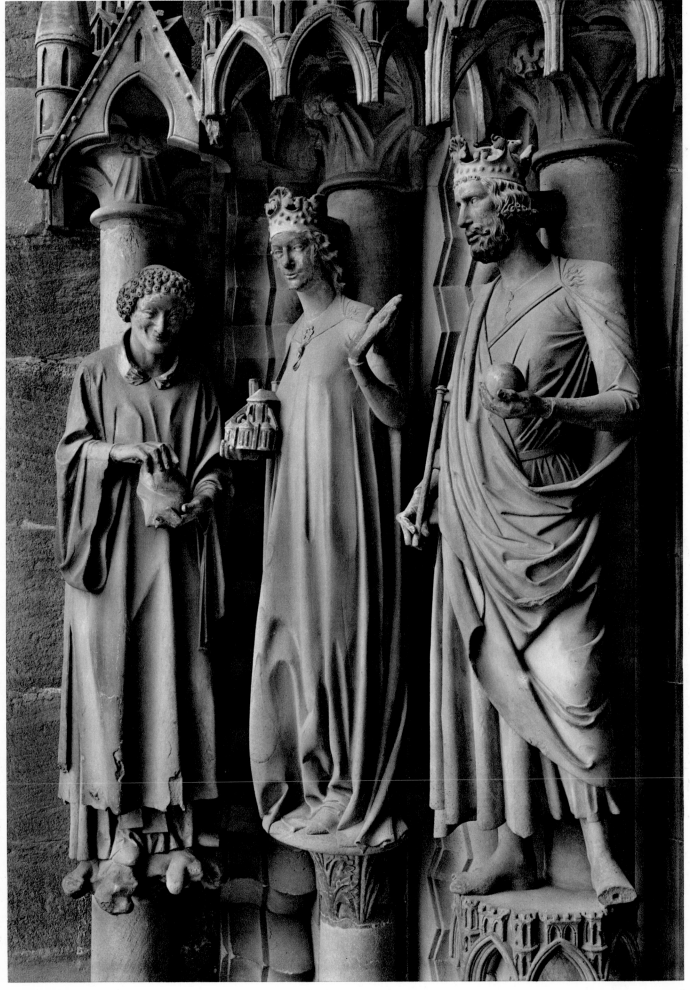

BAMBERG

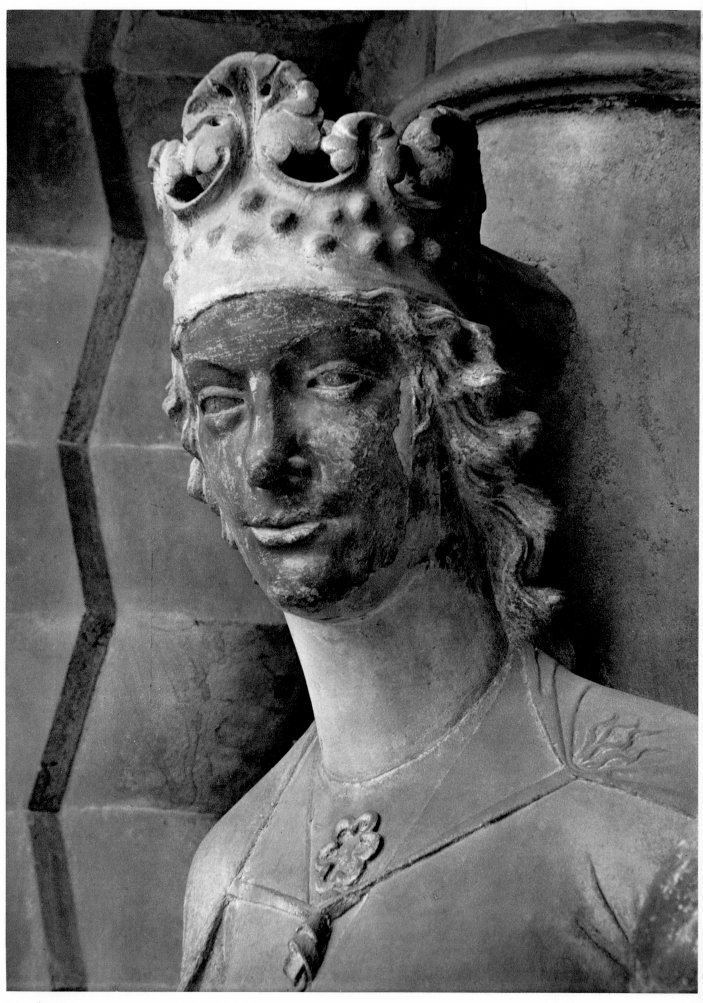

BAMBERG

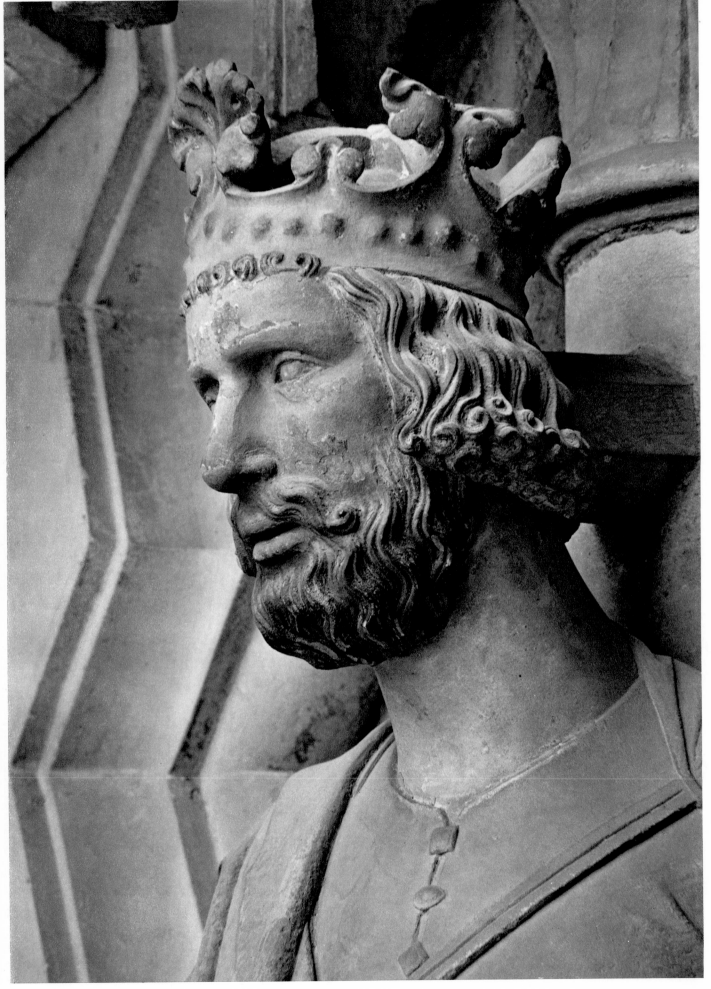

BAMBERG

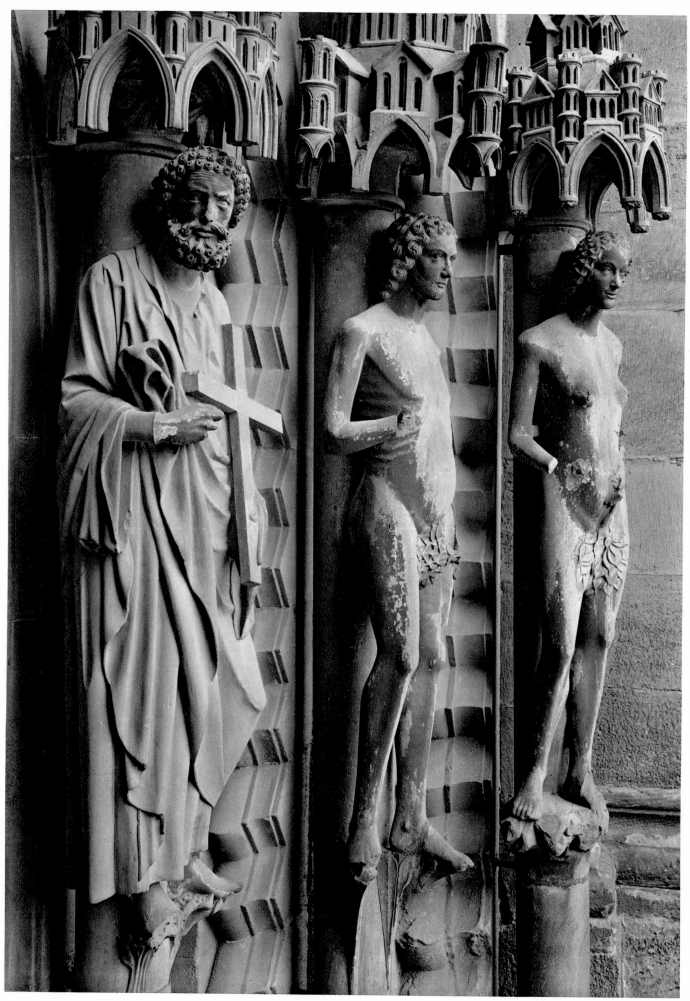

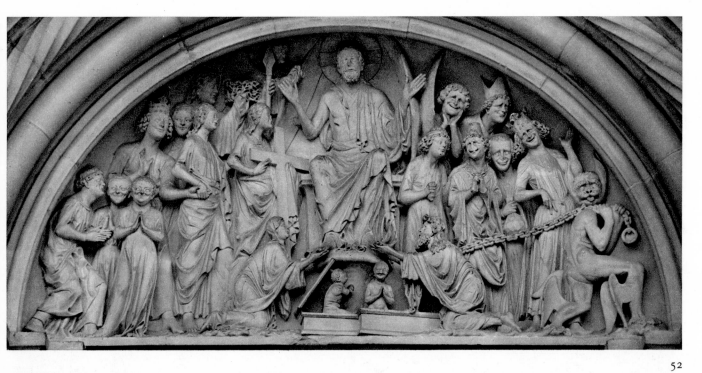

52

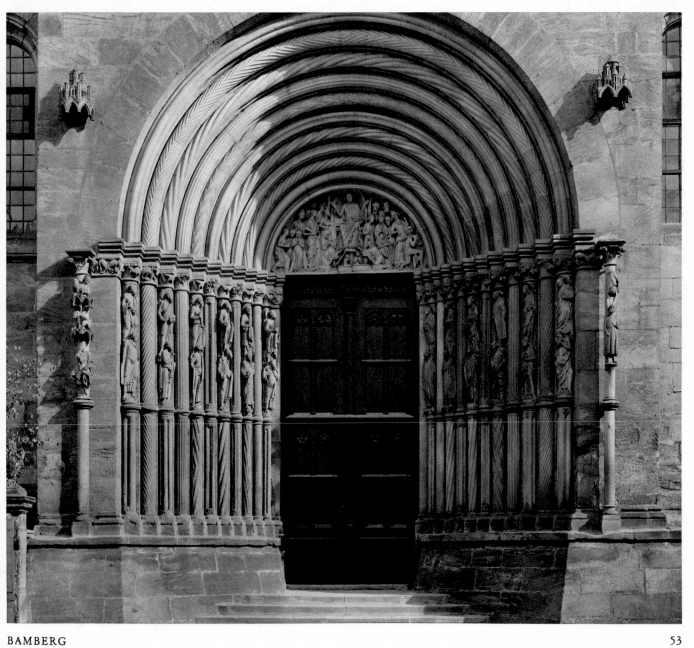

BAMBERG

53

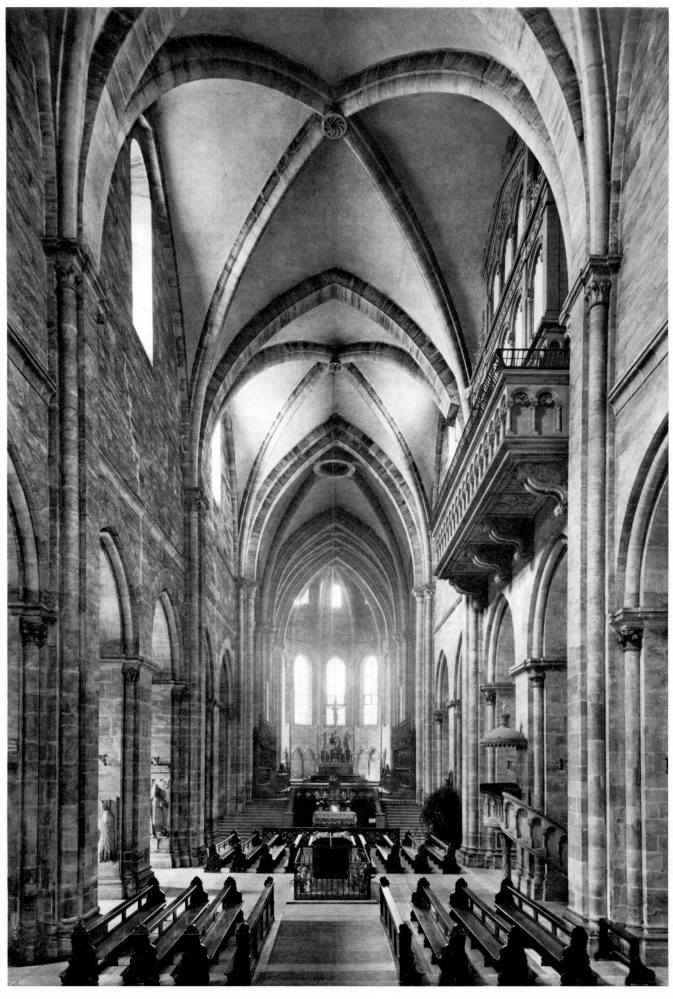

BAMBERG

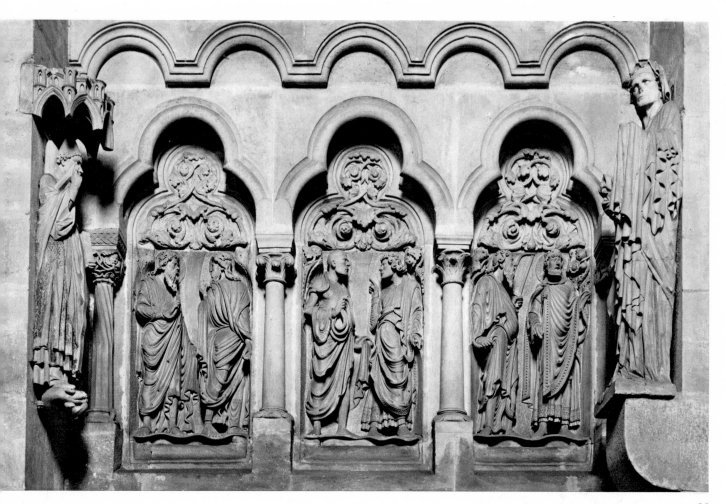

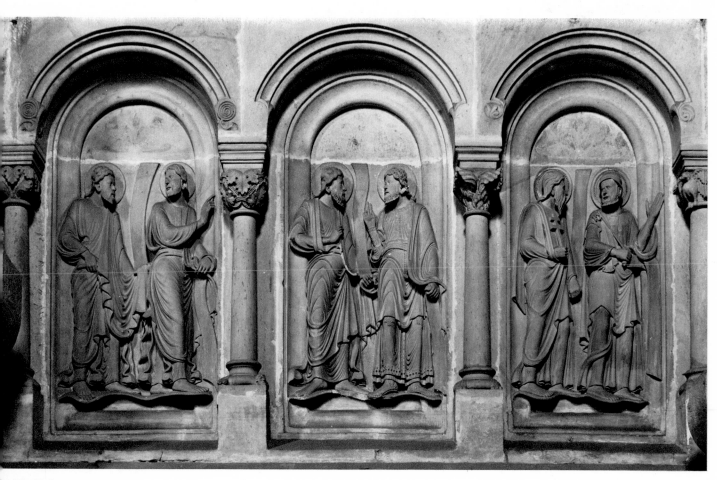

BAMBERG

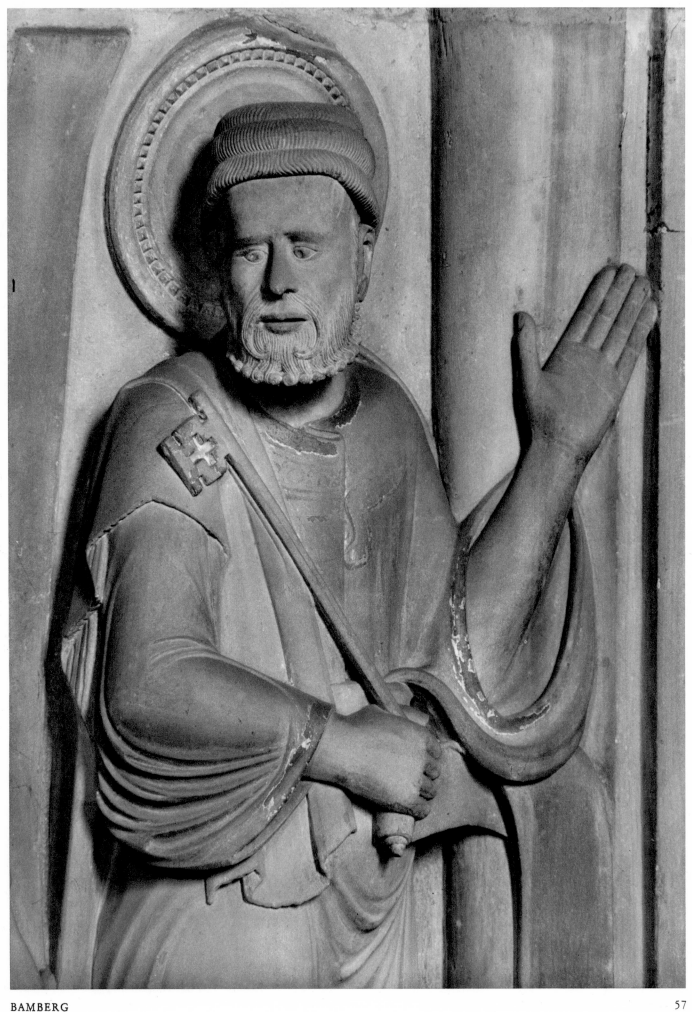

BAMBERG

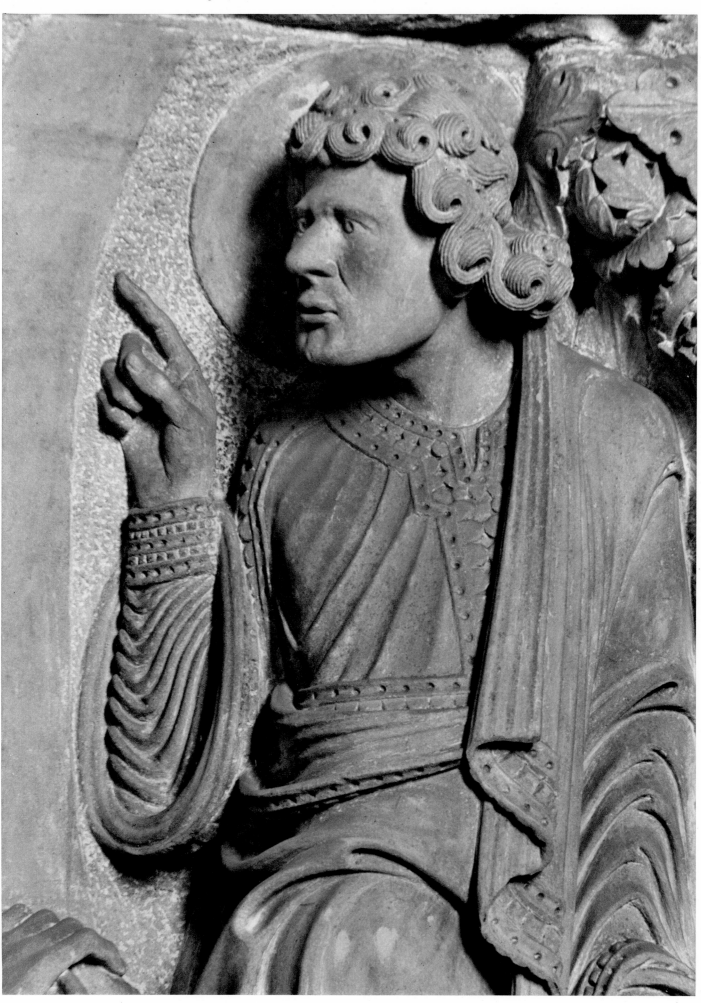

BAMBERG

BAMBERG

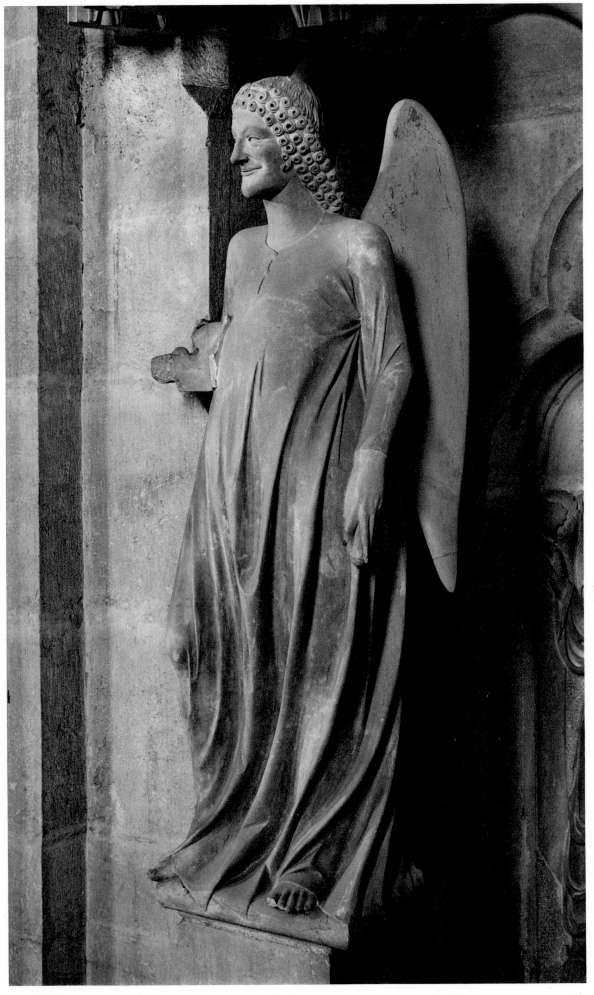

BAMBERG

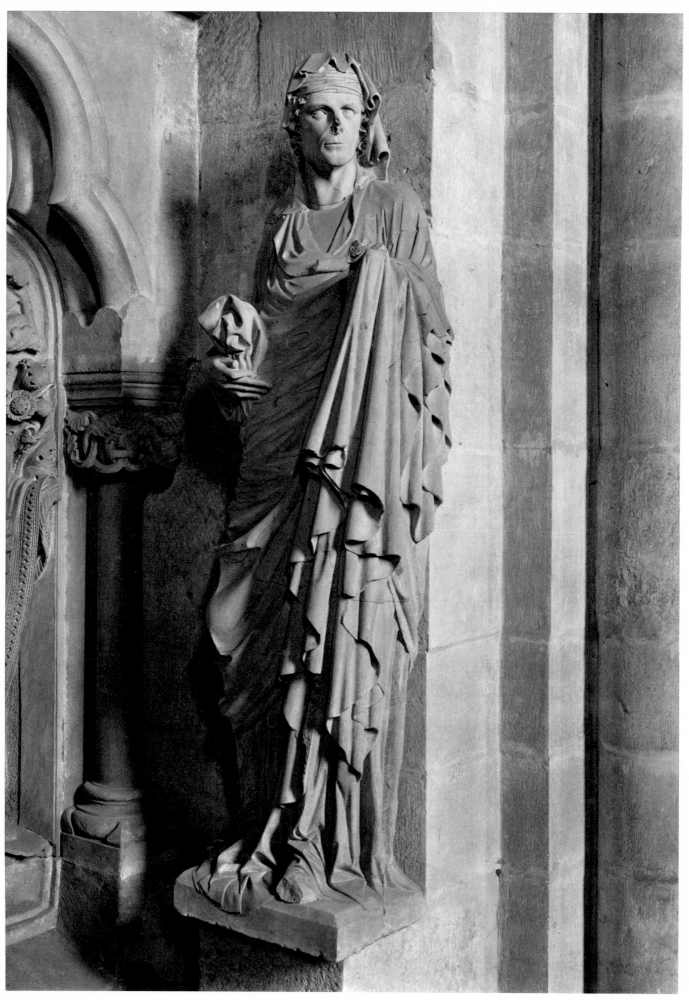

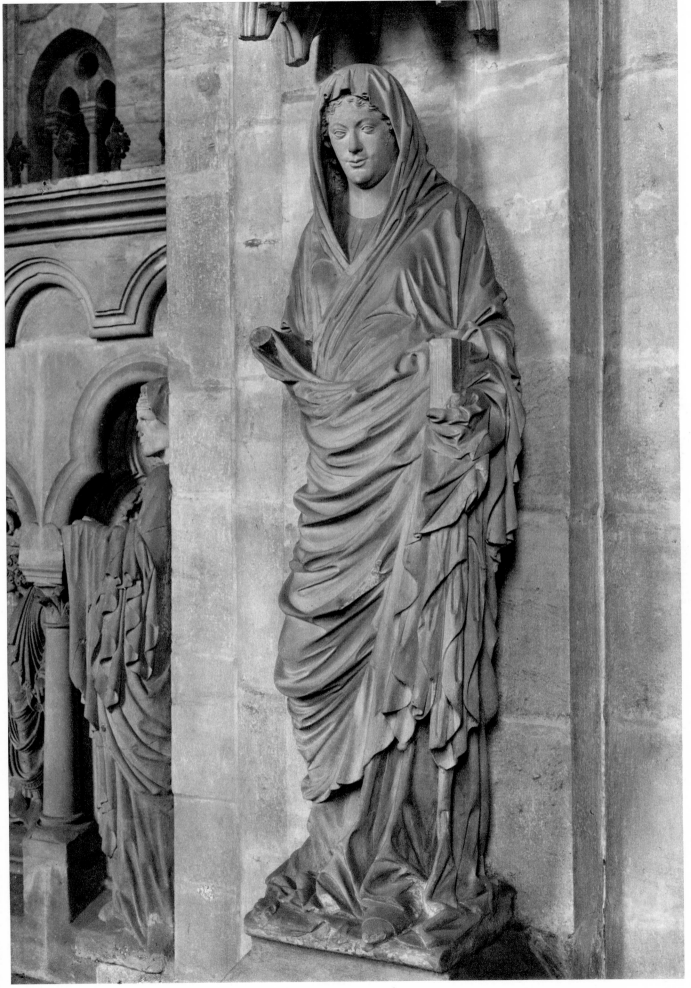

BAMBERG

65

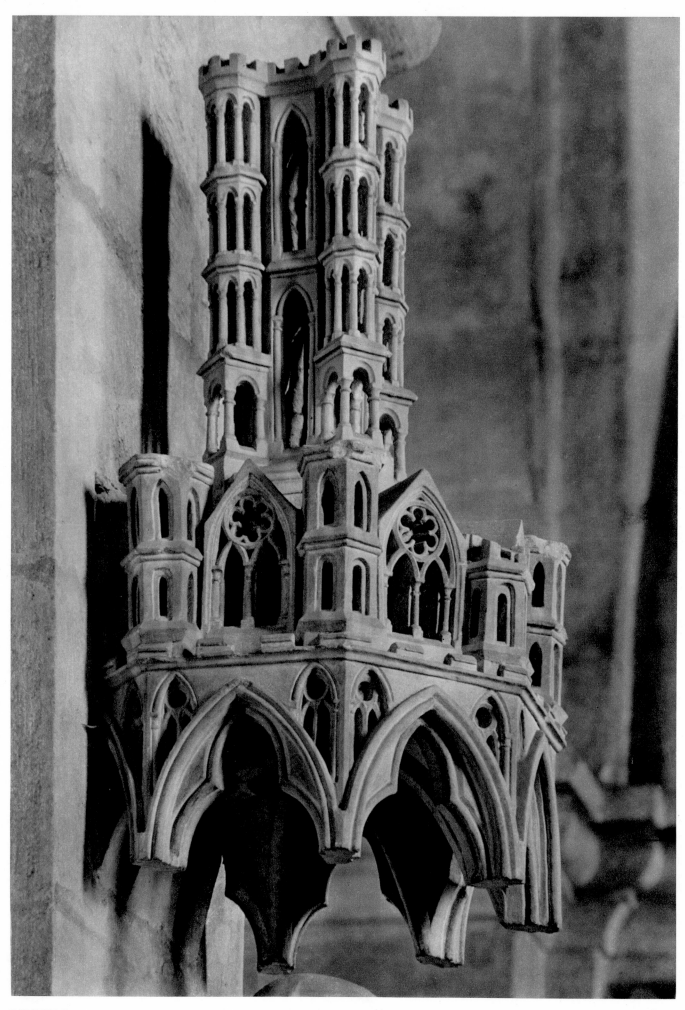

BAMBERG

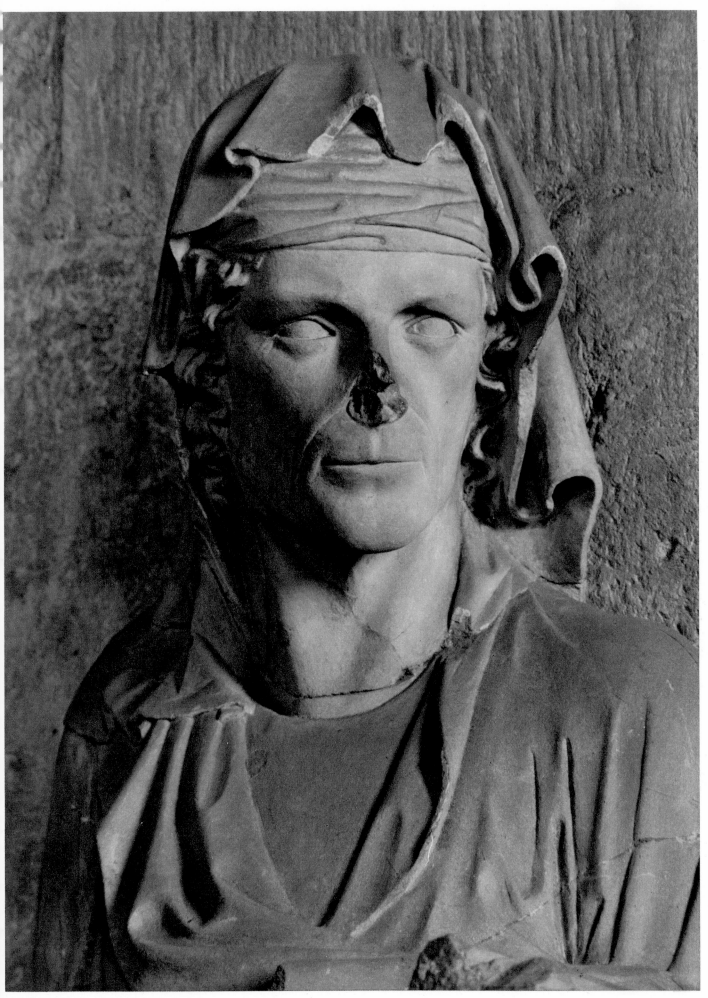

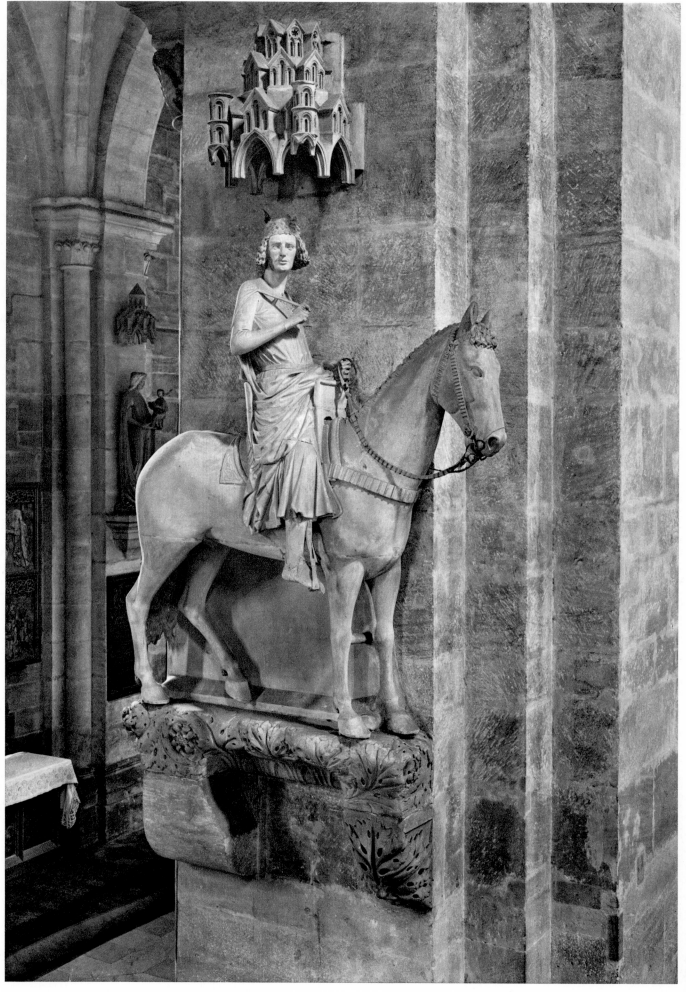

BAMBERG

SHB 1

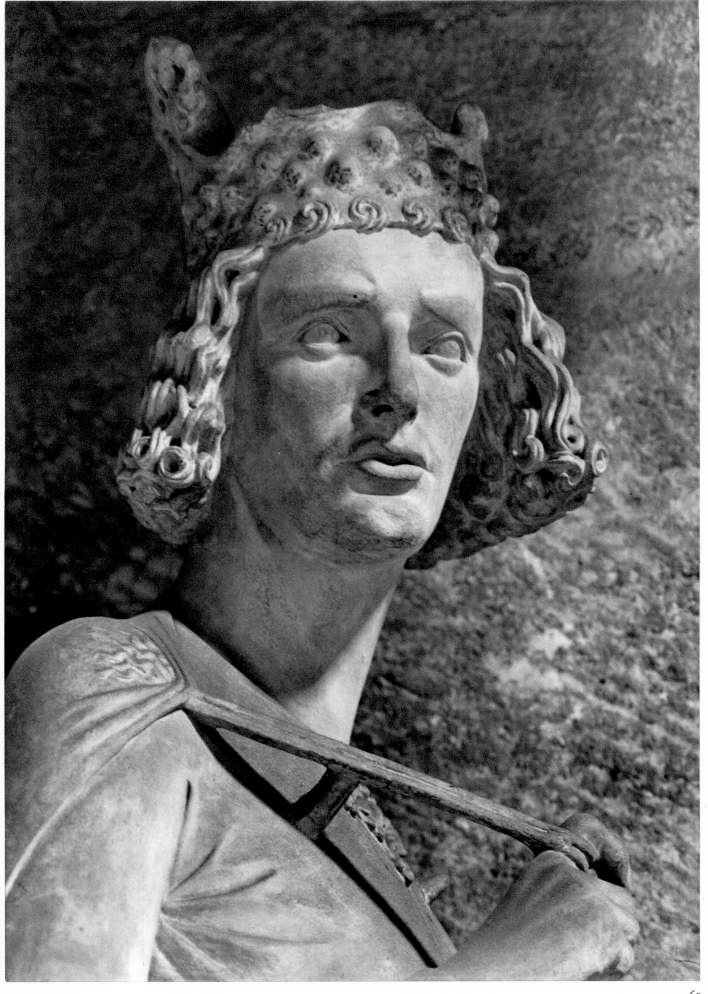

BAMBERG

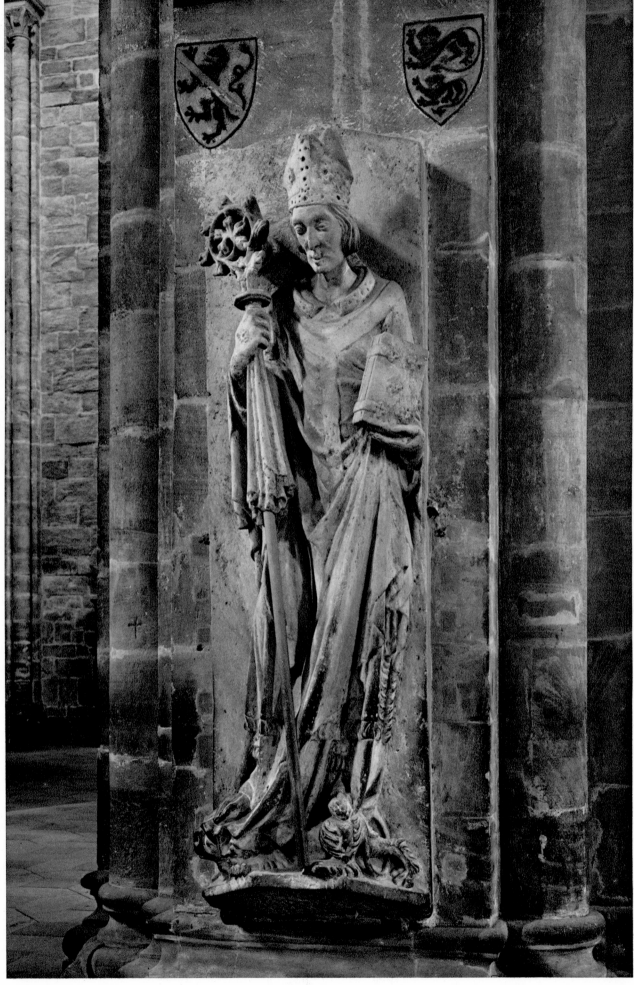

BAMBERG

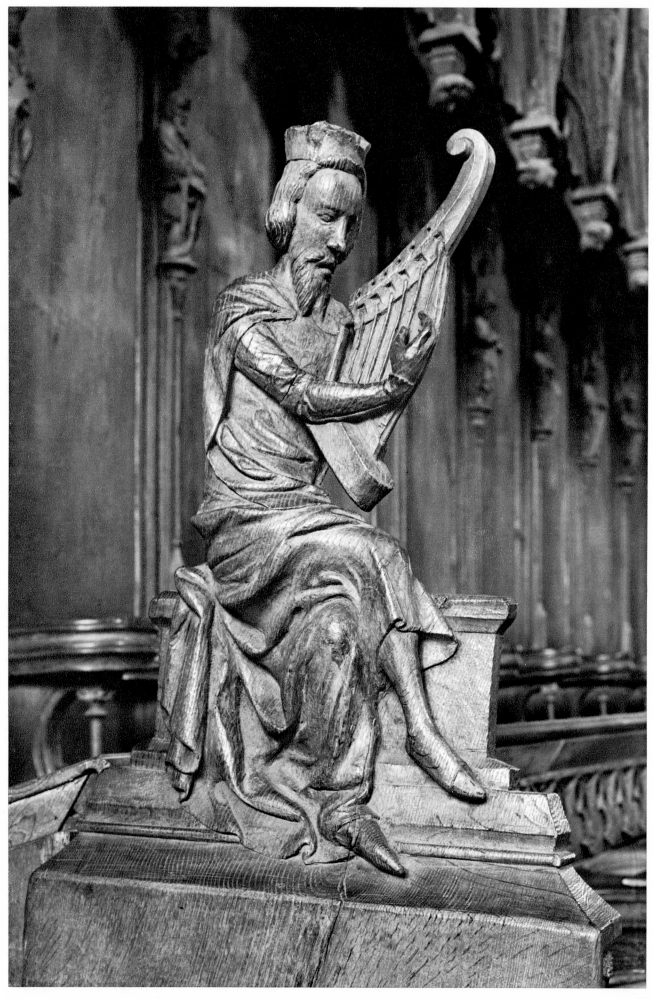

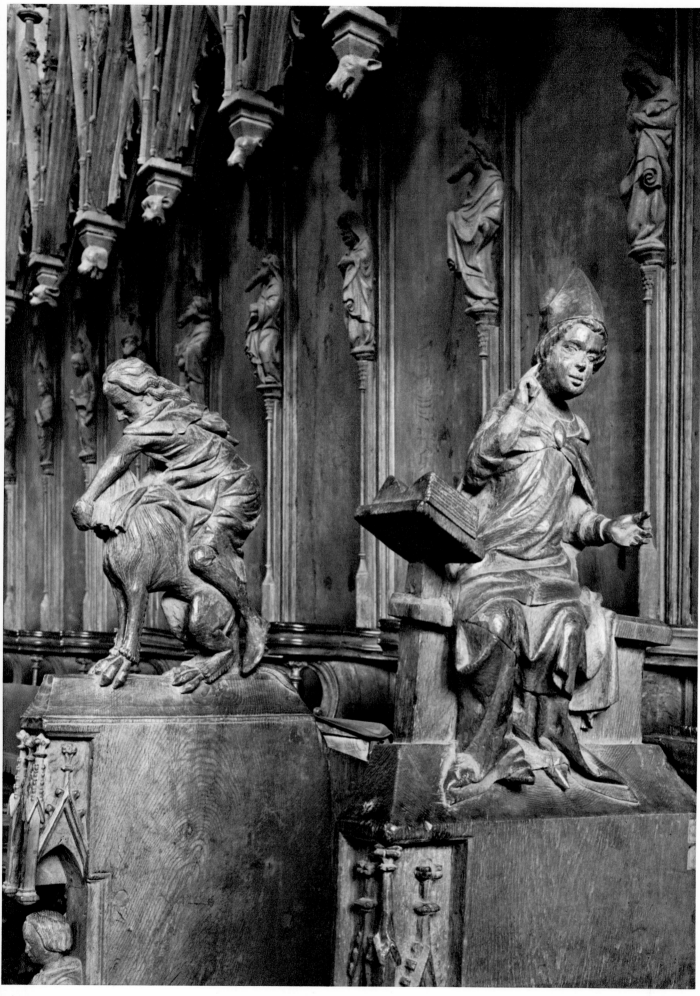

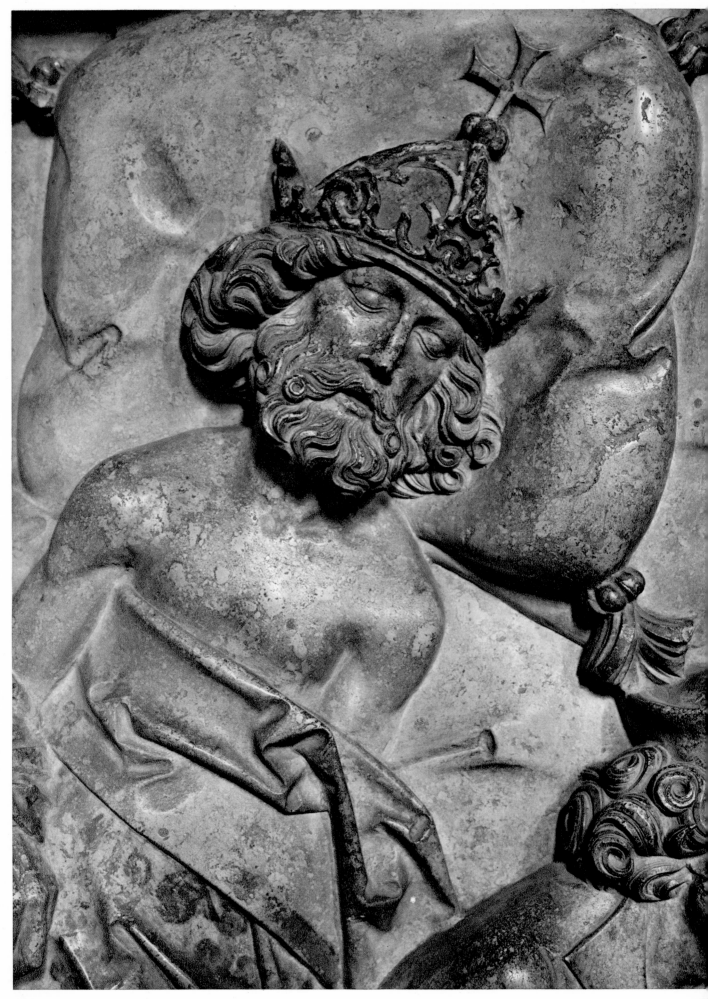

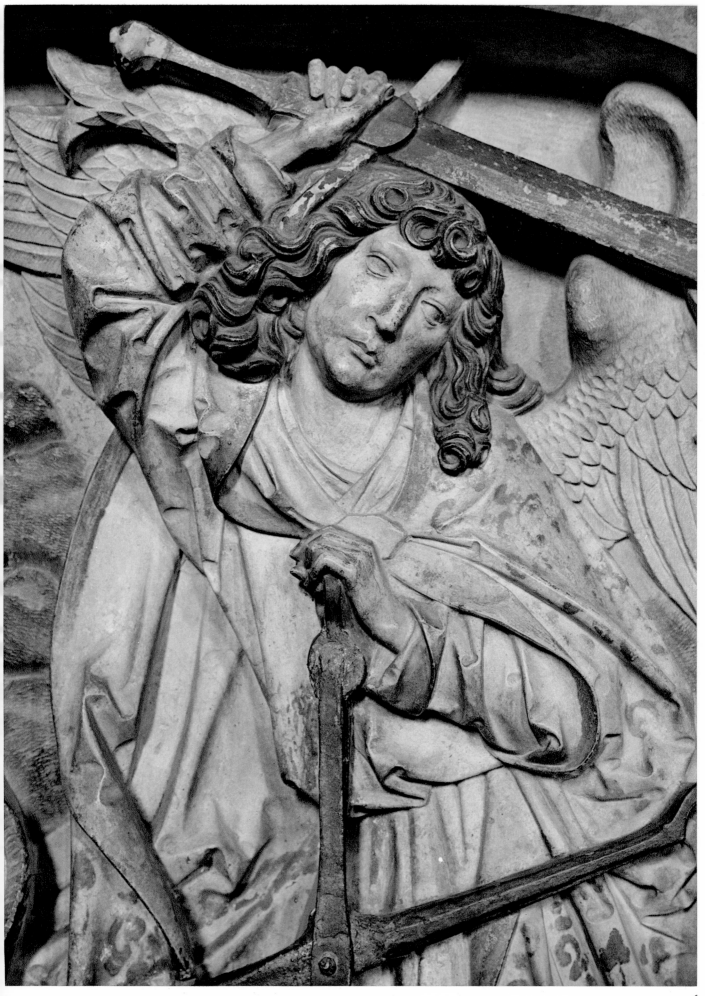

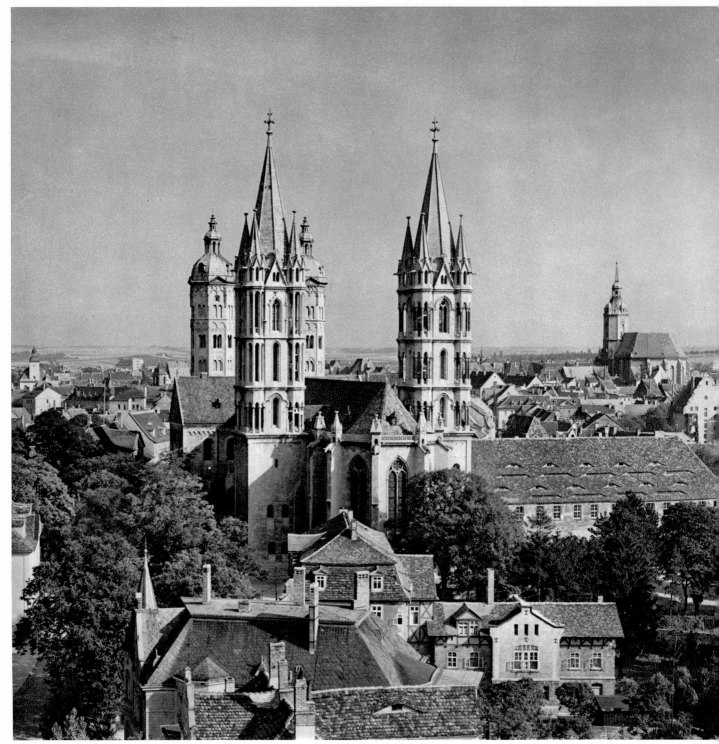

NAUMBURG

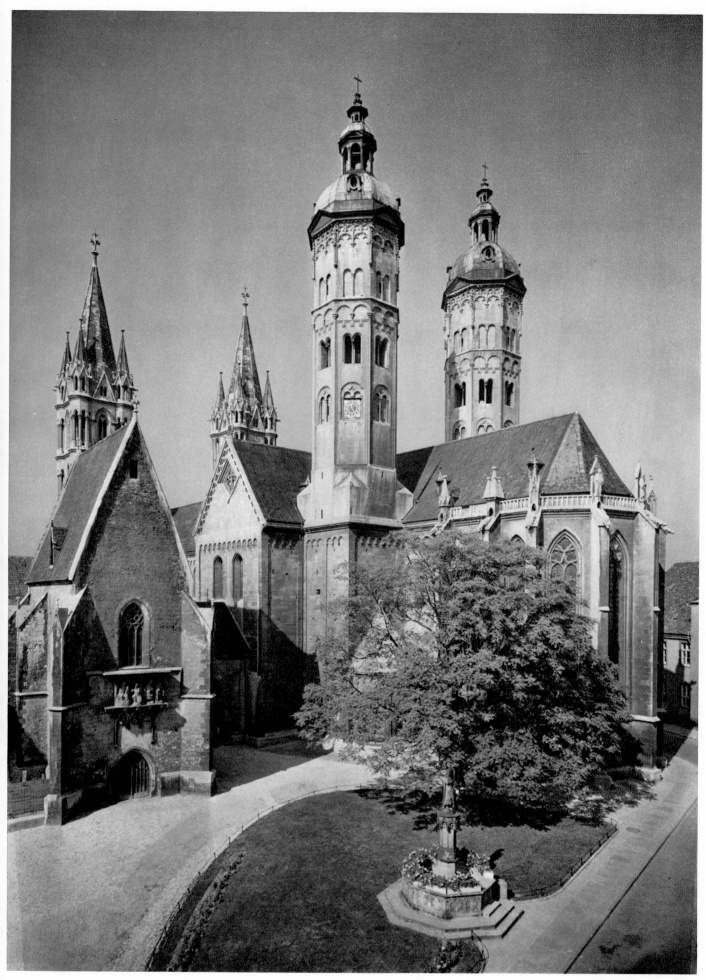

NAUMBURG

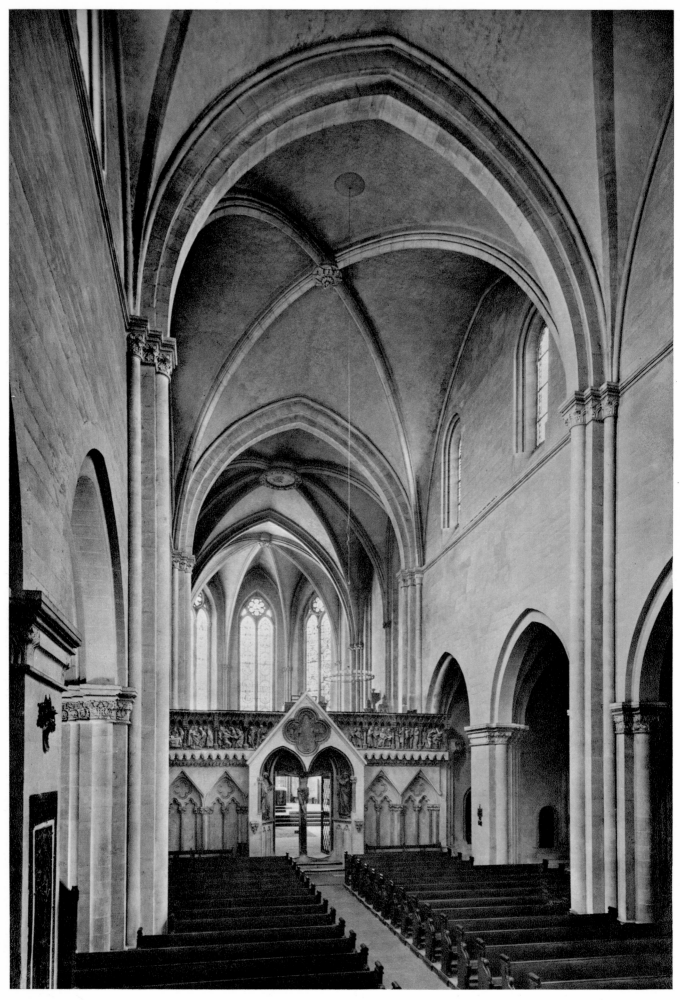

NAUMBURG

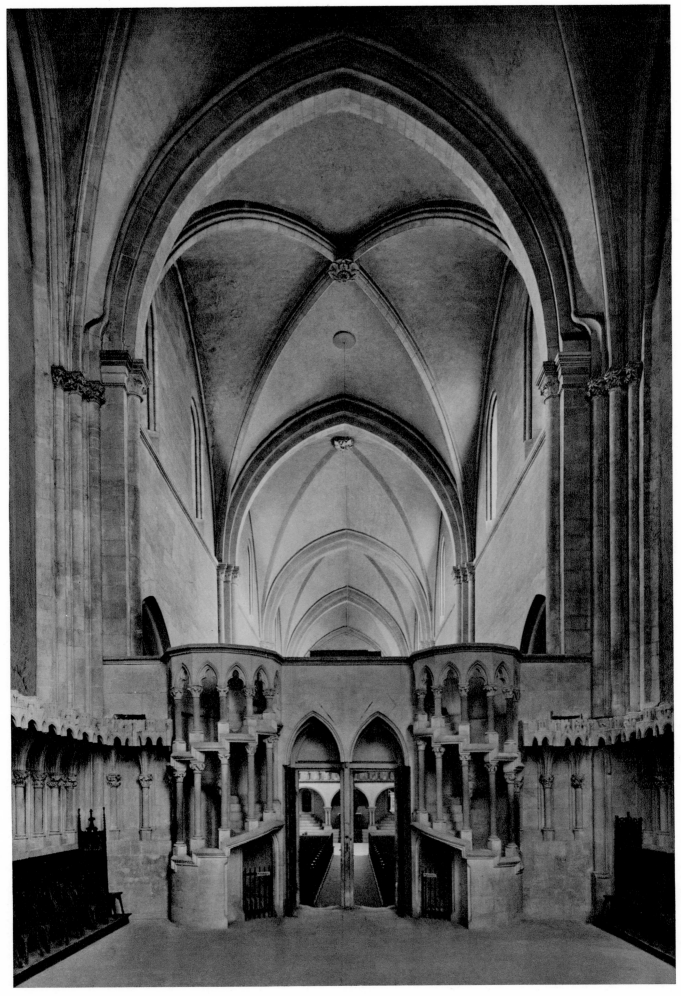

NAUMBURG

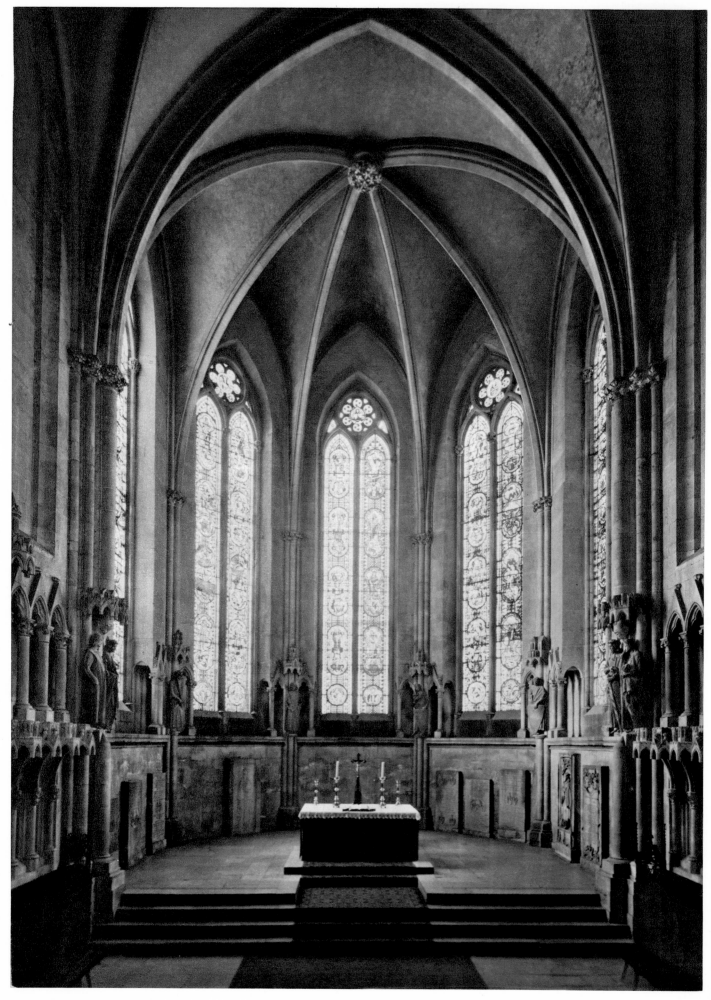

NAUMBURG

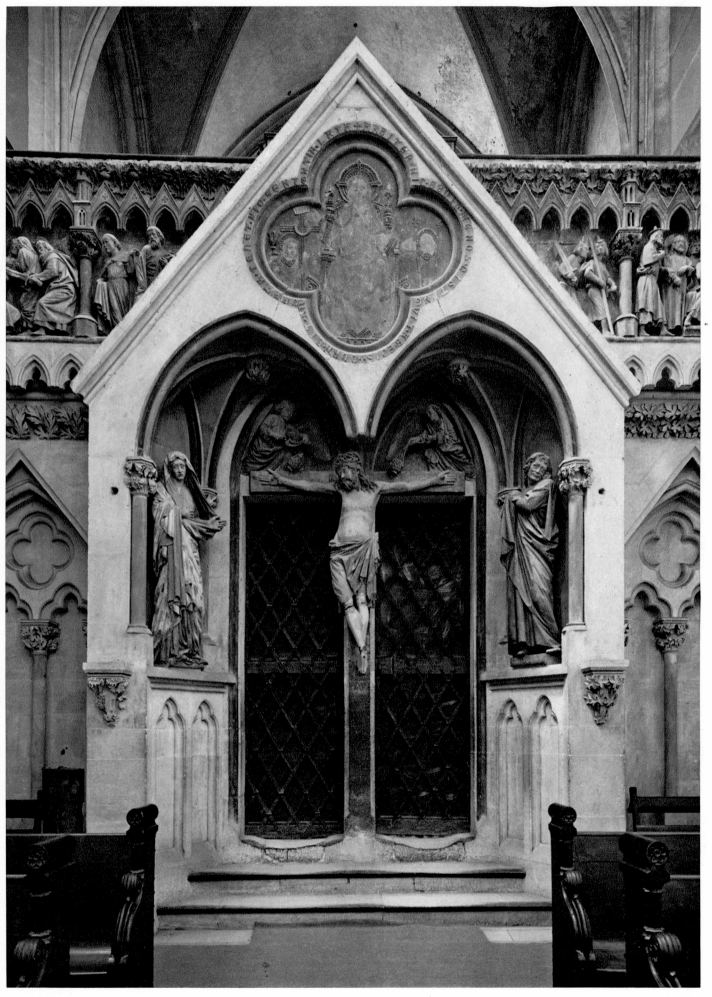

NAUMBURG

NAUMBURG

NAUMBURG

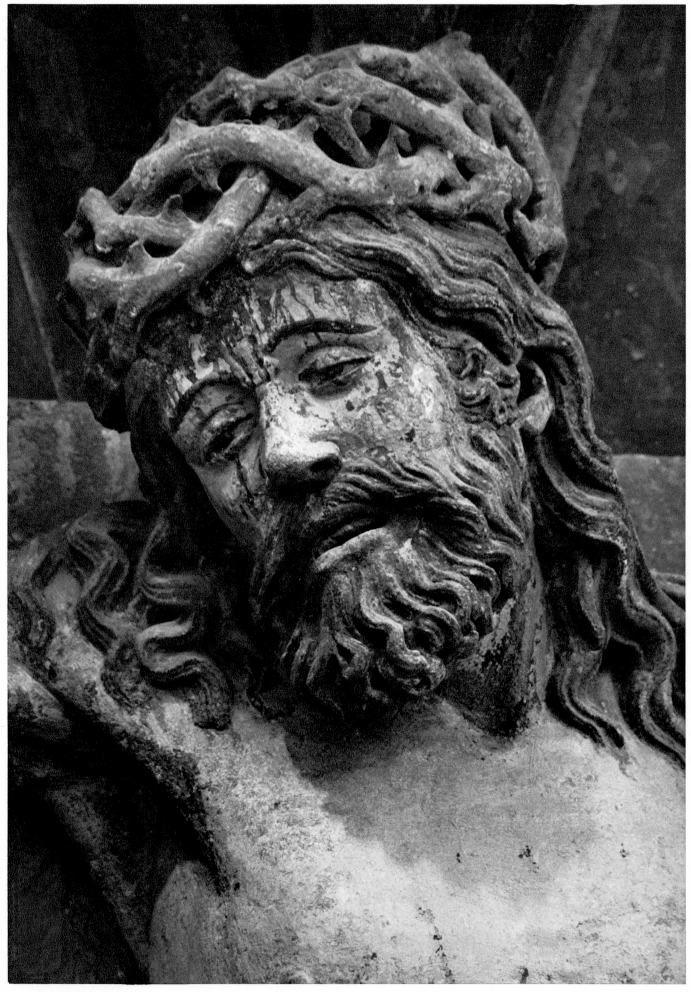

NAUMBURG

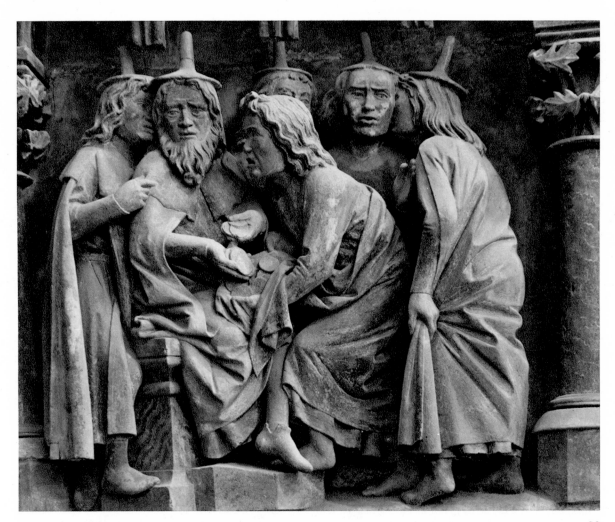

88

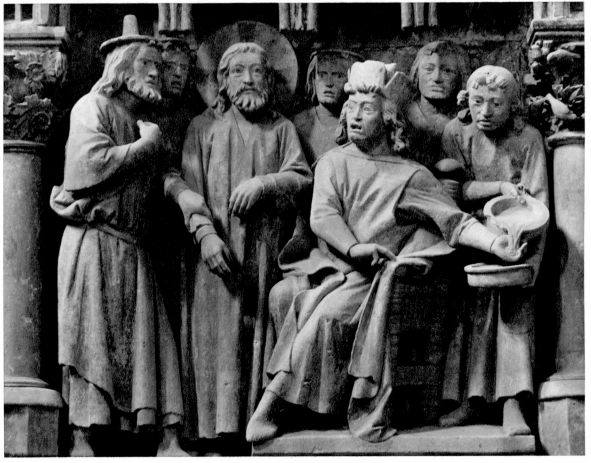

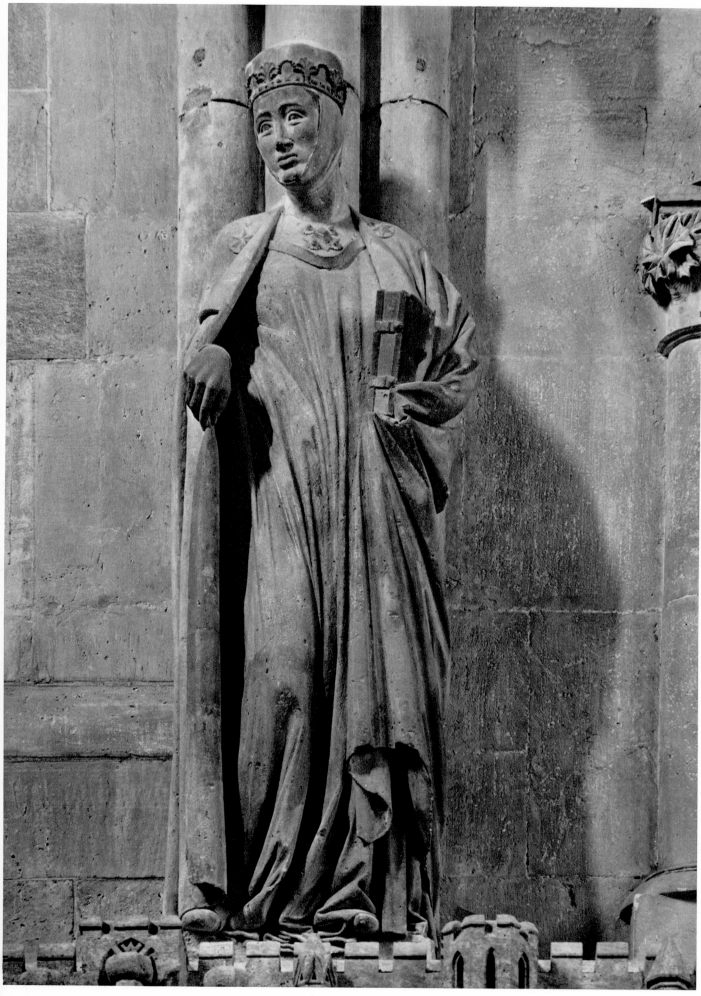

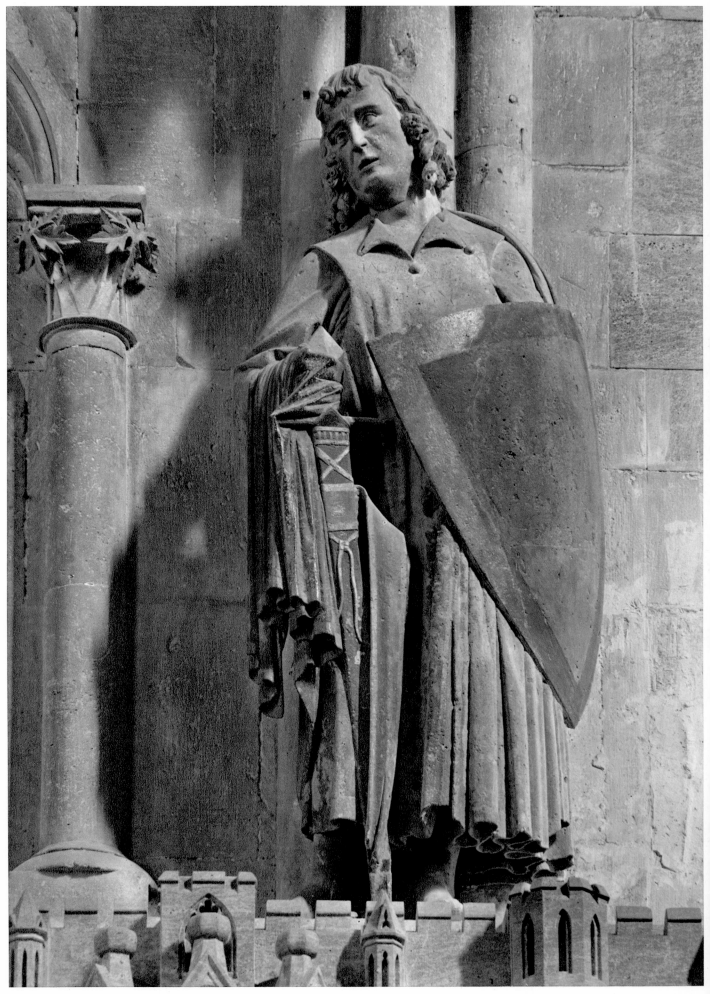

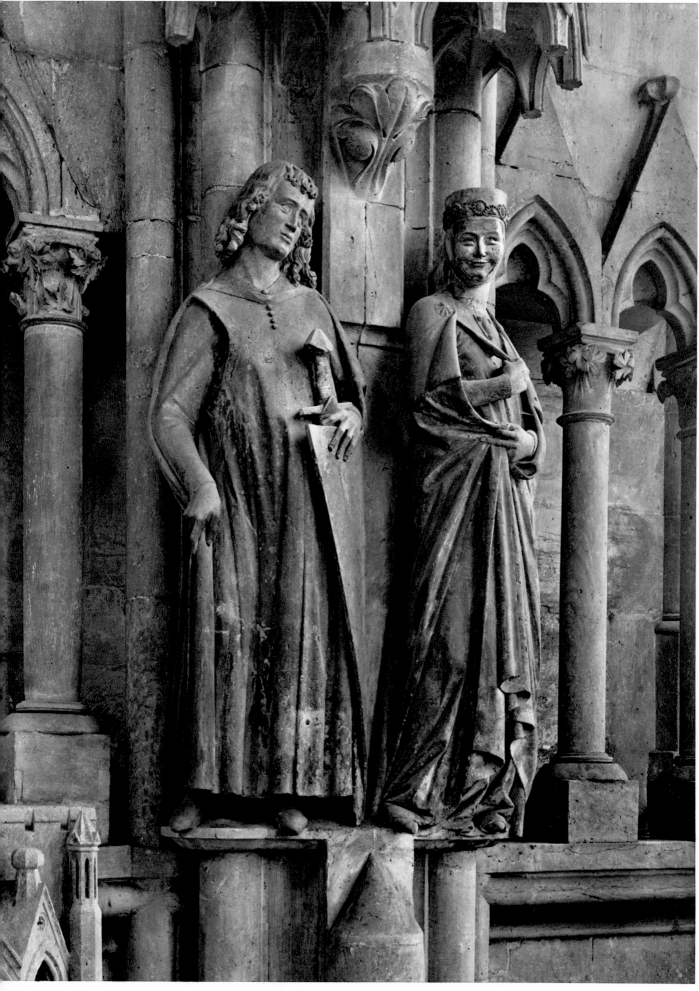

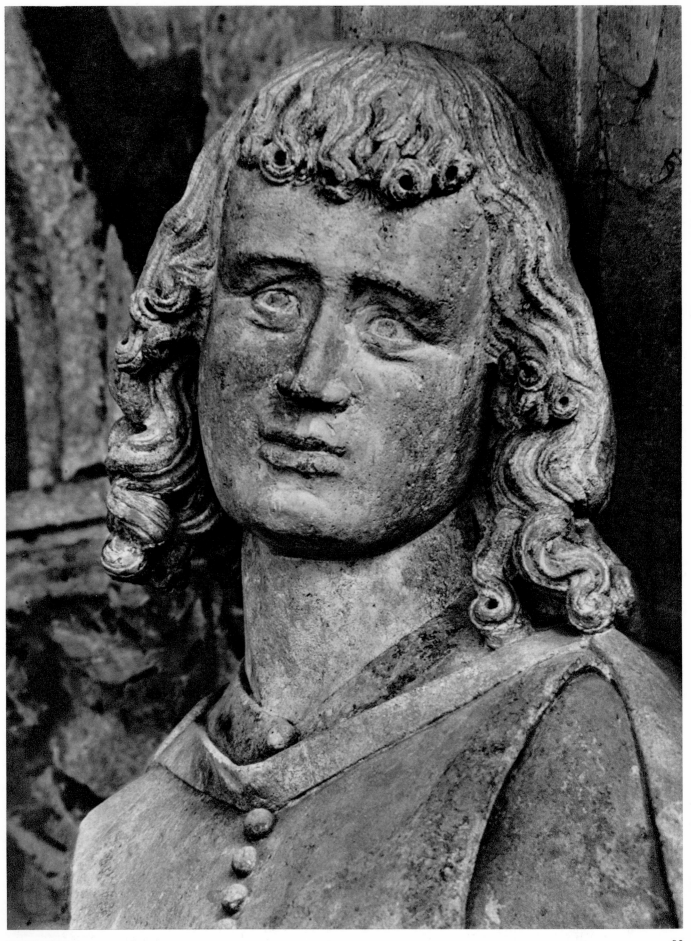

NAUMBURG

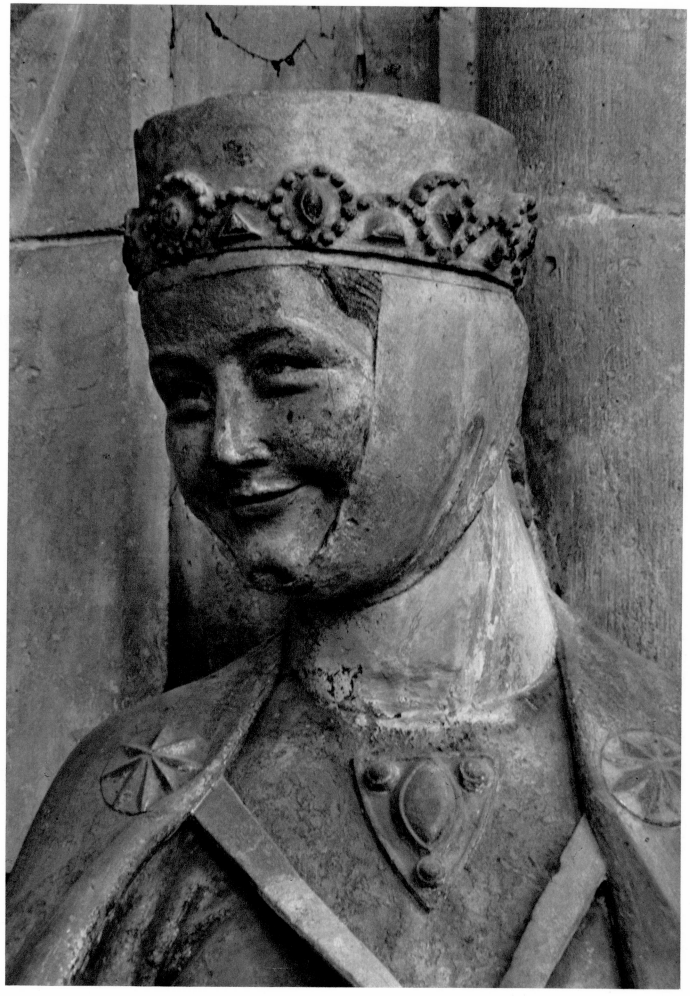

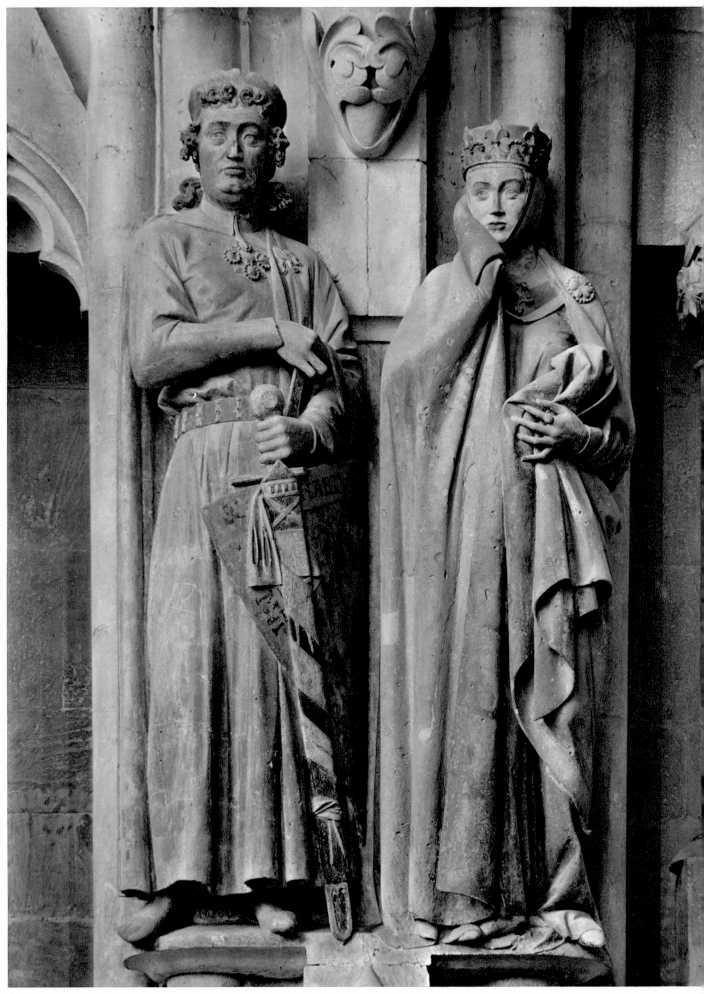

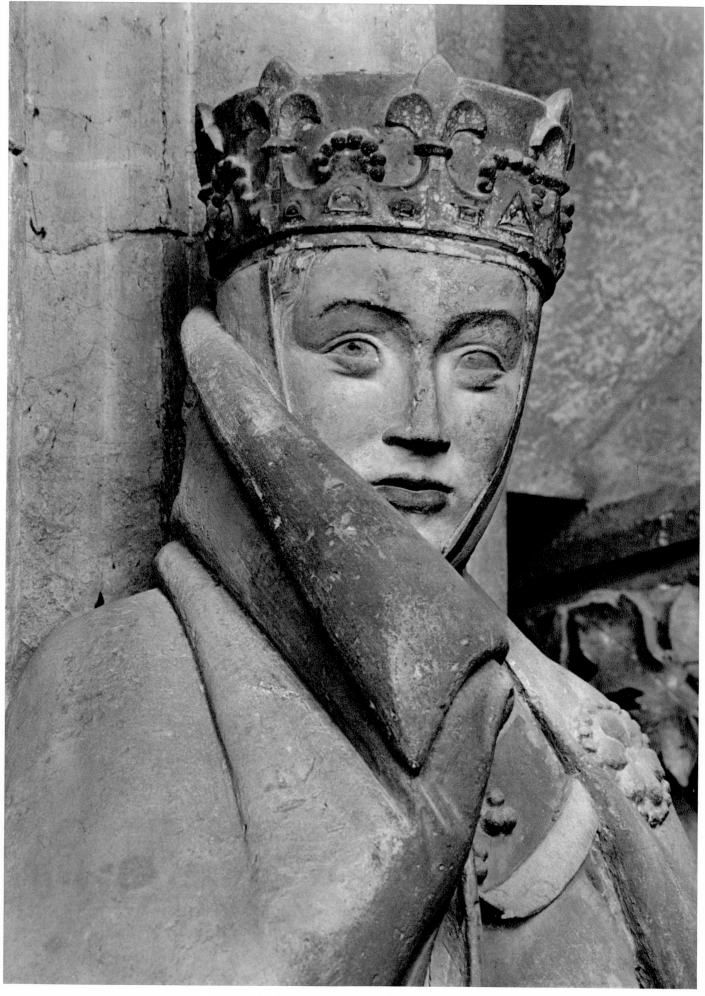

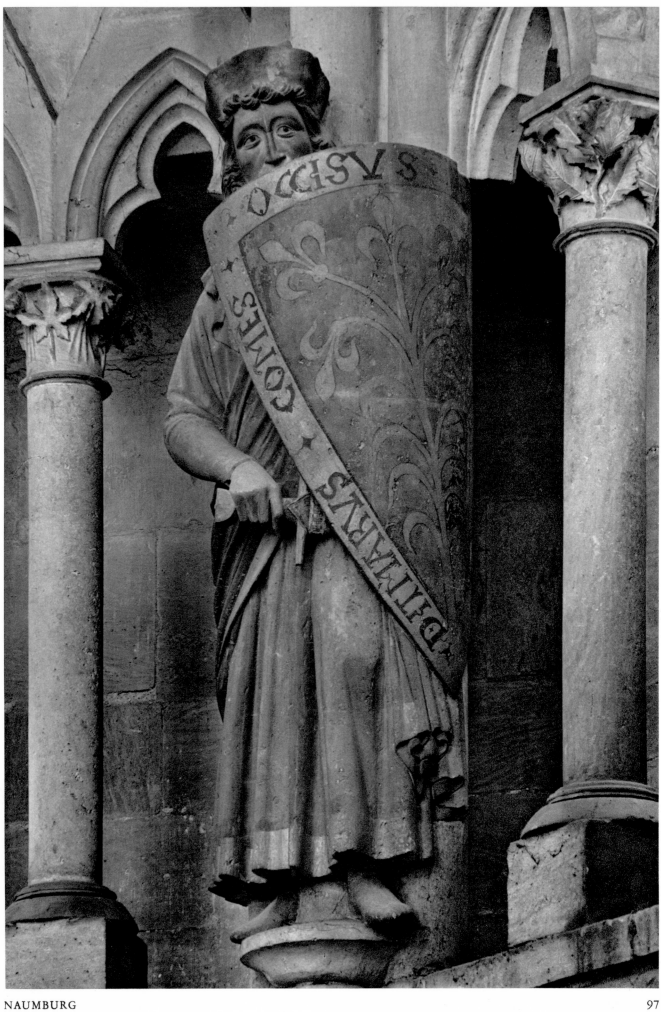

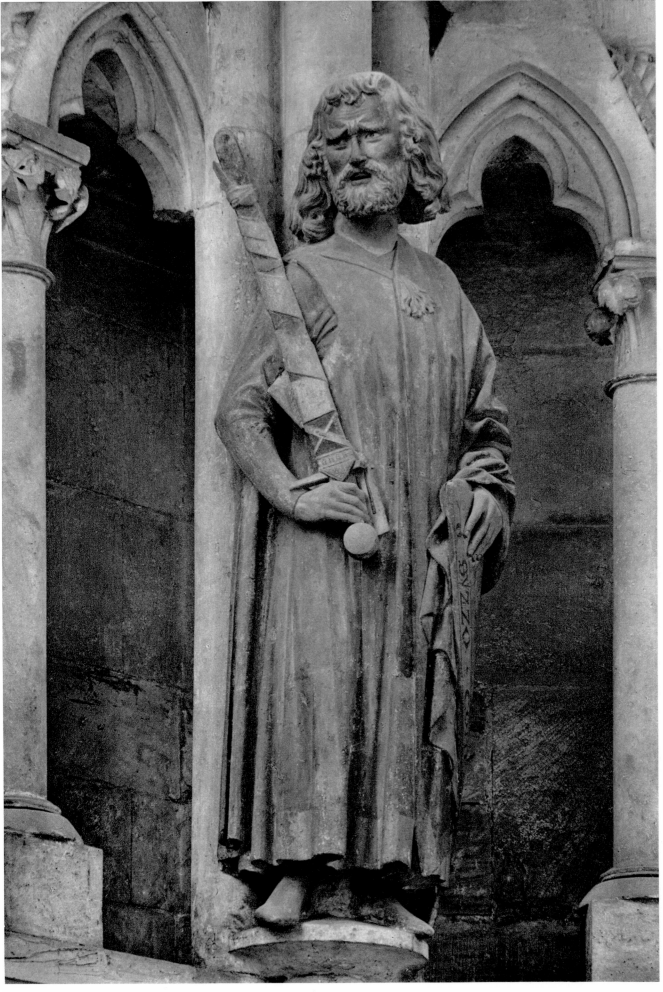

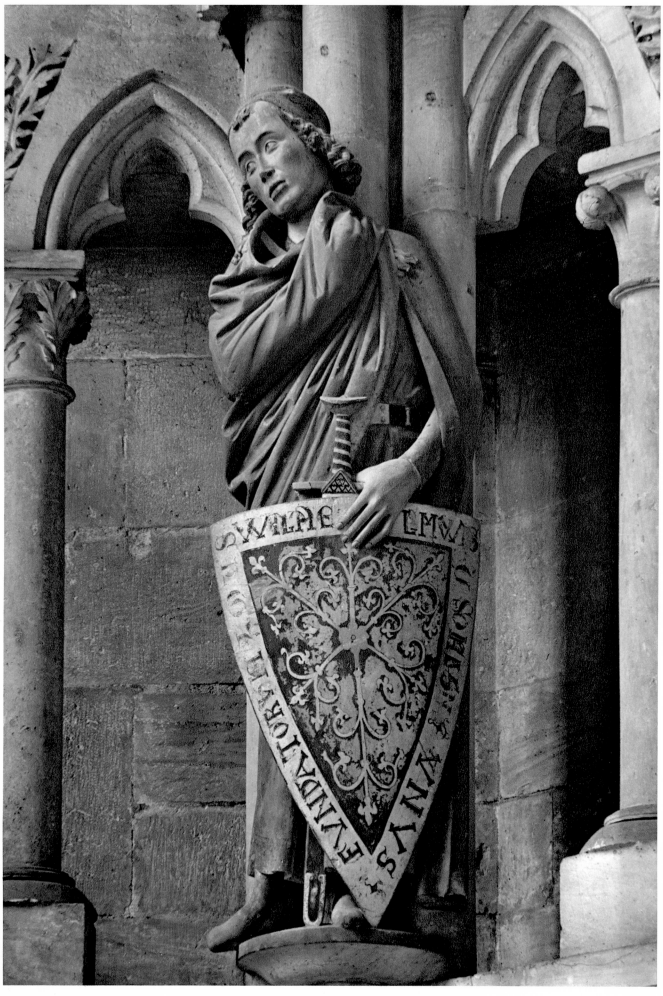

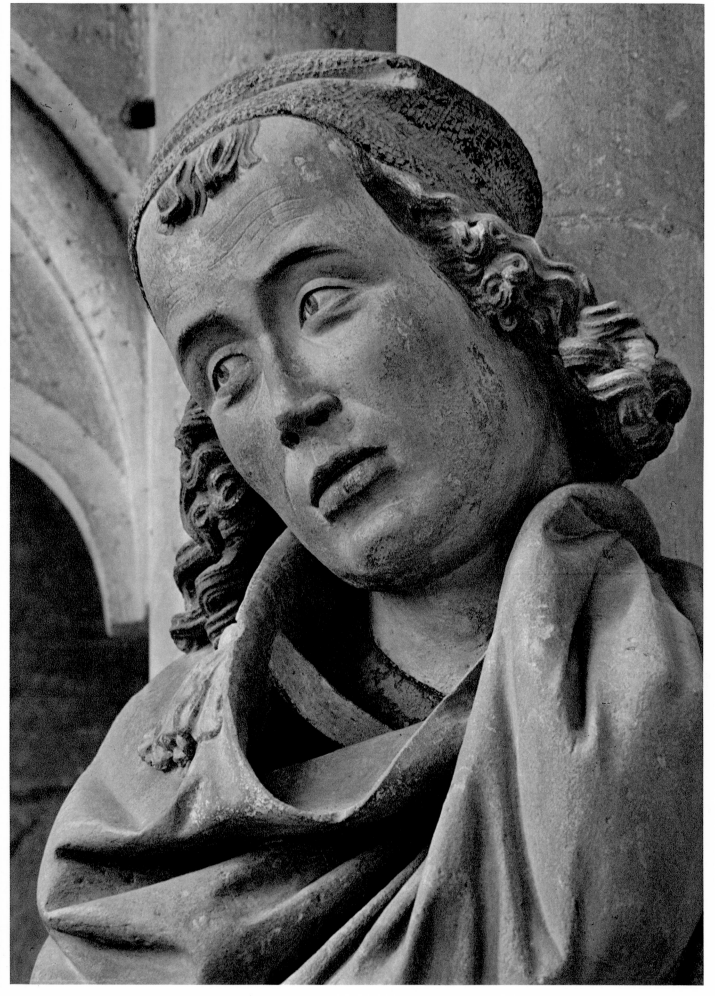

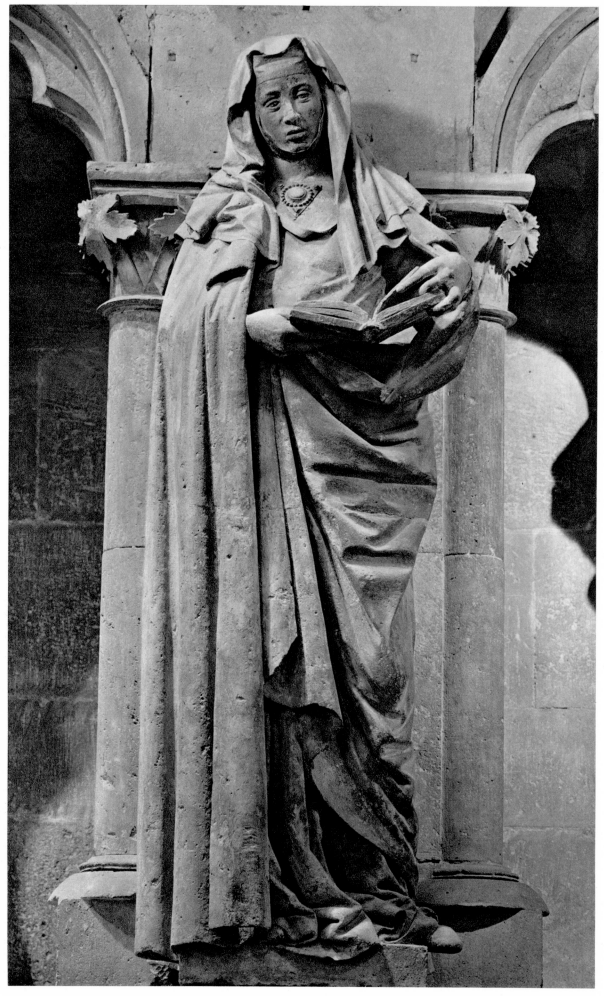

NAUMBURG

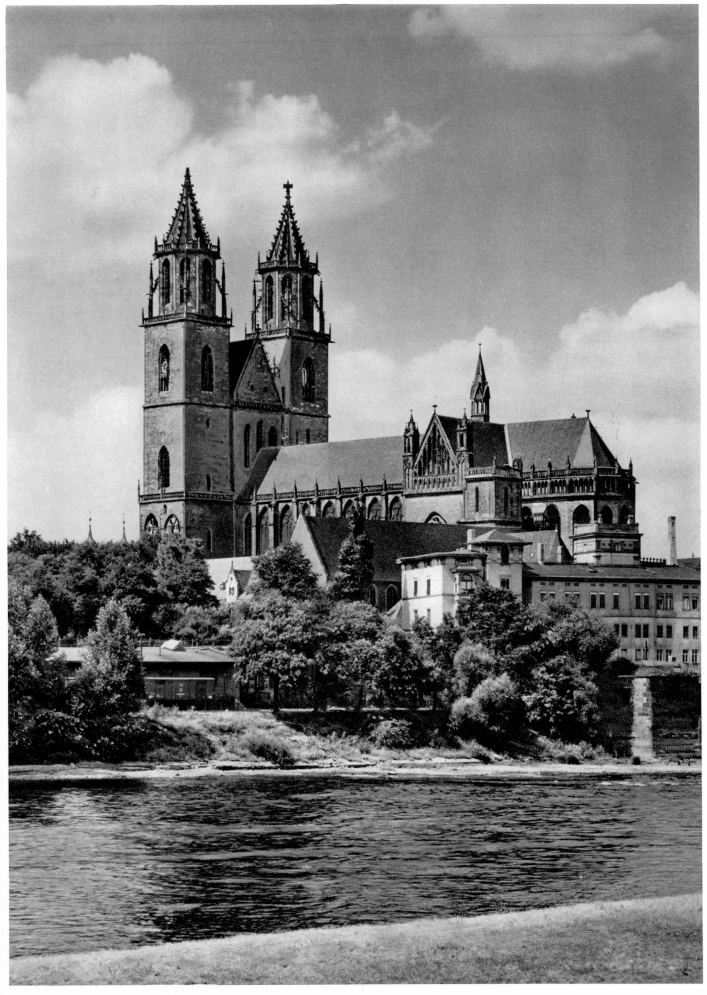

MAGDEBURG

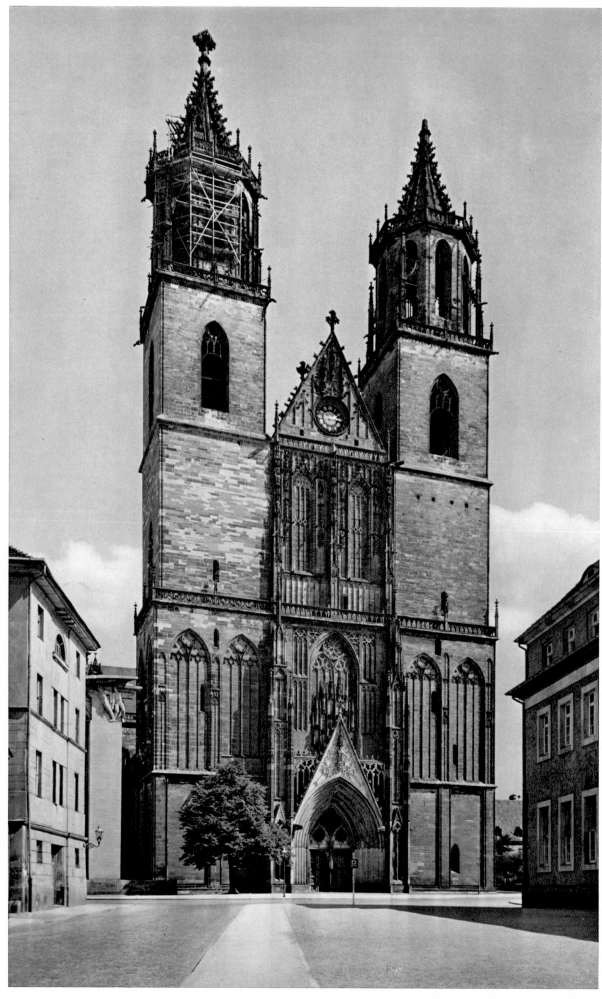

MAGDEBURG

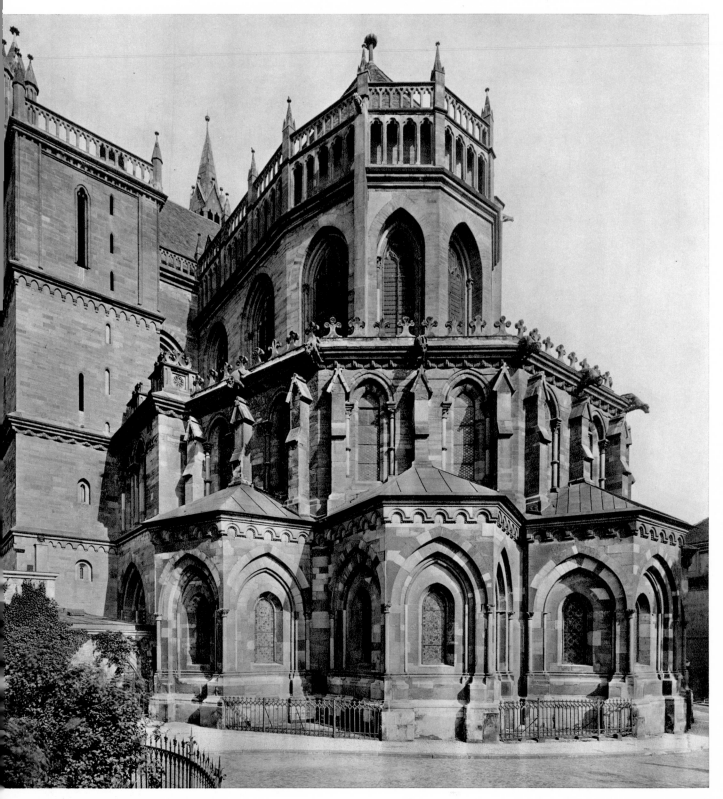

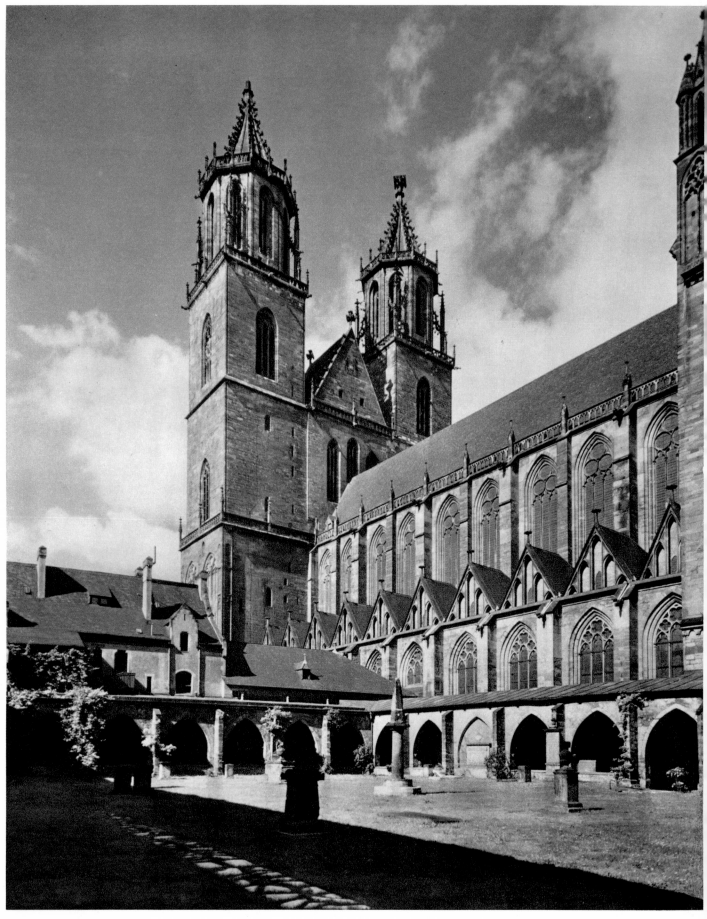

MAGDEBURG

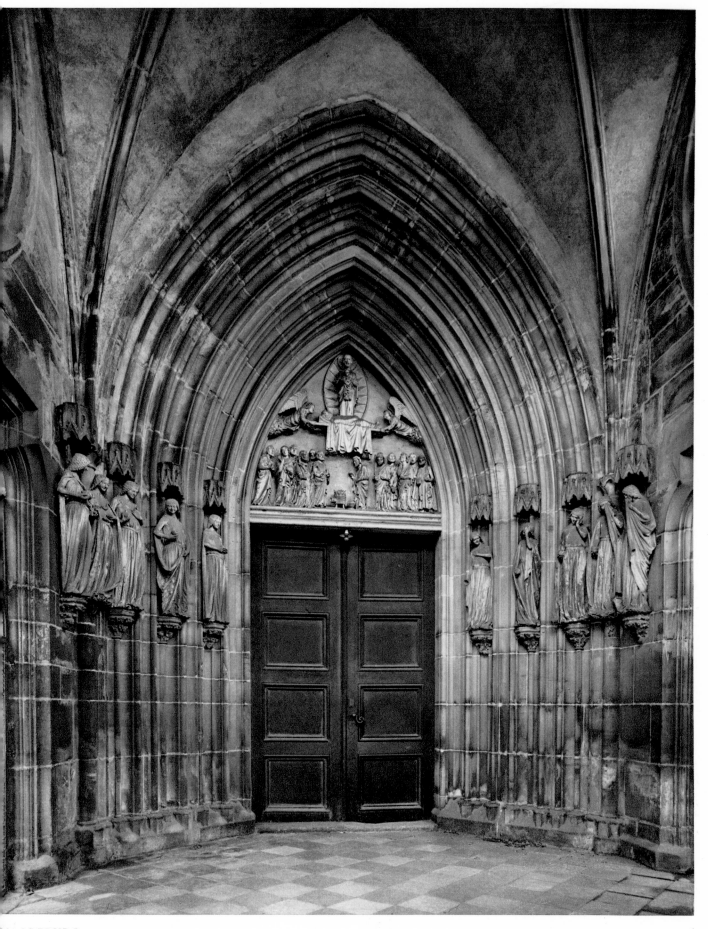

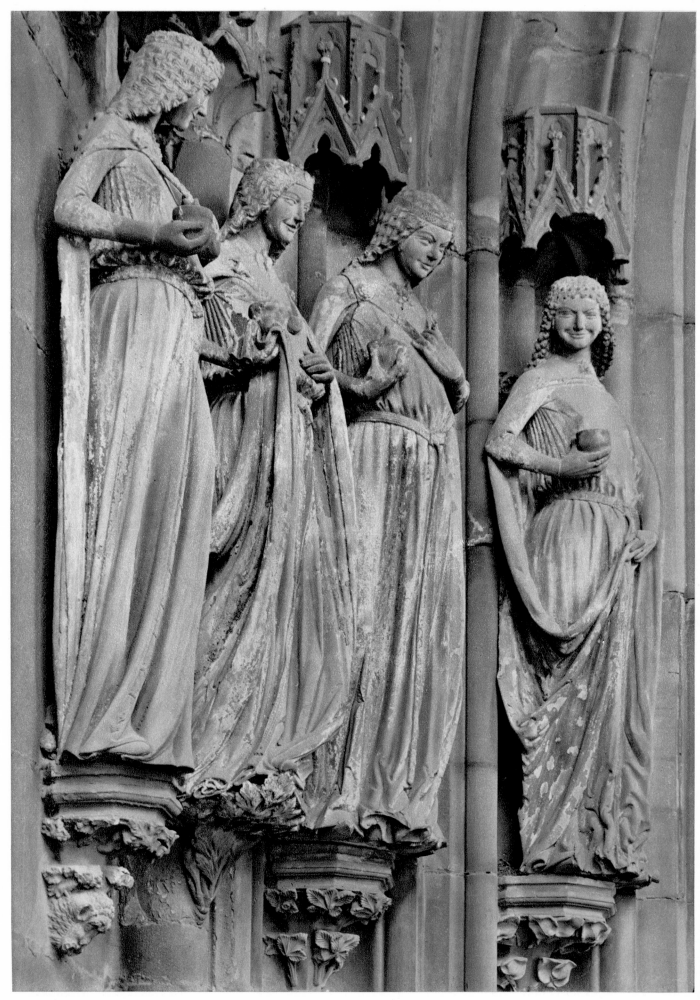

MAGDEBURG

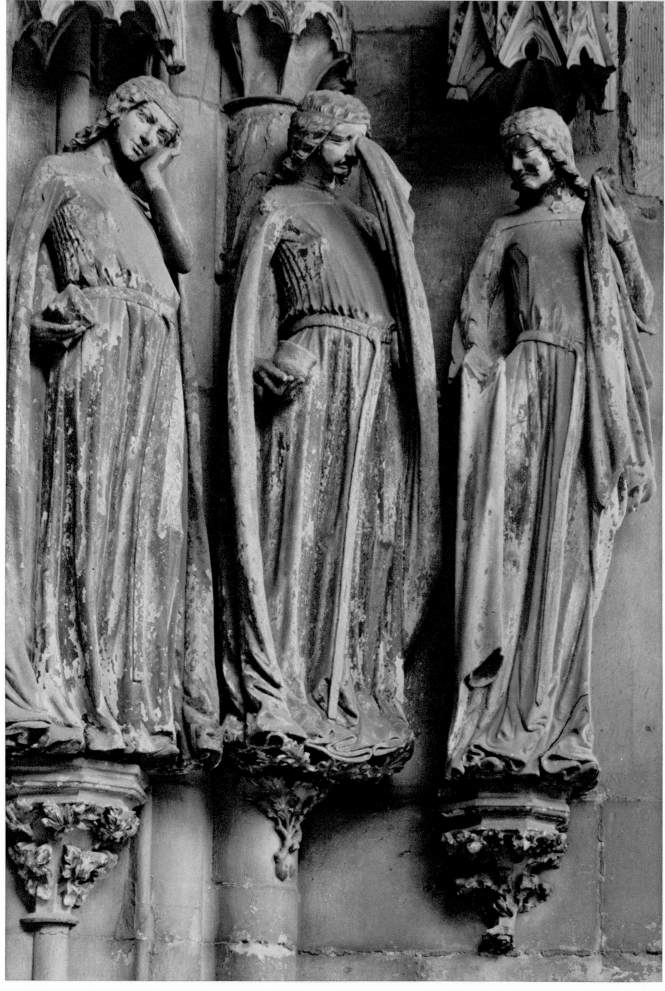

MAGDEBURG

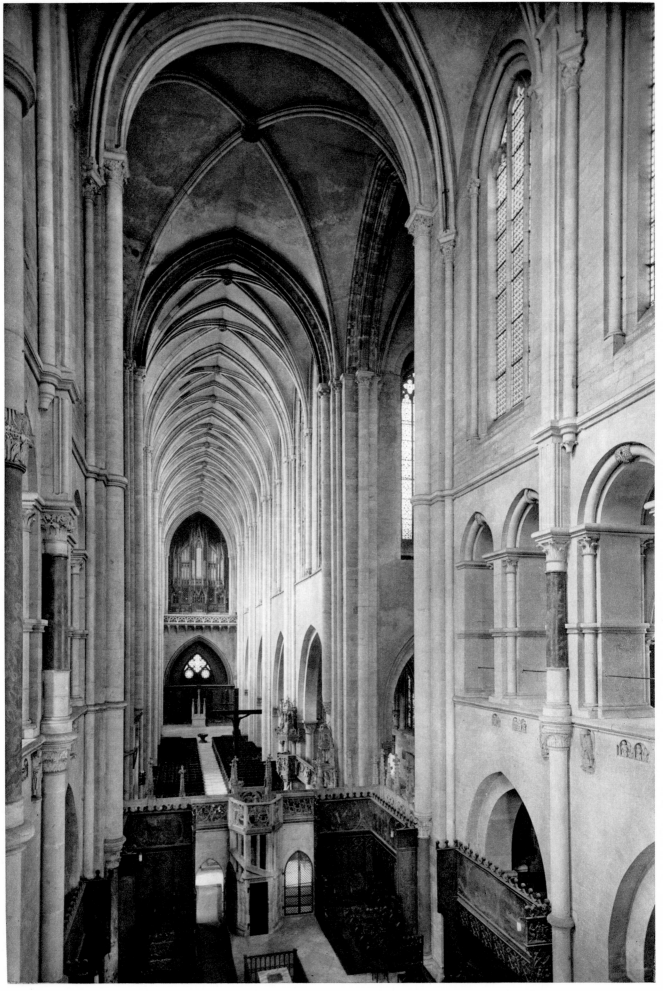

MAGDEBURG

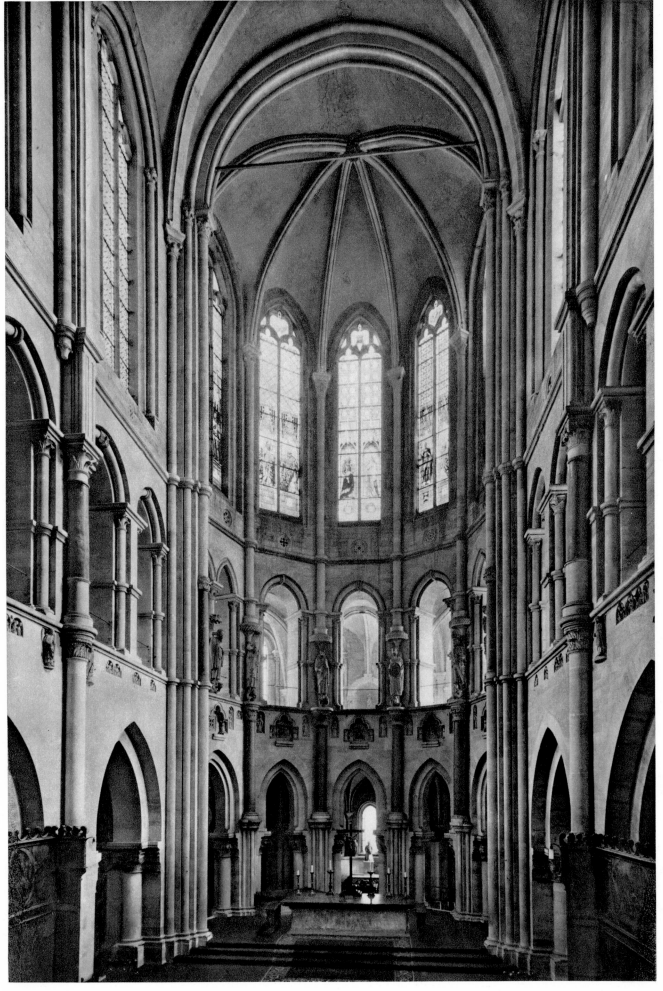

MAGDEBURG

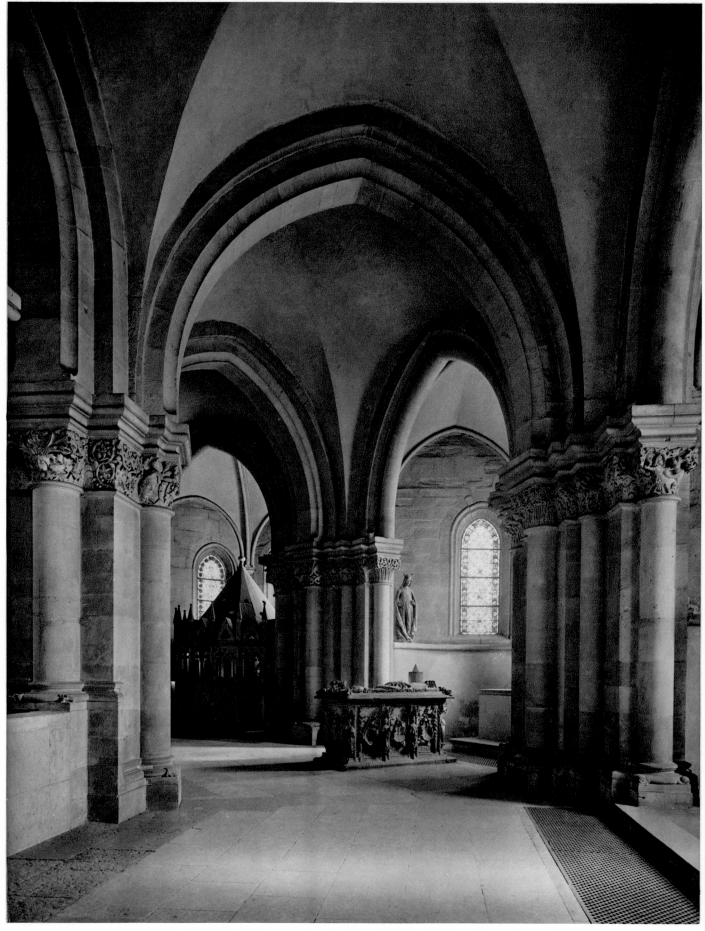

MAGDEBURG III

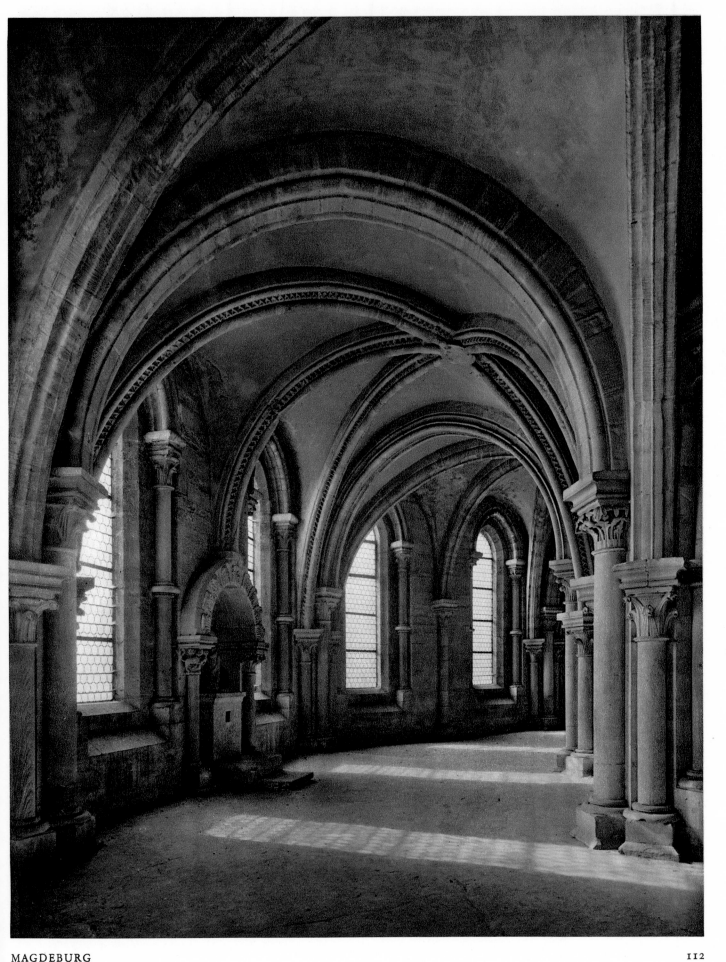

MAGDEBURG

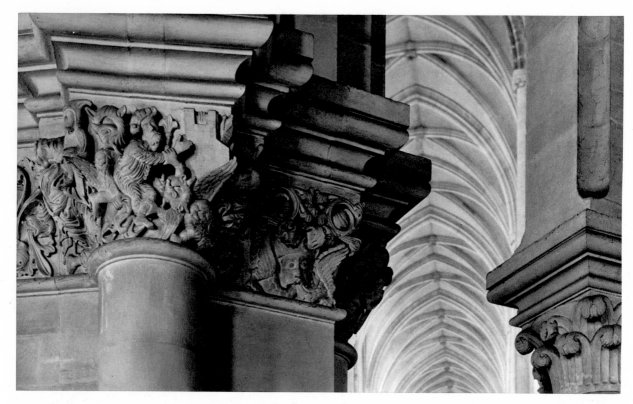

113

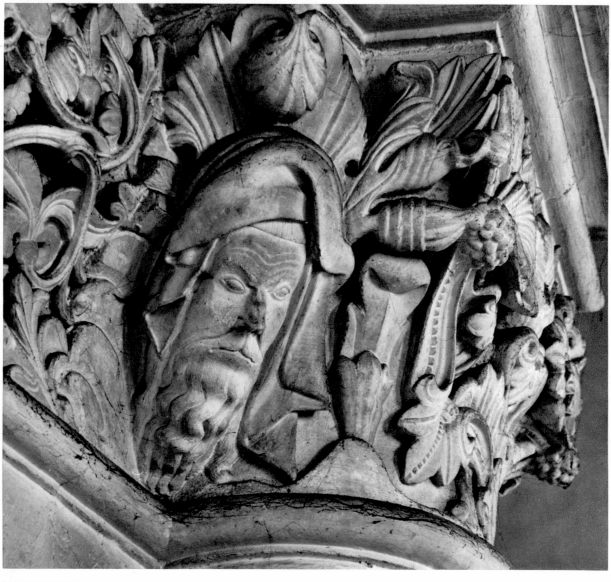

MAGDEBURG

114

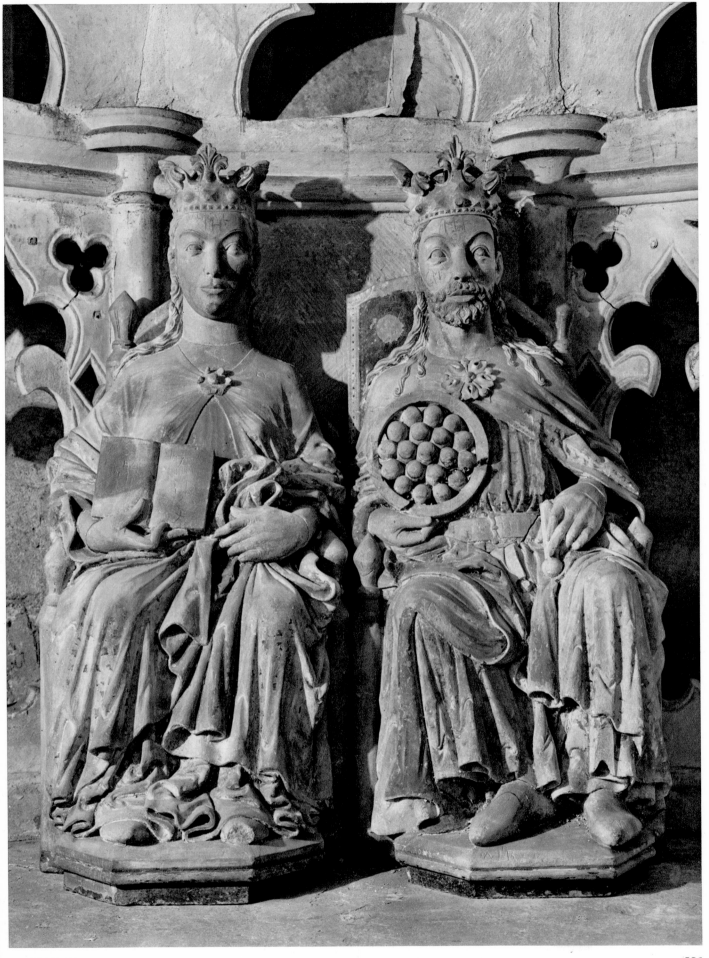

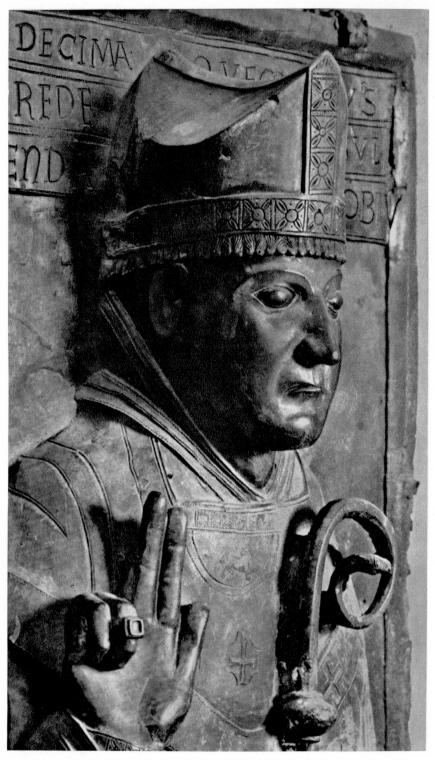

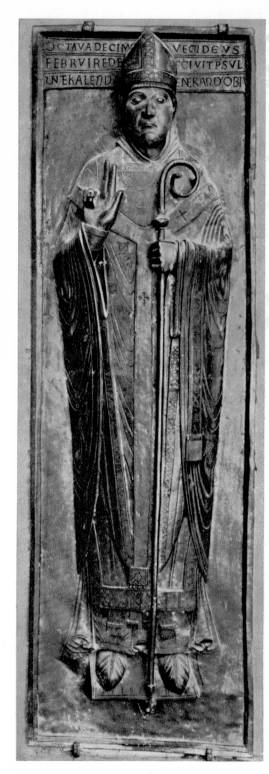

MAGDEBURG

MAGDEBURG

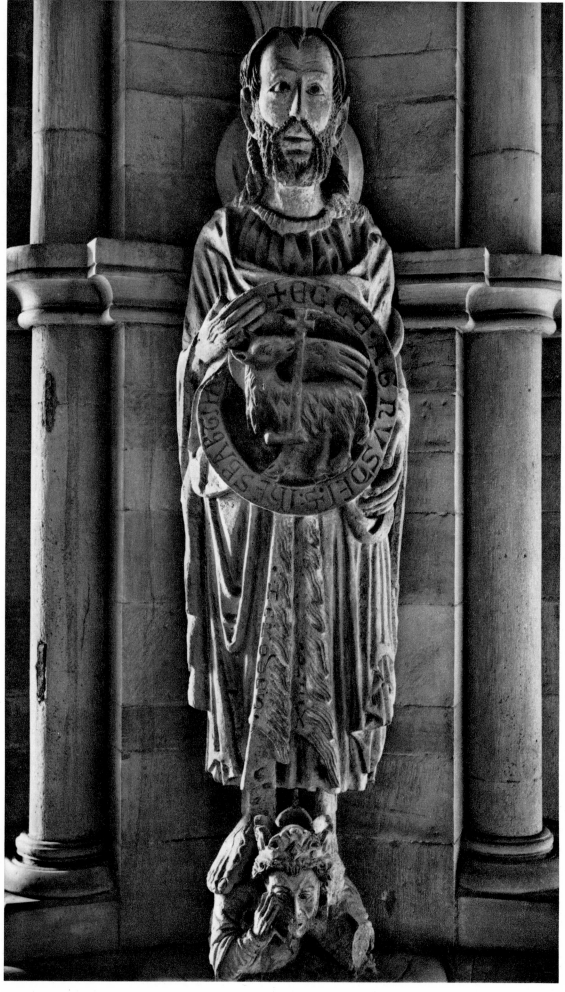

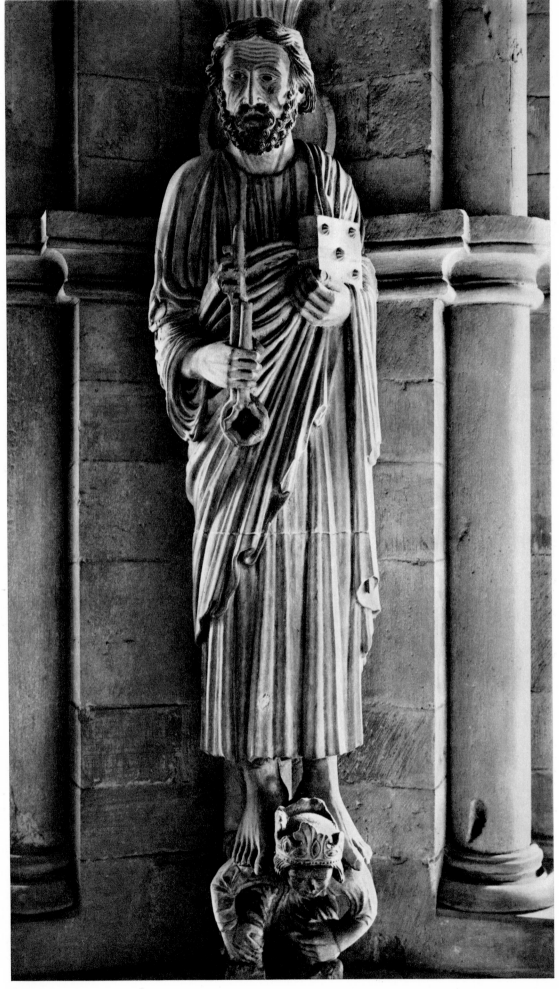

MAGDEBURG

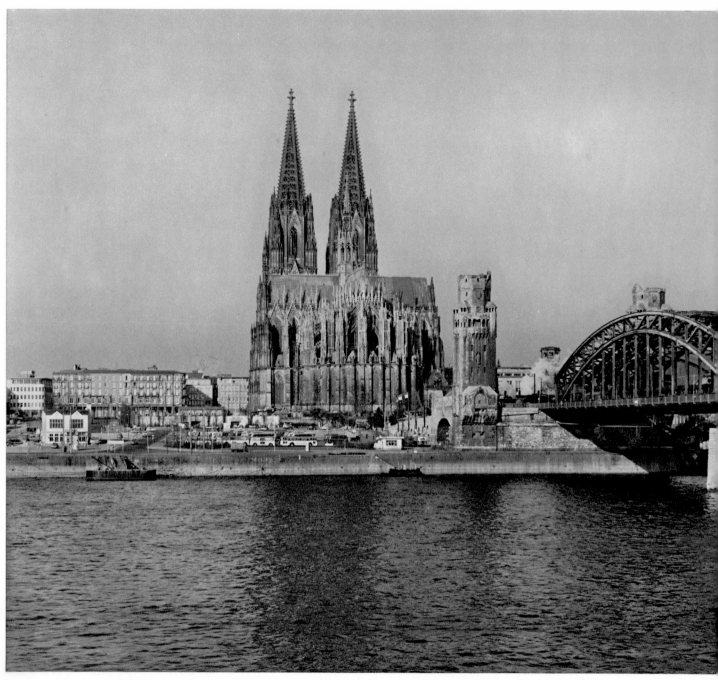

KÖLN

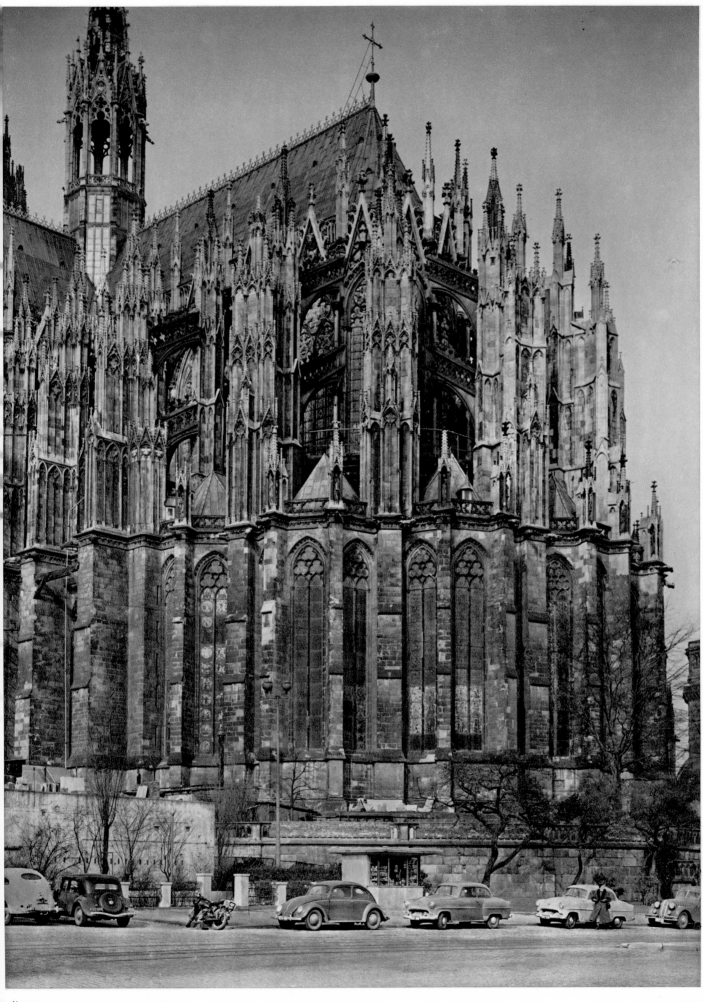

KÖLN

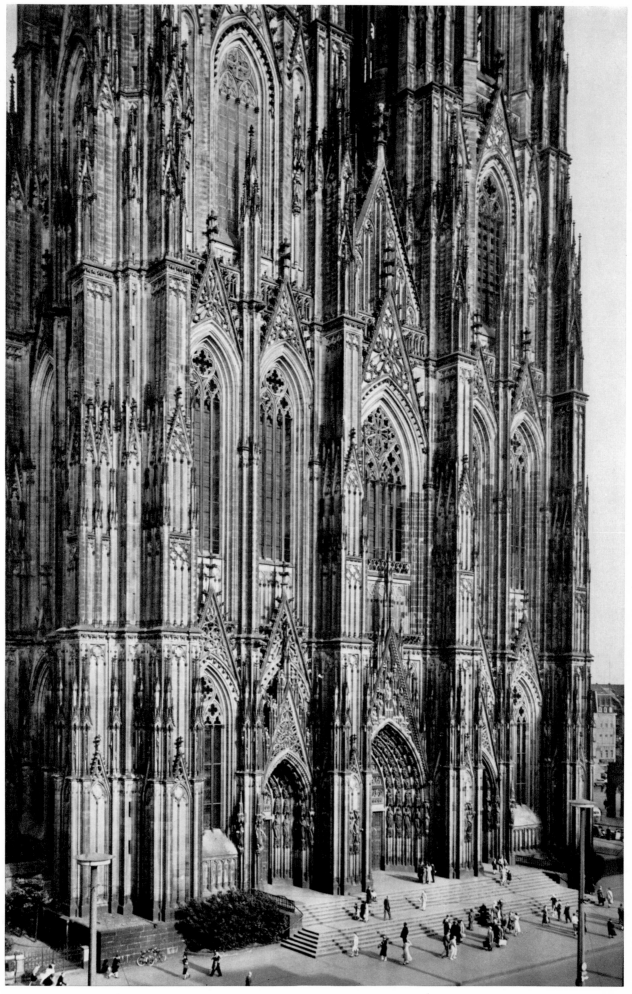

KÖLN

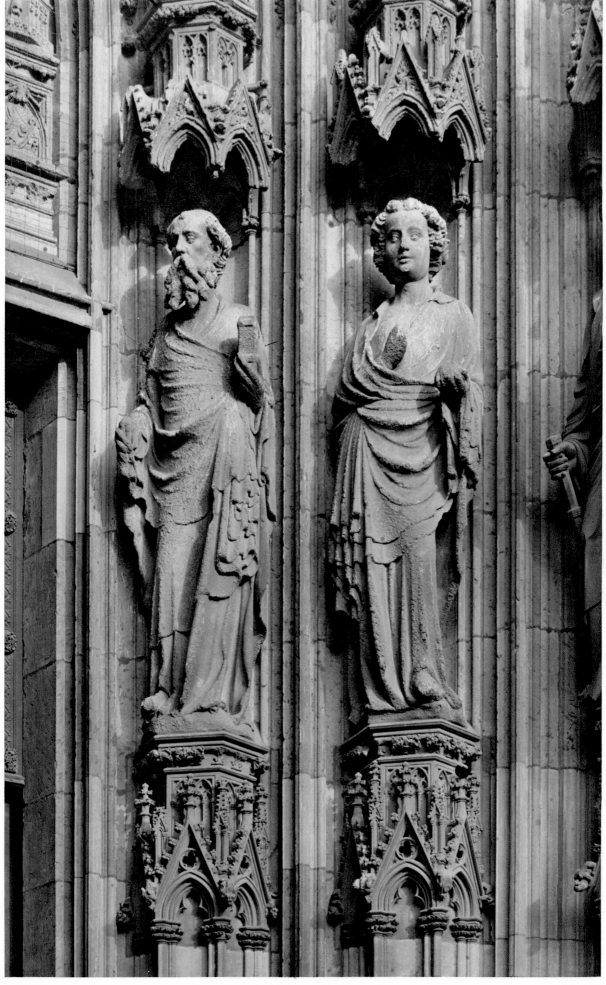

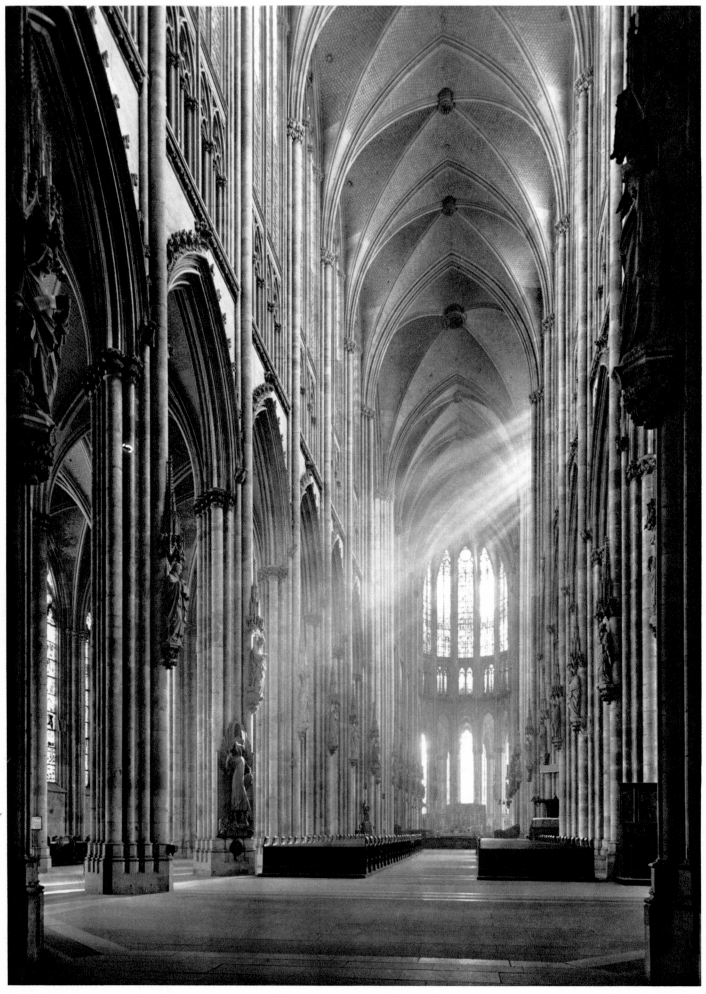

KÖLN

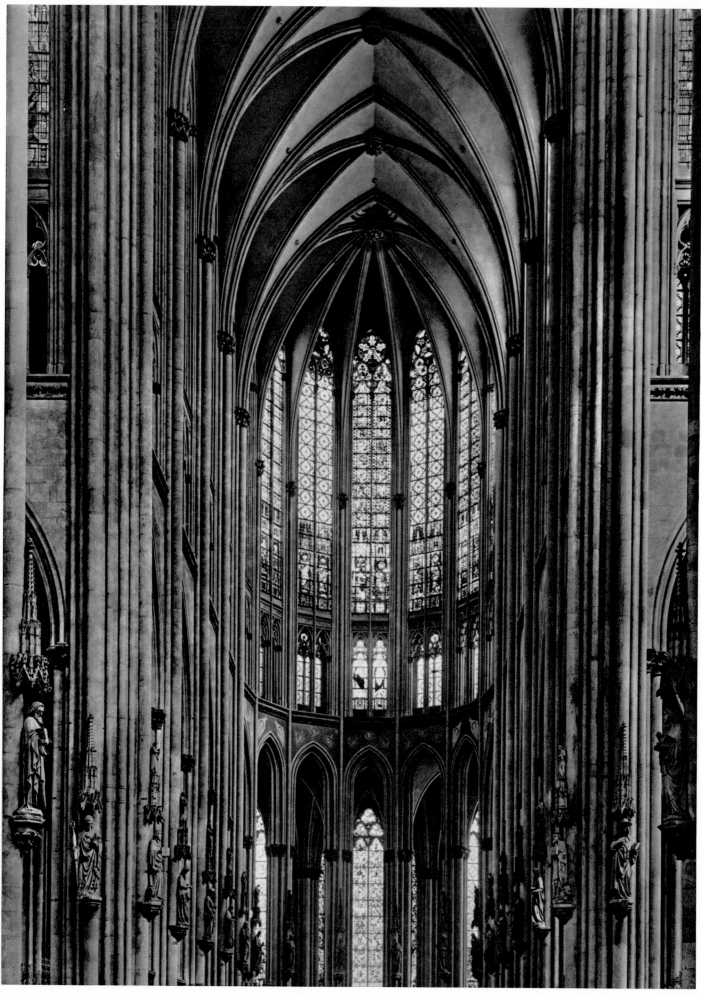

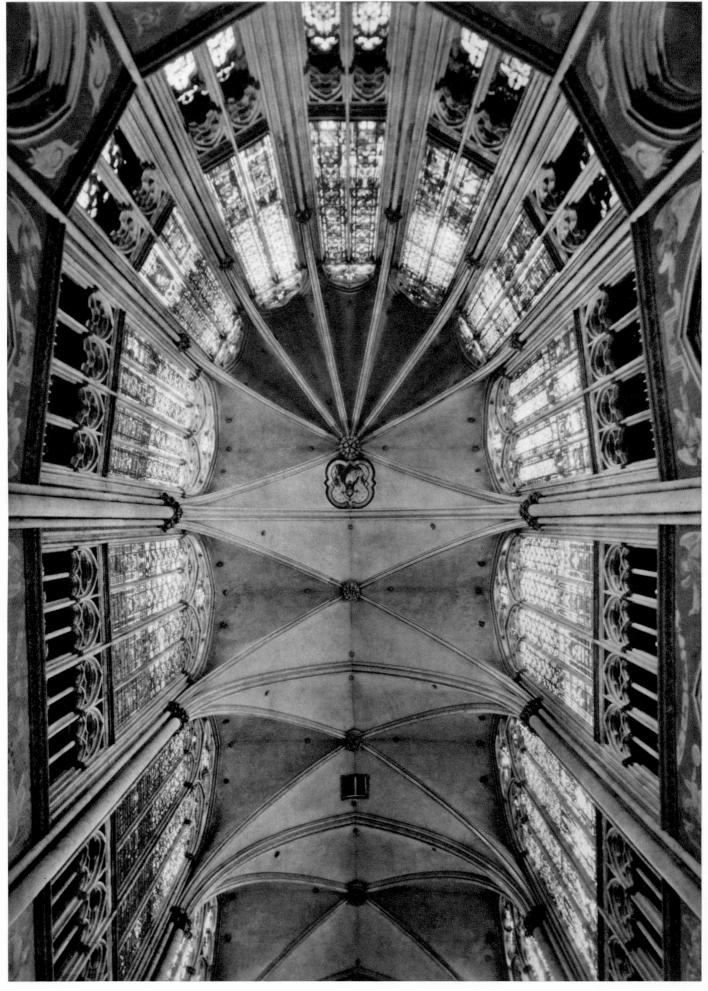

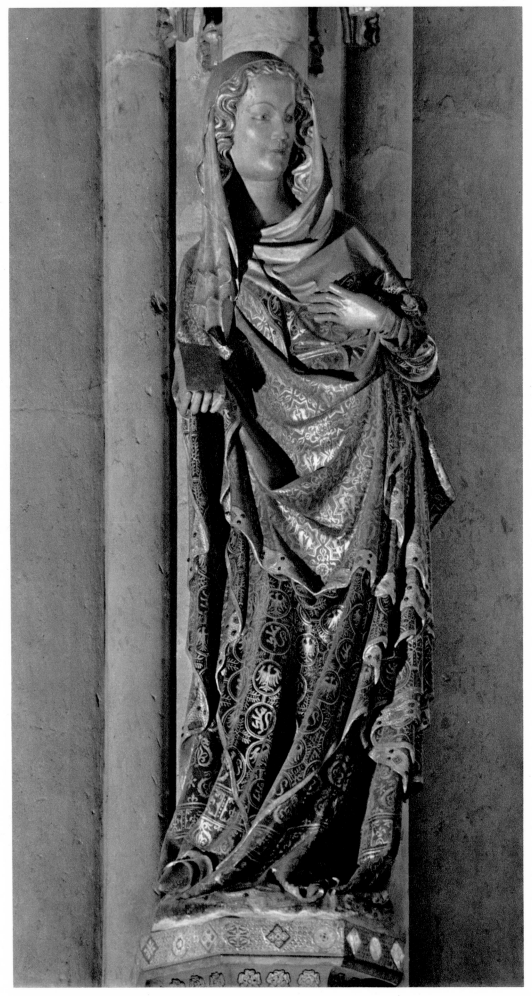

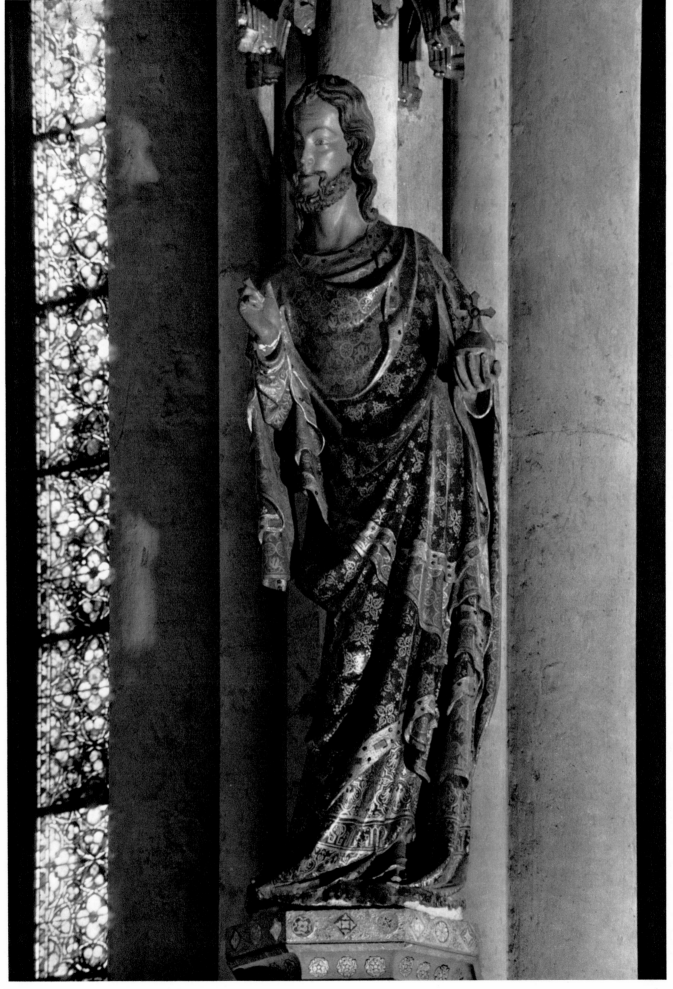

132

133

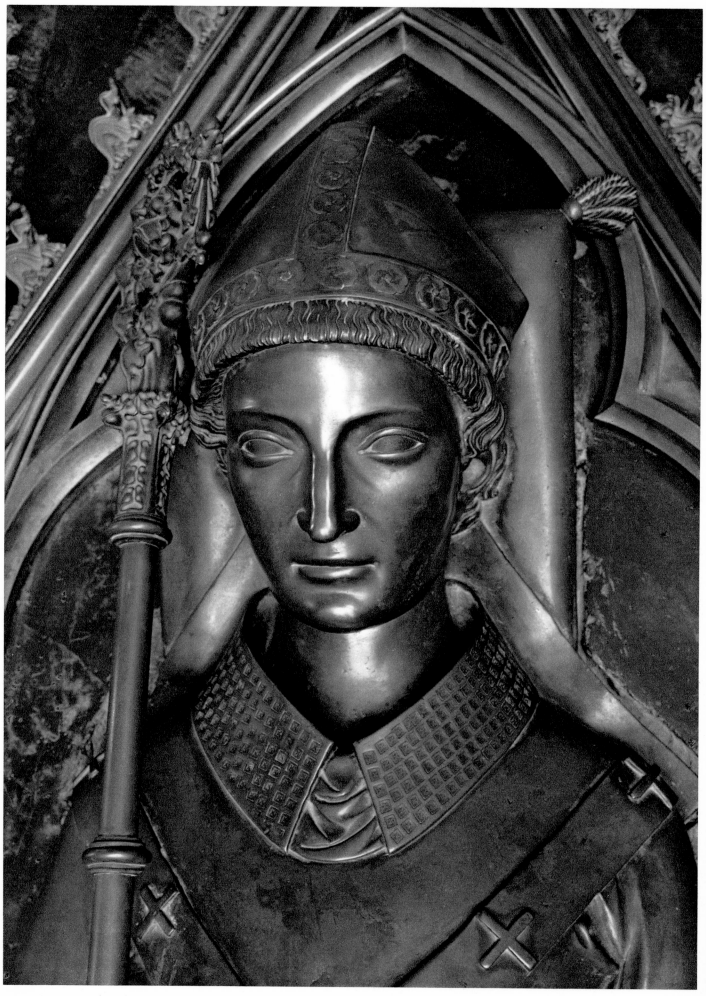

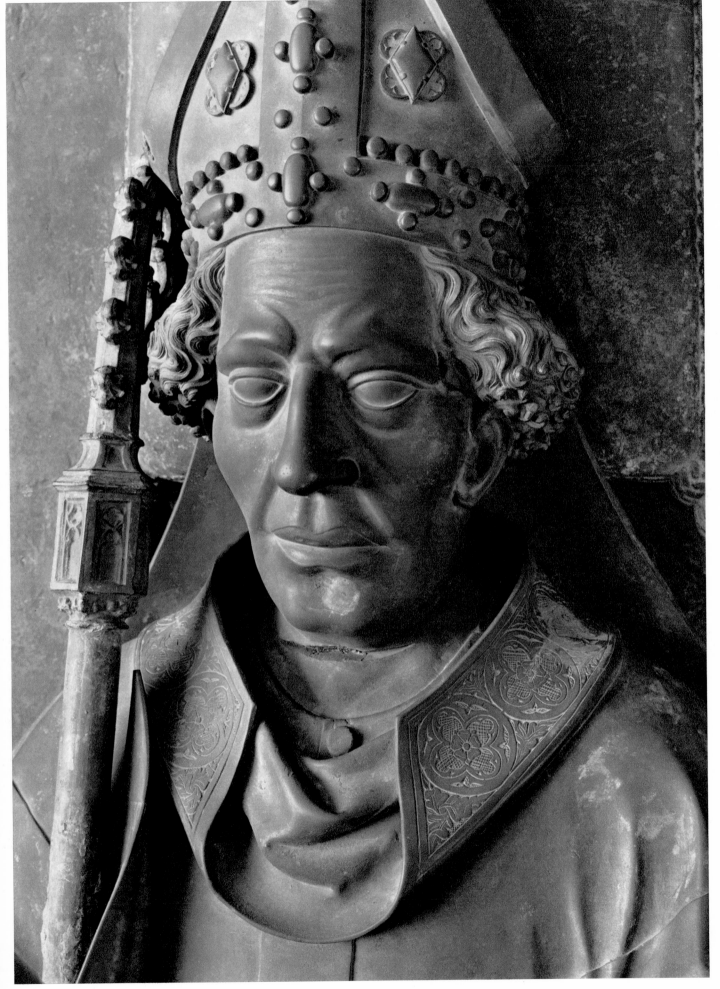

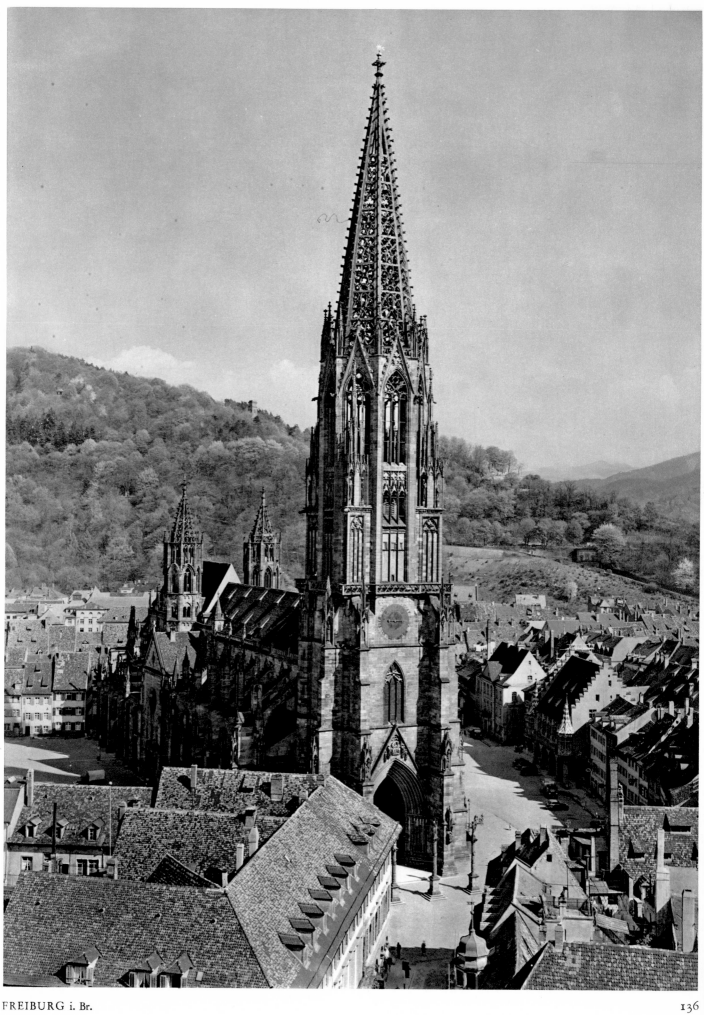

FREIBURG i. Br.

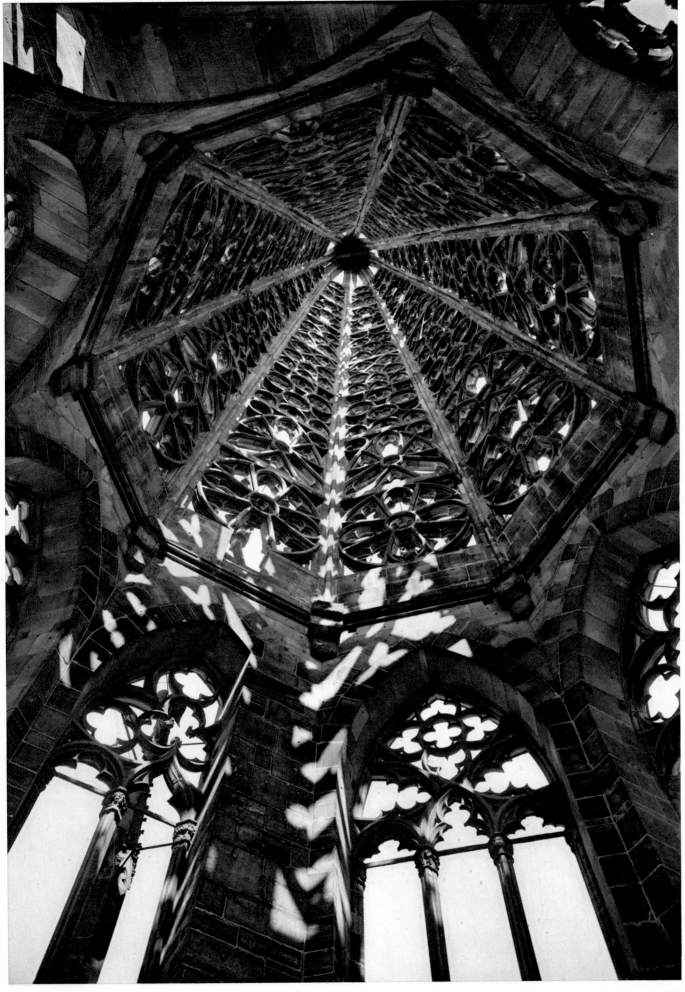

FREIBURG i. Br.

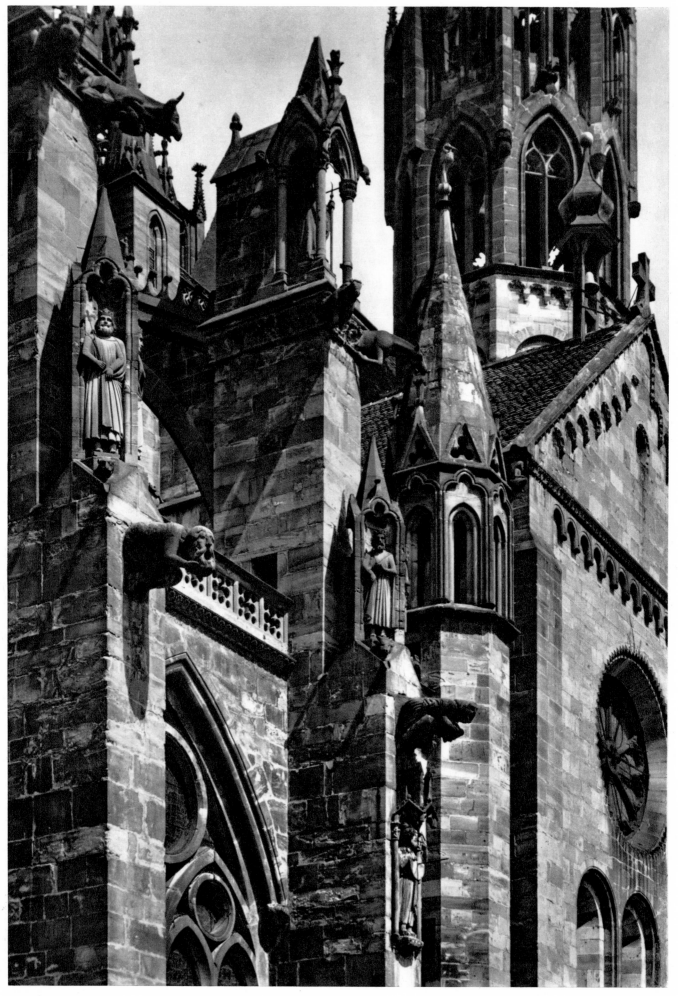

FREIBURG i. Br.

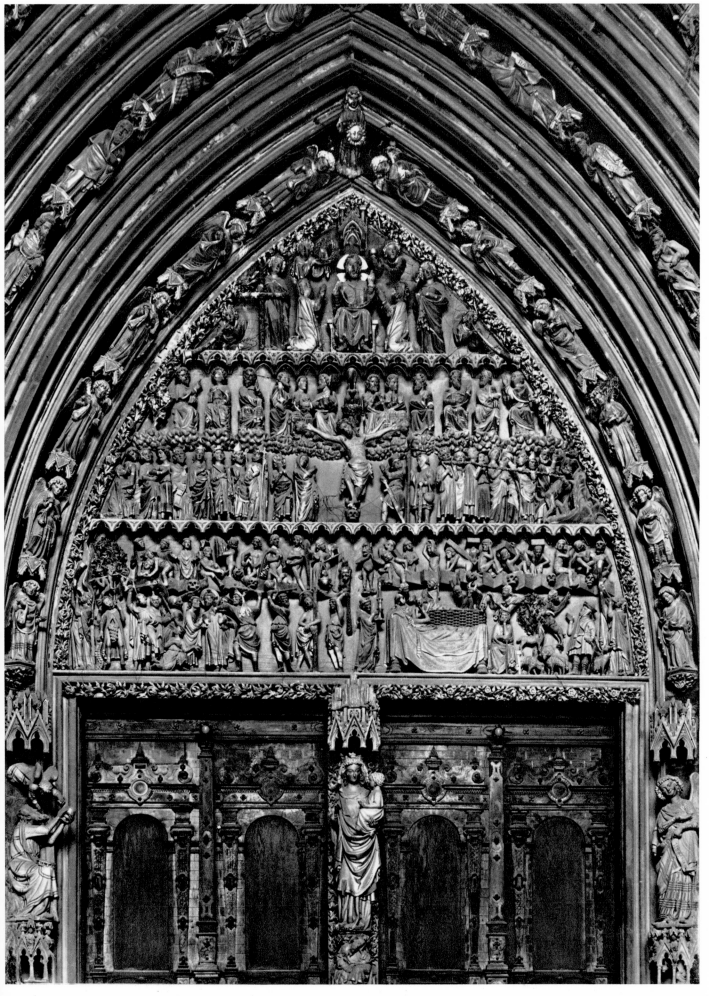

FREIBURG i. Br.

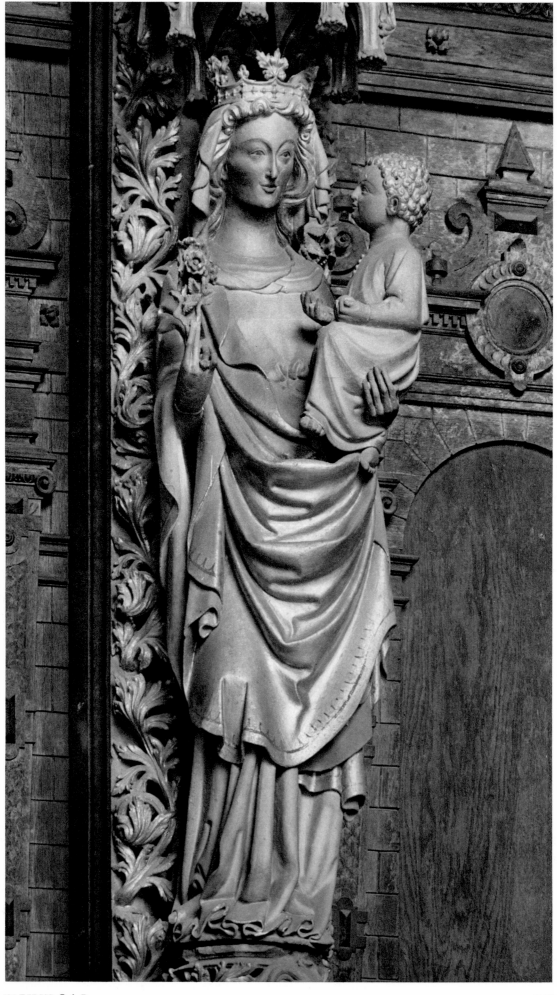

FREIBURG i. Br. 140

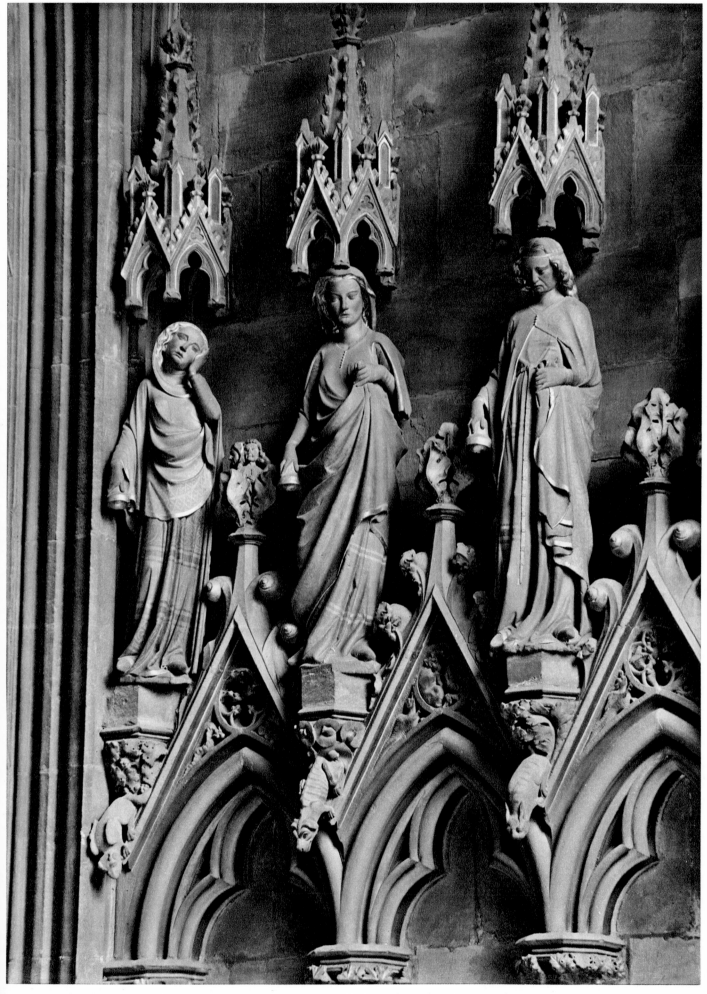

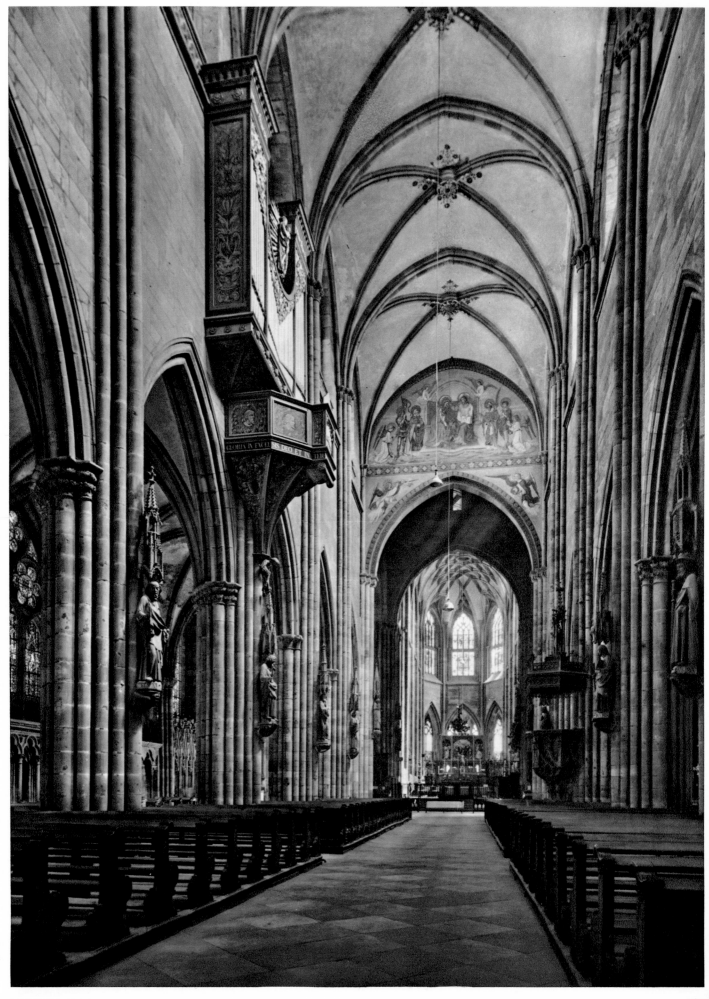

FREIBURG i. Br.

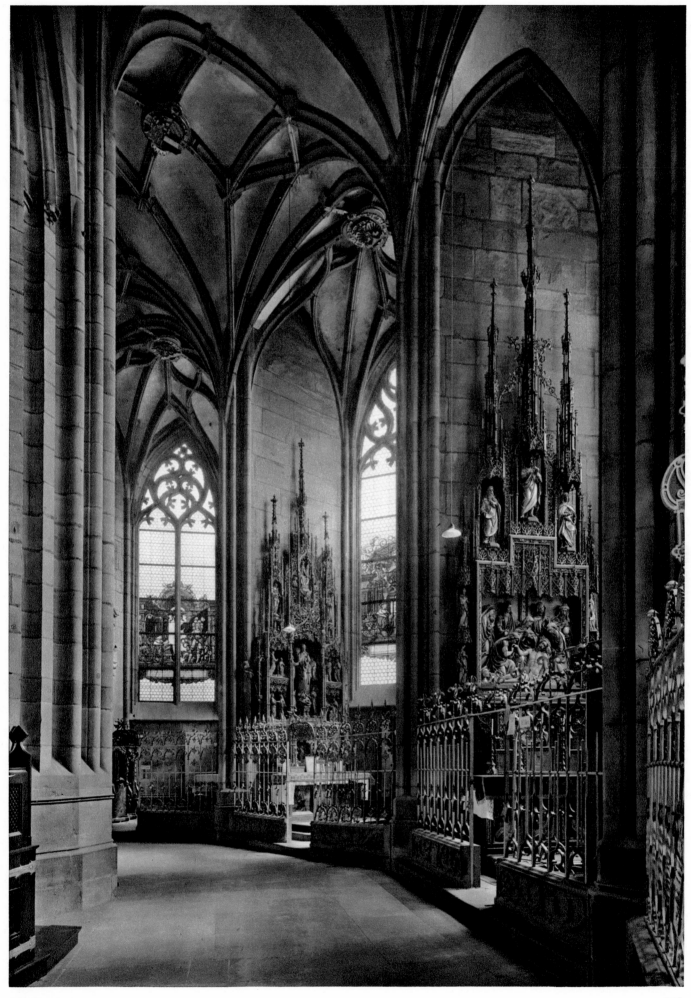

FREIBURG i. Br. 143

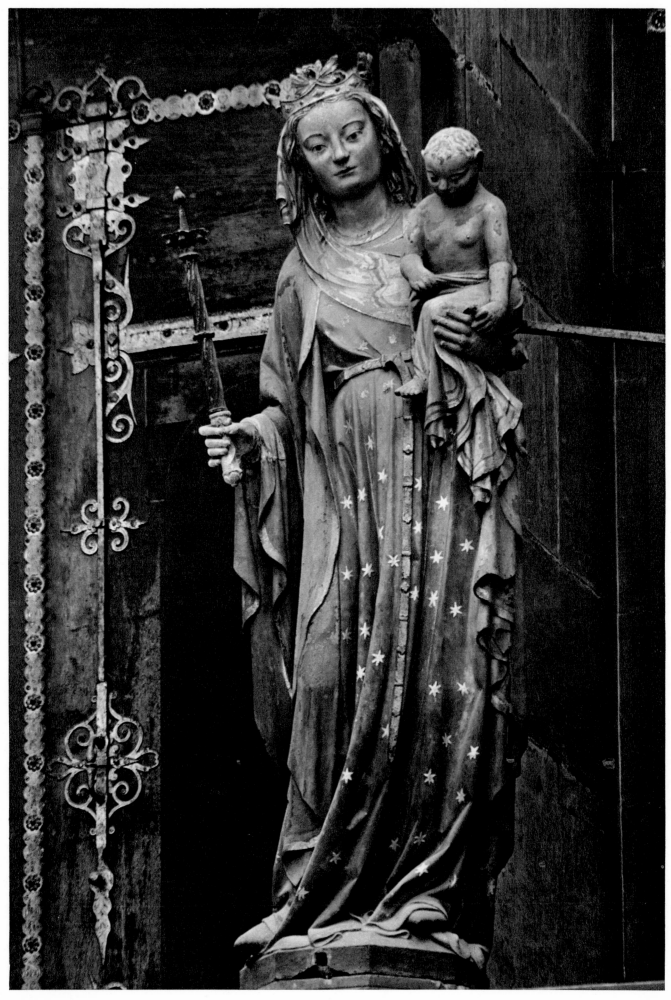

FREIBURG i. Br.

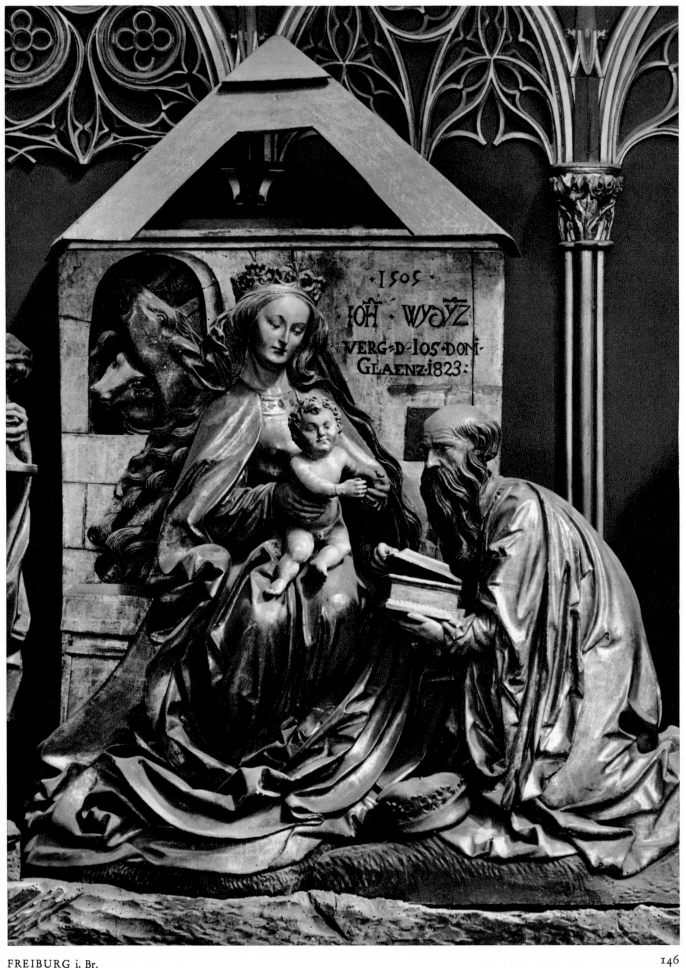

·1505·

IOH · WYDŸZ

VERG=D·IOS·DONI·
GLAENZ·1823·

FREIBURG i. Br.

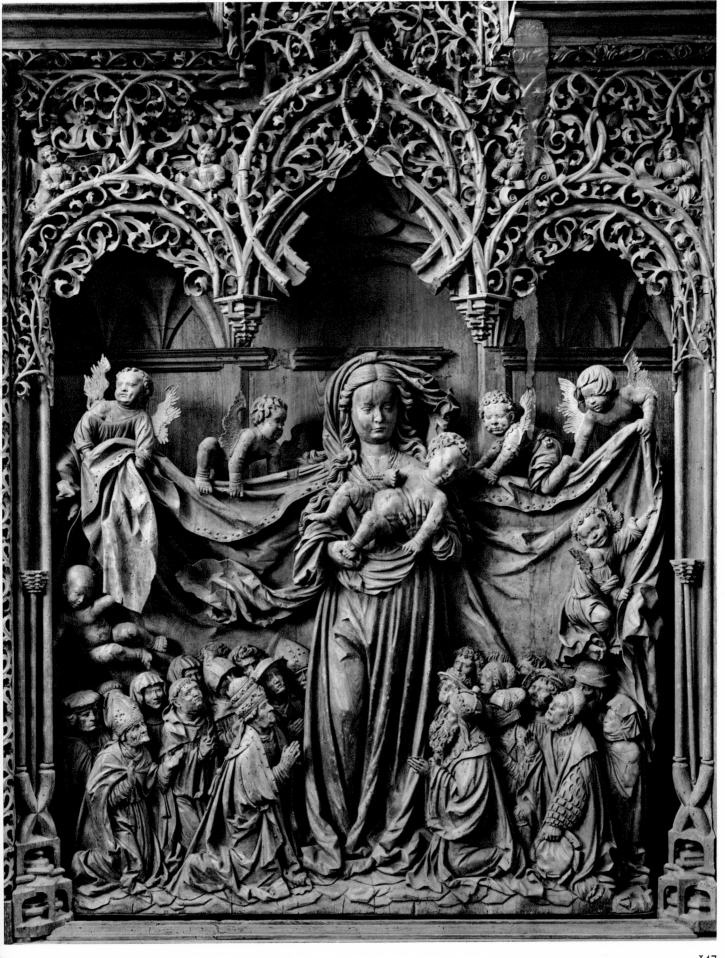

FREIBURG i. Br. 147

REGENSBURG

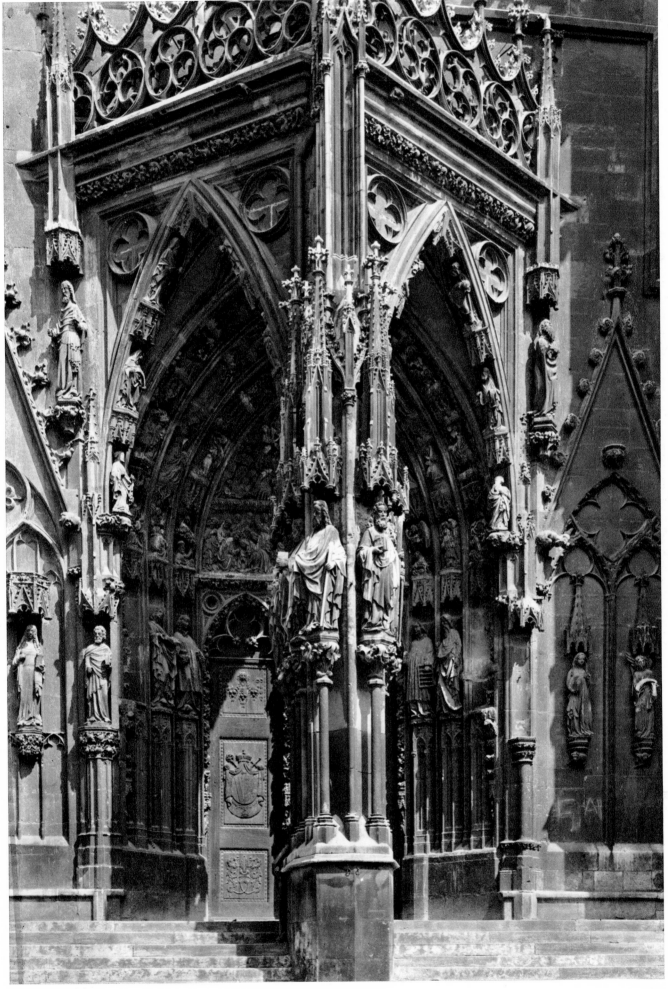

REGENSBURG

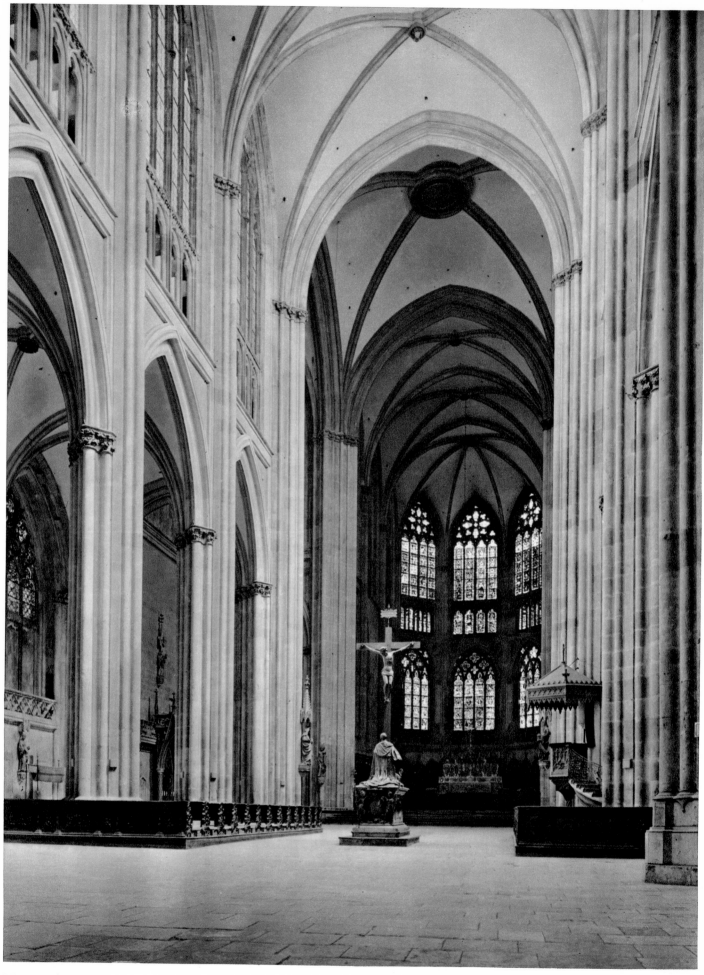

REGENSBURG

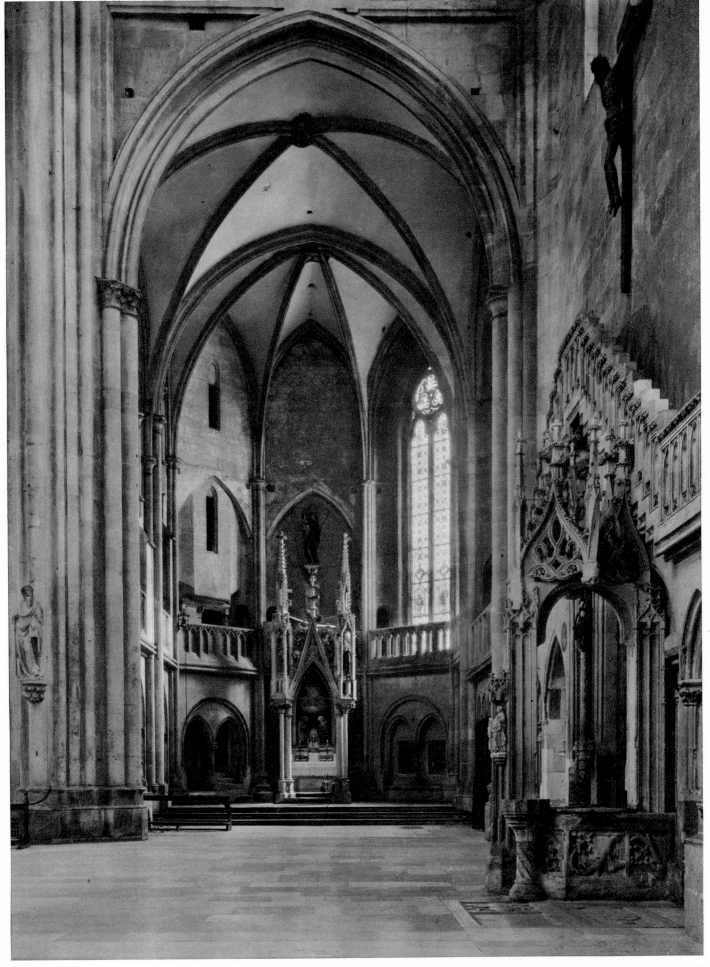

REGENSBURG

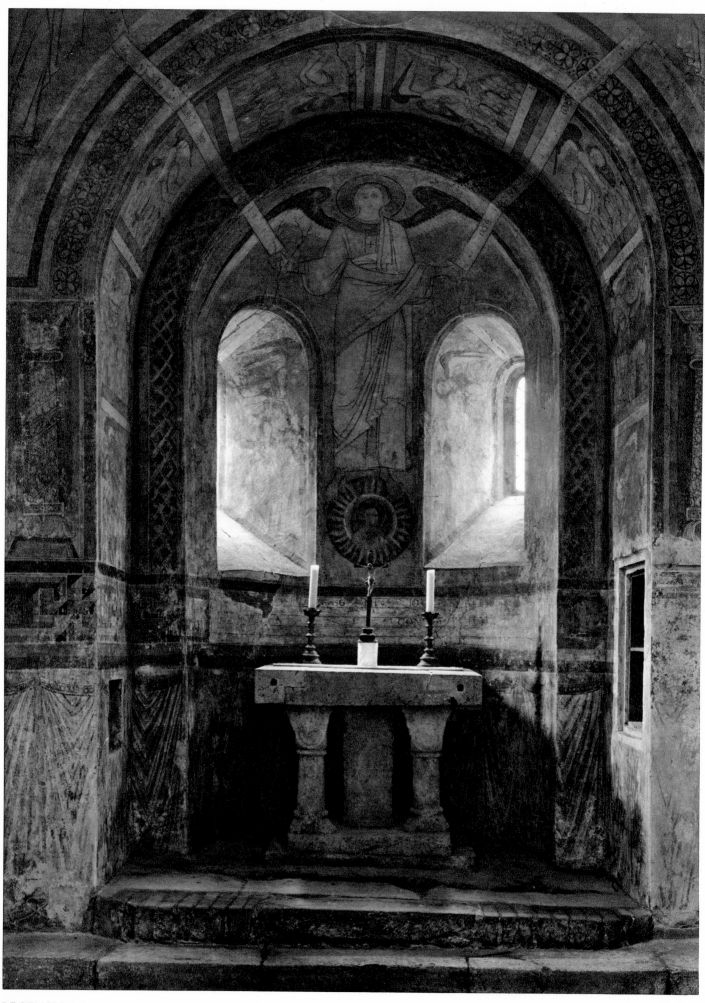

REGENSBURG

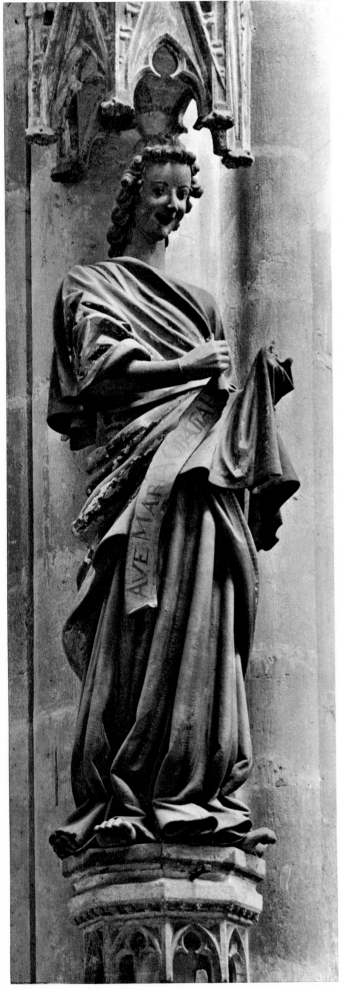

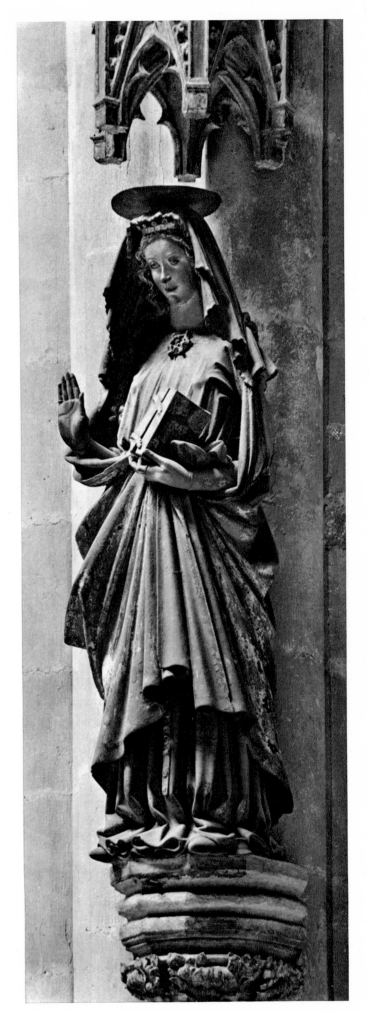

REGENSBURG

153

154

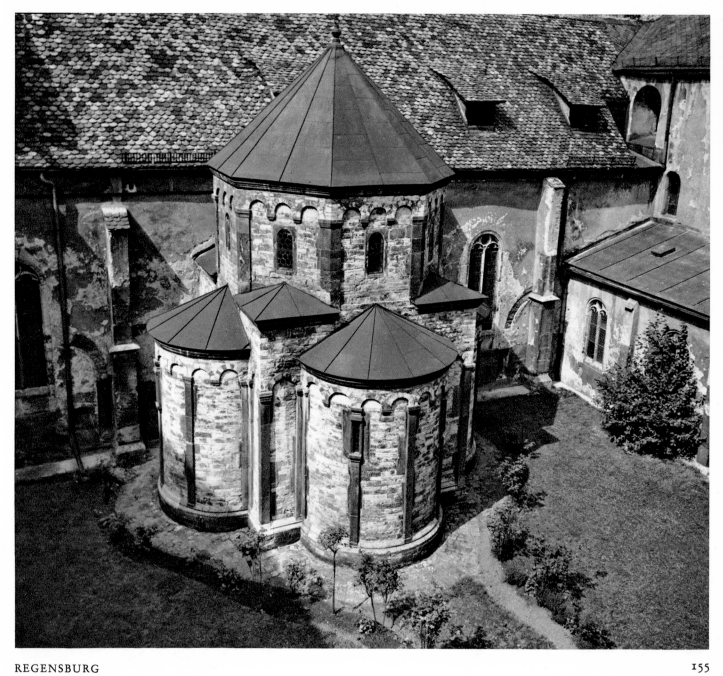

REGENSBURG

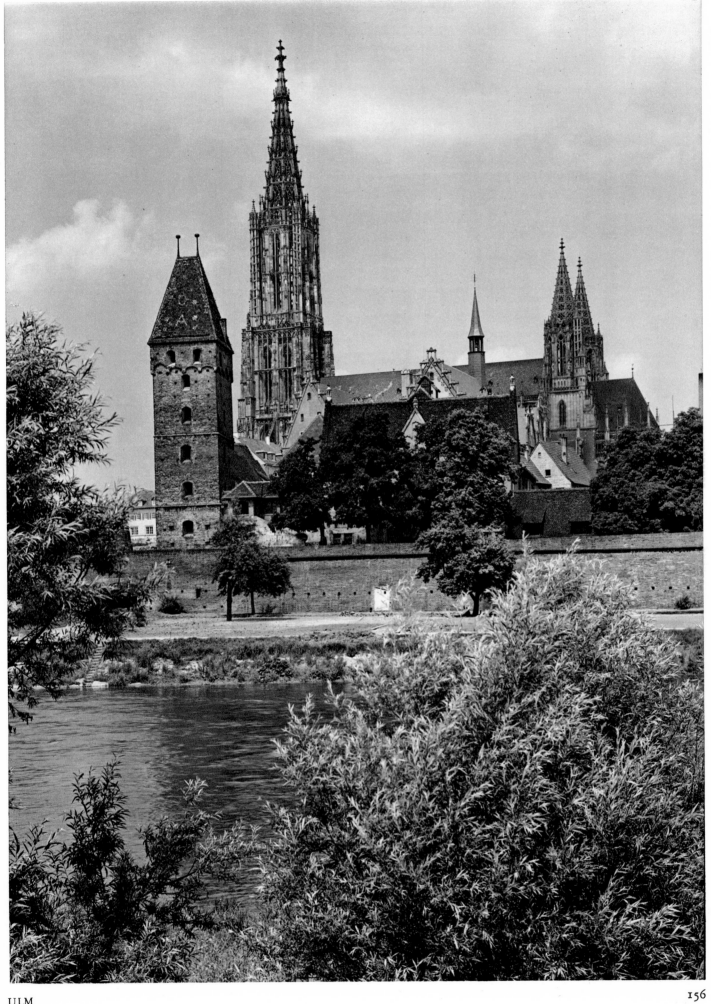

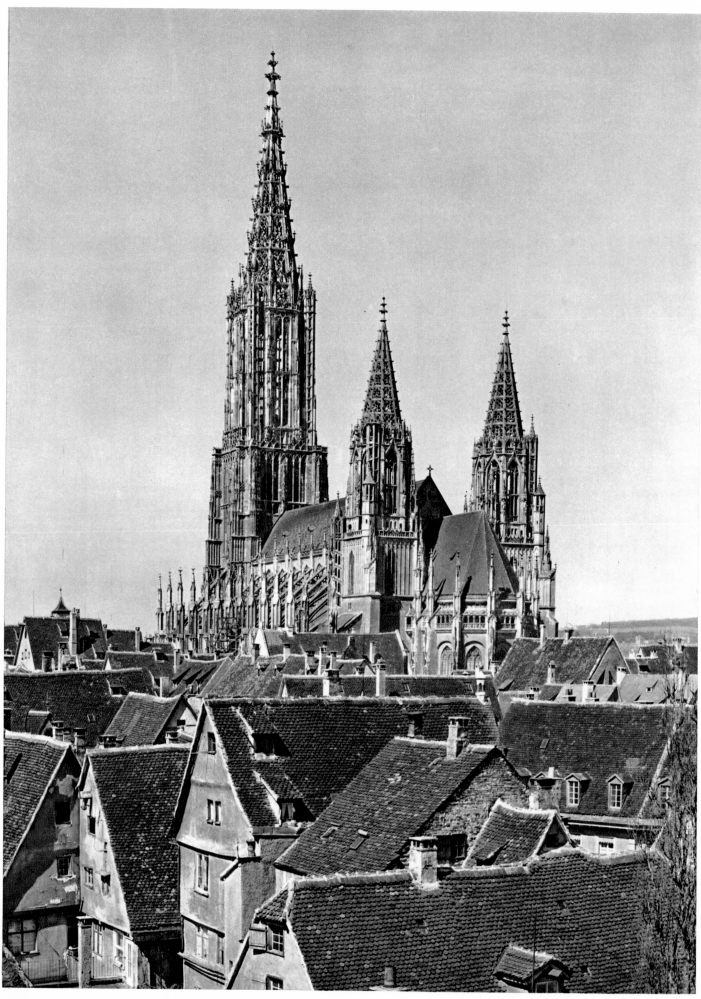

ULM

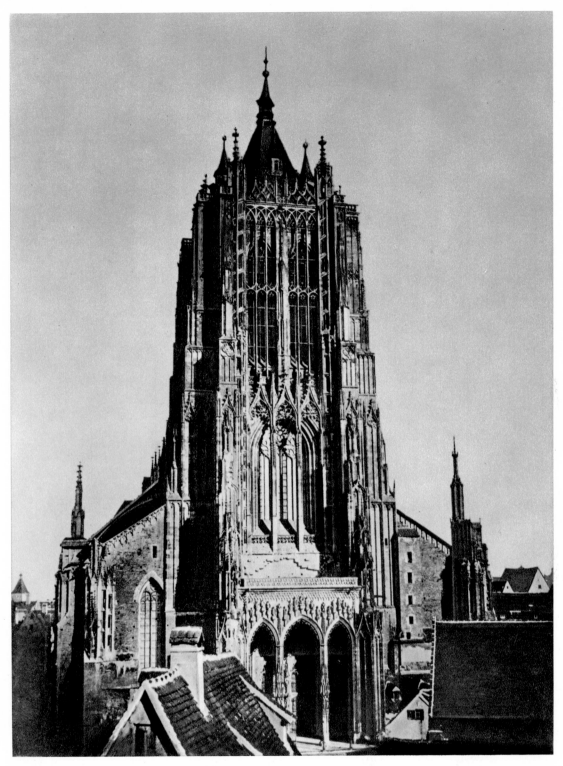

ULM

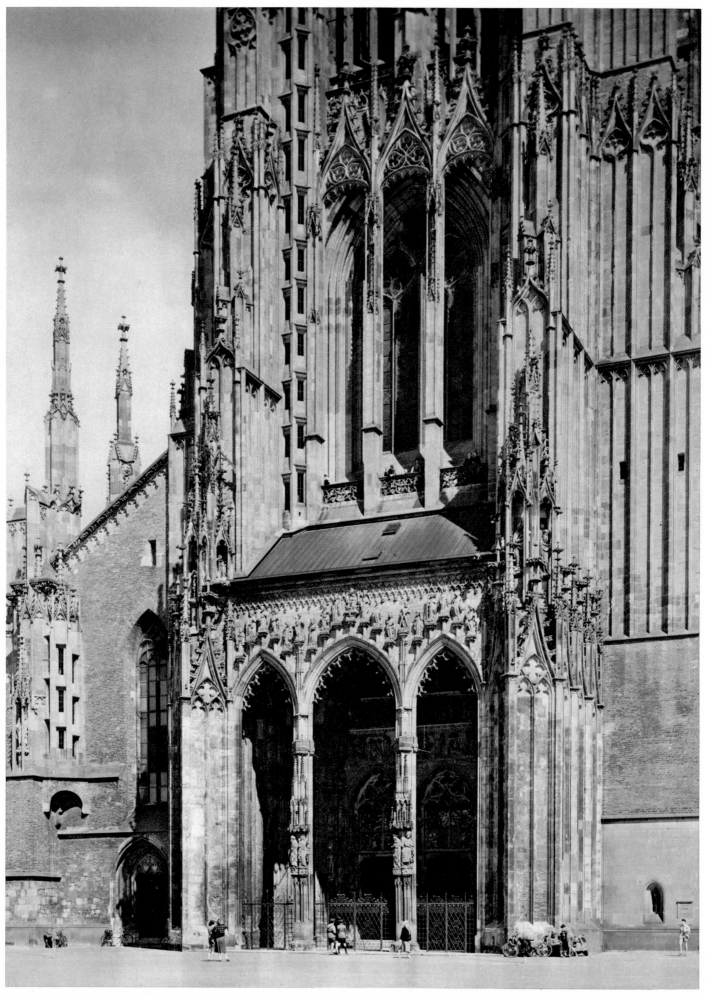

ULM

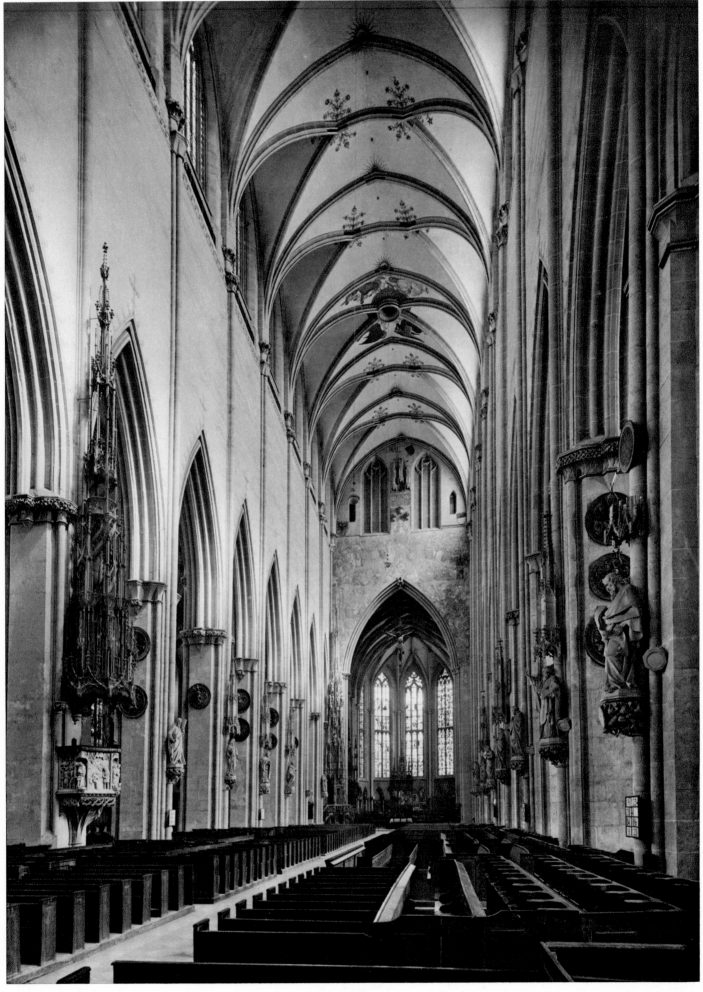

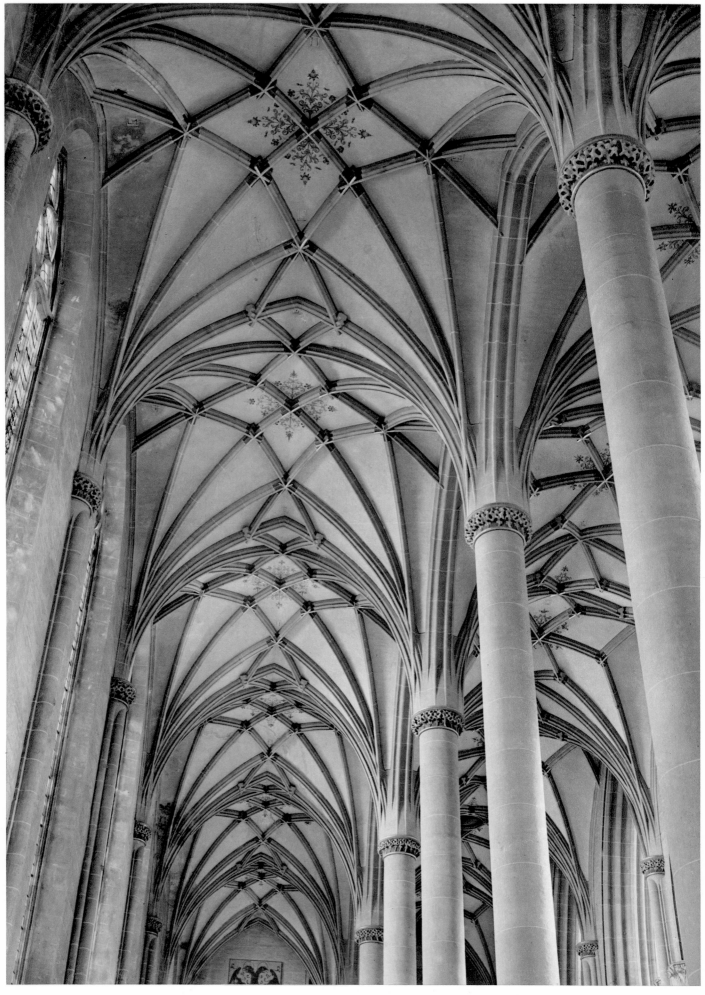

162

ULM

163

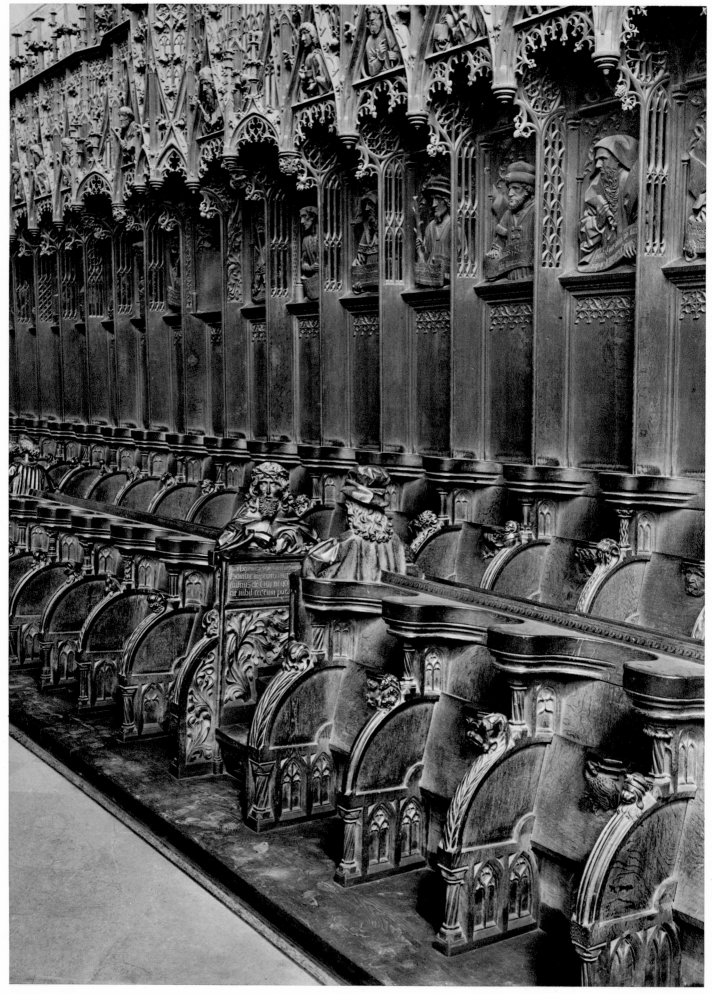

ULM

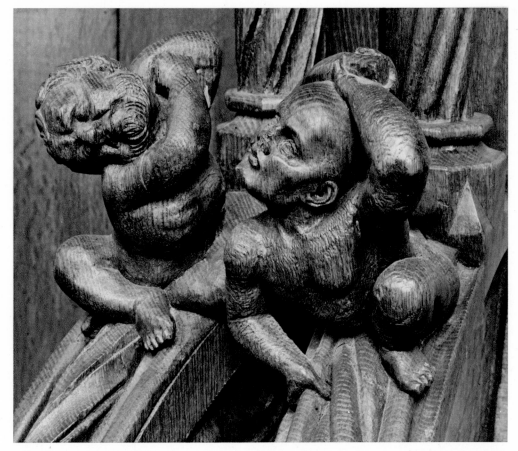

165

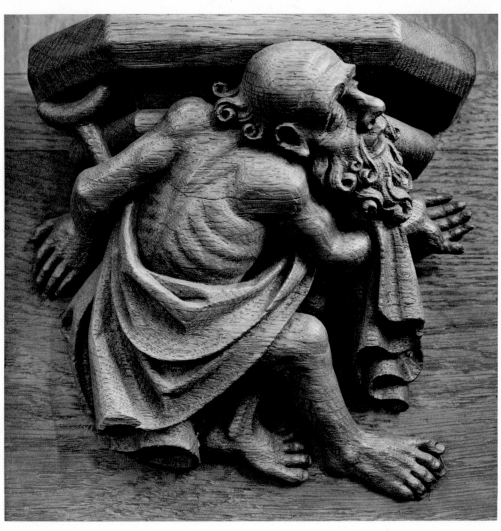

166

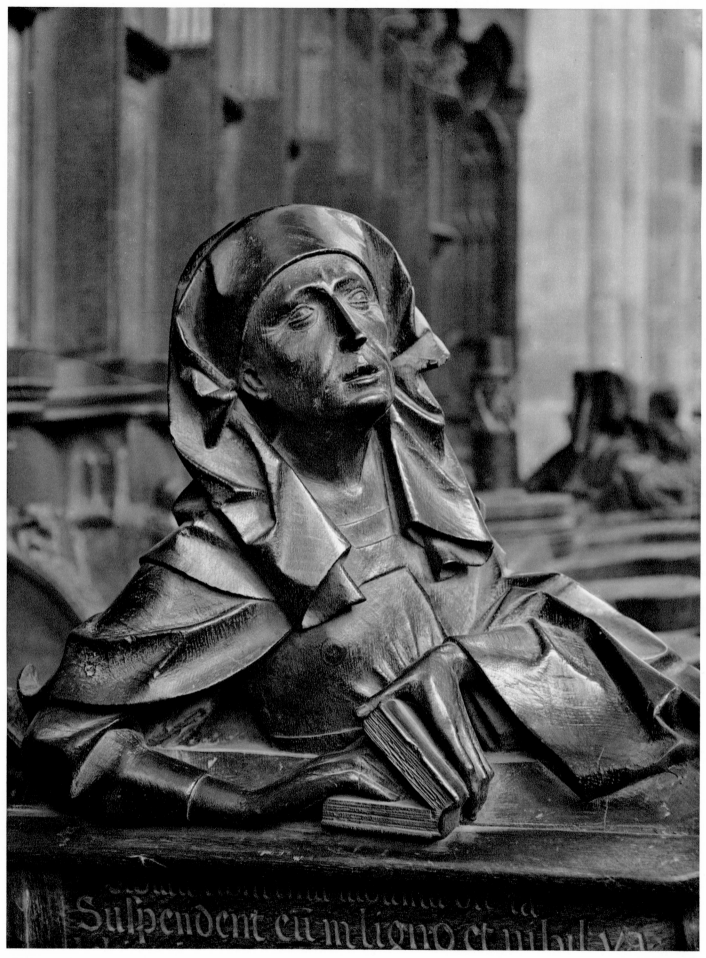

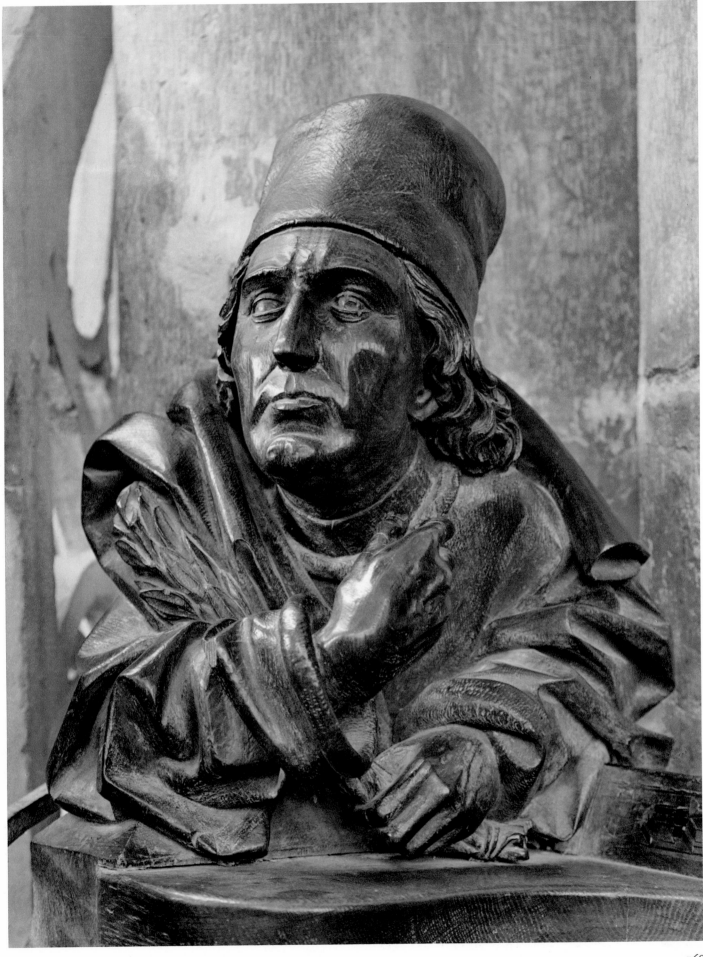

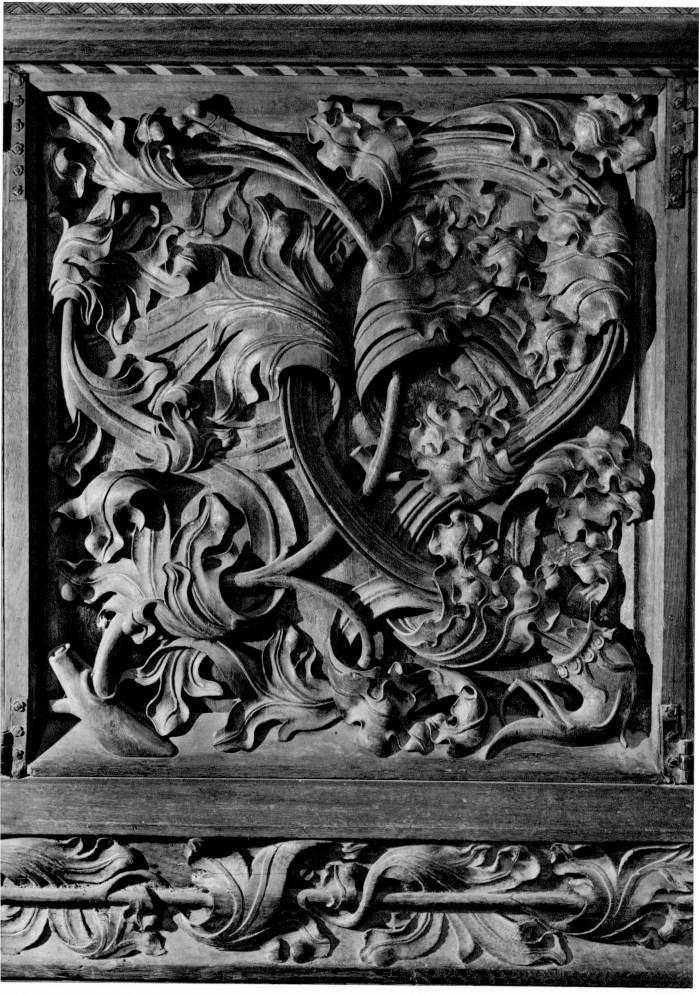

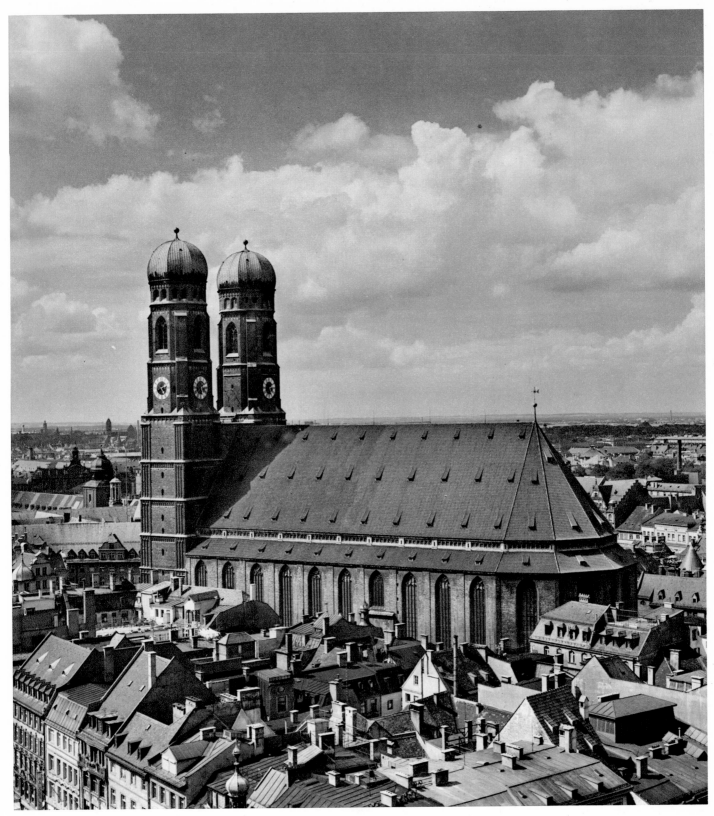

MÜNCHEN

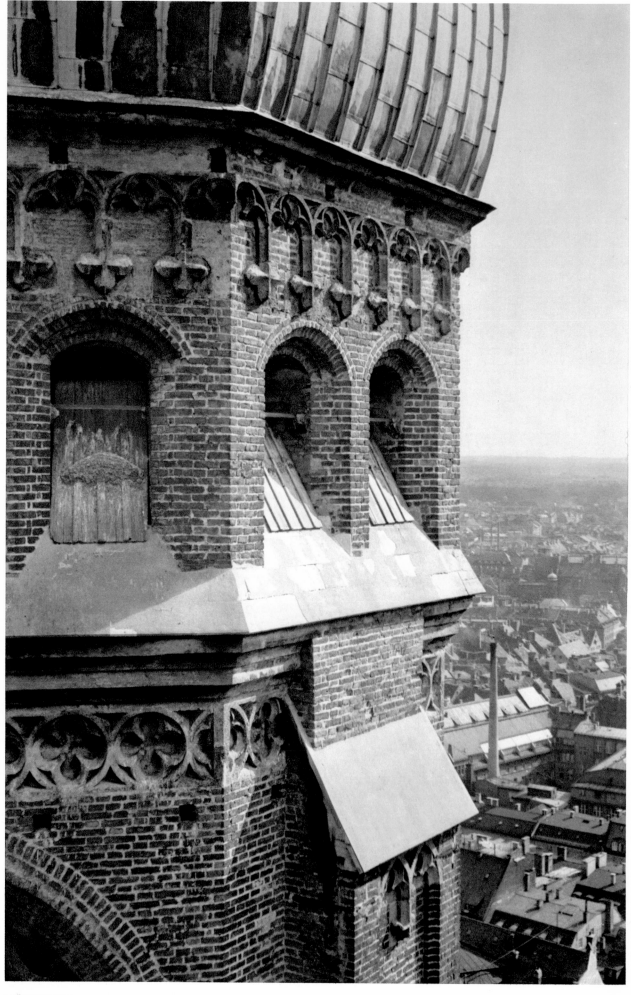

MÜNCHEN

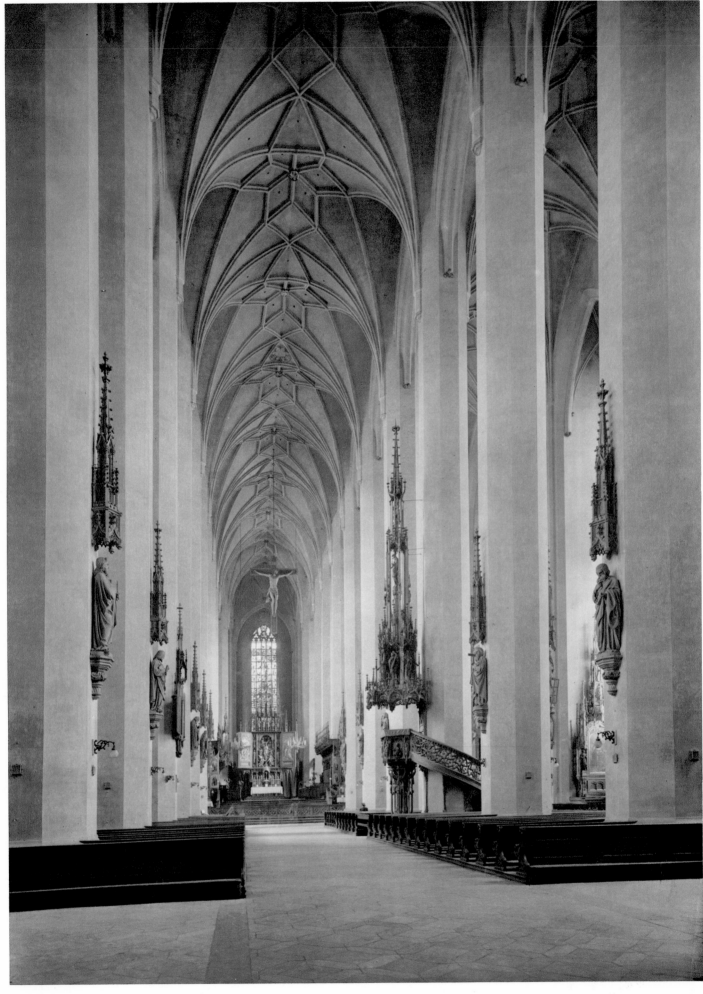

MÜNCHEN

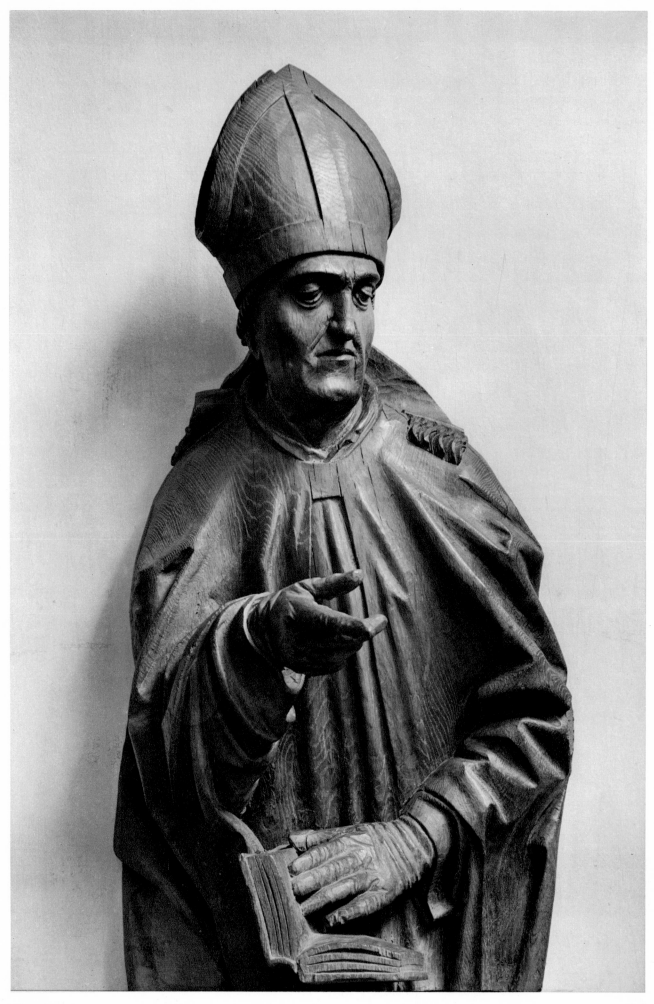